STIRRING UP
SEATTLE

'. . . . one goes on living as one does - and even manages to execute an occasional pirouette on the edge of the precipice.' Lytton Strachey

STIRRING UP SEATTLE

ALLIED ARTS *in the* CIVIC LANDSCAPE

R. M. CAMPBELL

PHOTOGRAPHS *by* ROGER SCHREIBER

ALLIED ARTS FOUNDATION
Seattle

in association with

UNIVERSITY OF WASHINGTON PRESS
Seattle and London

ALLIED ARTS FOUNDATION
4111 E. Madison St. #52
Seattle, WA 98112

UNIVERSITY OF WASHINGTON PRESS
www.washington.edu/uwpress

LIBRARY OF CONGRESS CATALOGING-IN-PUBLICATION DATA
Campbell, R. M. (Richard M.)
Stirring up Seattle : Allied Arts in the civic landscape / R.M. Campbell ;
photographs by Roger Schreiber. — First [edition].
 pages cm
Includes bibliographical references and index.
ISBN 978-0-295-99394-2 (hardback : alk. paper) 1. Allied Arts of Seattle, Inc.
2. Art patronage—Washington (State)—Seattle. 3. Civic improvement—
Washington (State)—Seattle. I. Schreiber, Roger, illustrator. II. Title.
NX712.A45C36 2014 700.6'0797772—dc23 2014018114

To the memory of my mother and father

Some of us are born to be bit players,
others have bitness thrust upon us.

Contents

Foreword

BY MARY B. CONEY

S OMETHING HAPPENED IN SEATTLE FROM THE MID-1950S TO THE
mid-1980s that made Seattle a different, better city than it had been.
There were the obvious changes: the hosting of the World's Fair, the
developing of Seattle Center, the saving of Pike Place Market, and the pre-
serving of Pioneer Square. But there were other changes, less dramatic in
scale but equally important in the lives of all who lived in our city during
this extraordinary period: the fight to regulate the billboards and bury
unsightly overhead wires that marred our streetscape; the protection and
promotion of street trees; the explosion of cultural events, both organized
and spontaneous; and the emergence of theater, music, and opera on a scale
hitherto unknown in the Northwest. Old buildings and neighborhoods were
considered historic and worthy of preservation. Aesthetics were becoming a
significant point of discussion in city council meetings and administrative
offices: public funding of art at the city, county, and state levels was no lon-
ger a pipe dream of the arts communities but an accepted value for the lives
of all citizens—poor, rich, or in between.

Change of this scope did not come from one group of citizens or civic
organizations; many played a part, in concert with one another and some-
times alone. But certainly a central source of energy started with a few indi-
viduals who came together to discuss Seattle's future, how it might grow,
what could be kept, what should be changed. With a whimsy that would
remain part of its character, this group of professors, architects, lawyers,
activists, and artists called itself the "Beer and Culture Society." Later it

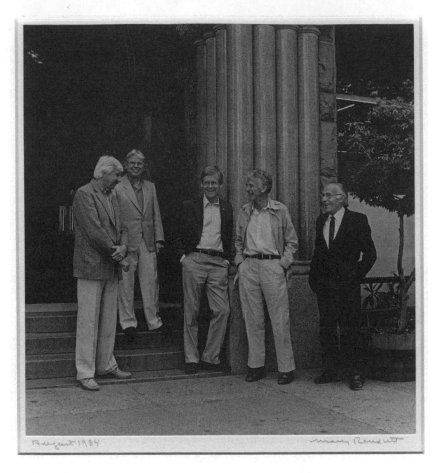

Five Architects, 1984. Left to right: Ralph Anderson, Al Bumgardner, Ibsen Nelsen, Fred Bassetti, and Victor Steinbrueck. Photo by Mary Randlett.

would take on the more serious name Allied Arts of Seattle, signaling its wide-ranging interest in all things cultural and architectural.

For thirty-some years, Allied Arts was a major force, engaging in almost all issues of the day, either leading the cause or joining with others to make their cases stronger, their voices more effective. But, even at the height of their considerable influence, the group kept a sense of play. They took the work seriously, but not themselves. One observer called them "a merry band of warriors."

Alice Rooney, longtime director, described the group's common charac- ter thus: intelligent, knowledgeable, tenacious, visionary, scrappy, coura-

geous, generous, and "a little bit quirky." Most had full-time careers, though many sacrificed, at least temporarily, their professional (and at times, personal) lives to attend endless hearings, write position papers, plot strategies for passing favored legislation, or stay late after a meeting to celebrate a victory. None, I think, gained financially from being a member of Allied Arts; it was not that kind of organization. It had cachet but was not part of Seattle's social set or business community—although it joined in with these when mutual goals could be served. Some played leadership roles in Allied Arts and were visible to the larger public. Others stayed offstage, pouring wine, collating minutes, handing out brochures, carrying placards. Peggy Golberg, who embodied the group's wit and style, called it "the best club in town"—though it was inclusive rather than exclusive, fitting with Allied Arts' history of welcoming newcomers into its midst.

It didn't last forever. More a torrent than a stream, the organization inevitably spent its force and has now settled into Seattle's sediment so deeply that its accomplishments are indivisible from the city itself. Some members have died, others have retired into their private lives, and many have gone on to other places, other work. A foundation in Allied Arts' name, started by former presidents and stalwarts, has kept alive the group's original mission of serving established artists as well as those who have yet to obtain success. It has also kept those of us still around in touch with each other. The friendships formed in those heady times were built not so much on nostalgia as on comaraderie and yes joy.

Stories abound, of course, elaborated by time and memory. The accumulation of those memories convinced us that there was a story to be recovered and shared in something more permanent than our joint and several selves.

Peggy Golberg and secret admirer at auction, 1981. Photo by Roger Schreiber.

Our first attempt at storytelling ended, sadly, with the untimely death of Walt Crowley, former president of Allied Arts, journalist, and founder of HistoryLink, an online source for local and Northwest history. Crowley's writings about Seattle during this period were, like Walt himself, astute, analytical, and sometimes acerbic. He did interviews with those in leadership roles, produced a monograph entitled *Urban Fusion: A History of Allied Arts, 1954–2004* and put together a timeline for this period that places Allied Arts in the context of the larger political scene. All of these inform the present book, either directly (as in the timeline that has been updated, edited, and reproduced here) or indirectly in ways that are not always apparent but always valued. His was a voice worth listening to, and we listened.

The second part of the story was provided by Jeff Katz, an archivist and recent arrival to Seattle. He was hired to interview members of Allied Arts who had played key roles in its history. Jeff brought himself up to speed on his subjects quickly and thoroughly by doing research in the University of Washington archives, the Seattle Public Library, and private collections. Based on this work, he prepared sets of questions that led the interviewees to recall former moments with unexpected clarity. His patient promptings brought forth a rich collection of videotapes, which will be available on the Allied Arts Foundation website. More importantly, transcripts from these tapes became a primary source for the profiles in this book. Their authenticity and immediacy owe much to Jeff, his research, and his skill at making the past dance once again.

Our final piece of good luck was made possible by the demise of the *Seattle Post-Intelligencer*, for the loss of this fine newspaper freed up the talents of R. M. Campbell, art and music critic, then dance as well as music, for the *P-I* for nearly thirty-five years. He was also drama critic for *Northwest Arts*. From that perspective, Campbell covered many of the major cultural events in Seattle and knew professionally and personally many of the people who were active in local and state cultural affairs. But as a good reporter, he kept his critical distance and independence. And that gave him then—as it does now—the independence of judgment that we wanted for our storyteller.

We gave Campbell access to our records, tapes, writings, and ourselves. Our only directive was that he focus on the period in which Allied Arts of Seattle was most active and most effective. Otherwise, he was free to think and write what he wished. We wanted a professional, and we got one. The archives at the University of Washington held the organization's most complete records, although not all of the material had full documentation. In

some cases, the specific dates of speeches or letters were not given. Some minutes and other records went missing from our offices, probably thrown out by an overly diligent staffer in an office move. Piecing everything together into a coherent, intelligible narrative was Campbell's greatest challenge and achievement.

We cannot presume to know how a book of this sort will be used by future generations. Perhaps it is a history that has value beyond itself: lessons, inspirations, a guide for cities other than our own. That is for our readers to discover. We do hope that the book revives a special time in history, that it honors, honestly and in detail, what a group of citizens was able to achieve because they cared about their city. It is a story worth telling for its own sake.

Acknowledgments

A DEBT OF GRATITUDE IN THE WRITING OF THIS BOOK GOES TO many people, beginning with those stalwarts of Allied Arts of Seattle and Allied Arts Foundation, Alice Rooney, Jerry Thonn, and Mary Coney. It is they who asked me more than four years ago, on behalf of the foundation, if I would be interested in doing a history of the organization, which has essentially been out of business for about a decade. My answer, which was quick to formulate, was yes. So many of the principal actors in the organization, especially in the early years, were people I knew, that the request seemed a natural fit for me. The only directive I was given was to concentrate on what Mary calls the "glory years"—the 1950s to the 1980s.

Also, my thanks to Pat Soden, former director of the University of Washington Press, who committed resources of this prestigious house to the project; to Nicole Mitchell, his successor, who oversaw the book to its finish; and to Mary Ribesky, assistant managing editor at the press. Roger Schreiber, an esteemed photographer with a long involvement in the affairs of Allied Arts, not only provided fresh photography but acted as photo editor in seeking out needed vintage photographs. My profound thanks. The many cuts that were used throughout the book—charming and literate and amusing—are from the huge Peggy Golberg collection, many of which she used in her long career as a printer. Pat set a word limit, which, though I thought it reasonable, required me to make further decisions about subject matter—what to write about at length, or not at all. Thus, some areas of interest would inevitably get the bulk of attention and others, regrettably, almost none, such as

arts education, artist housing, varied approaches to minority communities, and the development of Magnuson Park. For more than a decade, the executive committee of the foundation worked to realize the writing of such a book. The first chapter in that process was written shortly after the turn of the century by the late Walt Crowley, a former president of Allied Arts and a founder of History Link, who did interviews and wrote a timeline, which Mary updated for the book. It proved invaluable, not only to fill in some blanks, but also to give a chronological structure to a book that does not proceed with a straightforward narrative. The second chapter concerned Jeff Katz, an archivist of the first order, who in 2009 did a series of superb videotapes of the leading figures in Allied Arts, of which I made liberal use. My thanks for his good work. His interviews, along with Walt's, are intertwined with mine. My gratitude also goes to Mary, former Allied Arts president and professor emerita at the University of Washington, who, at Pat's suggestion, edited the book. She brought a huge range of professional experience and sound judgment to the project. We managed to stay friends throughout this long process—no small accomplishment!

My gratitude also to a number of Allied Arts former presidents and trustees, who, over the years, made significant contributions to the organization, and, ultimately, if perhaps only indirectly, to the writing of this book, but of whom no profile was written. They include Ibsen Nelsen, Paul Silver, Judith Whetzel, Rae Tufts, Shirley (Turner) Collins and Alfred Collins, James Uhlir and Camille (McLean) Uhlir, Marga Rose Hancock, Tom Graff, Norman J. Johnston, and Henry Aronson. Thanks also to Karen Kane, president of the Allied Arts Foundation, not only for her many contributions to Allied Arts itself but for keeping the foundation informed of our progress. Karen's cheerful encouragement was much appreciated.

The vast Allied Arts archives are housed in the Special Collections, University of Washington Libraries, a well-lit, appealing space in the basement of the Allen Library, adjacent to Suzzallo Library. I spent many months looking through hundreds, if not thousands, of well-arranged documents, spanning some fifty years. These were the primary source for the book. It was in the 1980s that the generally pristine condition of the files of the earlier years began to slip, leaving large gaps. At first these gaps were minor, then they grew in significance as the organization began its dissolution. The Special Collections staff was uniformly helpful and the source of not only knowledge but wit. I commend Carla Rickerson especially. I was always a little bit happier when I saw her behind the reference desk when I arrived for a day's work.

In addition to the financial commitment of the UW Press, there are those patrons who made particularly generous donations so that this project could move forward. Without them there would be no book. I would like to thank them not only for their financial aid but also for their moral support along the way. They include Nancy Alvord, Katharyn Alvord Gerlick, David and Jane Davis, Gladys Rubinstein, Janet Wright Ketcham, Ann Pigott Wyckoff, Virginia Bloedel Wright, Mary McLellan Williams and J. Vernon Williams, Peggy Golberg, Gerald and Carolyn Grinstein, Anne Gould Hauberg, Daniel Block, Thomas T. Wilson, Jerry and Ernalee Thonn, Edna and Melvin Kelso, Linda Strout, Cynthia and Christopher Bayley, and Betsy Schmidt, as well as the Wyman Youth Trust, the Carey Family Foundation, and anonymous donors.

All the same, those were the days!

Allied Arts of Seattle Timeline

1952 UW Professor John Ashby Conway begins hosting informal "Beer & Culture Society" meetings on the state of Seattle's arts and urban design in early 1952.

1954 American Institute of Architects (AIA) state president John Stewart Detlie convenes "Temporary Steering Committee on the Allied Arts," chaired by architect William Bain, Sr., at Olympic Hotel on February 1.

First "Congress of the Arts" meets at UW's Penthouse Theater and approves the creation of a permanent "Allied Arts of Seattle," with John Detlie as president, on October 3.

The US Supreme Court affirms the constitutionality of public art funding and policies. Allied Arts begins to lobby city government to charter an official Municipal Art Commission in October.

1955 Allied Arts establishes Committee on Roadside Treatment, chaired by Norman J. Johnston, UW professor of architecture and urban planning, to advocate regulating billboards on major Seattle streets, in January.

Allied Arts urges creation of "federal advisory commission on the arts," and supports the Washington State Museum on the UW campus in seeking a new building to house its Native American art and other collections. In 1964, the state museum opens in its new

Downtown business district from Queen Anne Hill (1950s). Photographer unknown. University of Washington Libraries, Special Collections.

building, renamed the Thomas Burke Memorial Washington State Museum.

Seattle City Council passes ordinance 84162 to establish a "Municipal Arts Commission," on May 31. Mayor Allan Pomeroy and the City Council appoint ten members to the new commission, with John Detlie as the first chairman, on August 1.

Allied Arts adopts a new policy that "AAS, while the sponsor and parent of the Art Commission, would retain 'independence of action'" on August 22.

State World's Fair Commission begins meeting in the fall.

Second Congress of the Arts meets and re-elects John Detlie as president on November 20.

Allied Arts of Seattle officially incorporates in Washington State on December 20. It is later certified as a 501c(4) nonprofit advocacy organization.

1956 Seattle City Council rejects Robert Jackson Block's first petition to fund a new civic center. The proposal is referred to a special com-

Downtown from Queen Anne Hill, 2012. Photo by Roger Schreiber.

mittee, chaired by attorney Harold Schefelman, and later submitted to votes in a modified form.

Municipal Arts Commission adopts thirty-three-point "Program for the Arts" to guide urban beautification and cultural development in June.

Seattle voters approve $7.5-million bond issue for new civic center in November.

Third Congress of the Arts elects UW professor John Ashby Conway to succeed John Detlie in November.

Allied Arts launches drive to regulate billboards along state highways and major arterials.

1957 World's Fair Commission submits its report to the legislature in January, recommending a 1959 event. The target date is later moved to 1962.

Allied Arts sponsors Pacific Northwest International Writers Conference at the UW in January, spearheaded by Allied Arts counsel Ralph Potts.

Fourth Congress debates and rejects Ralph Potts's proposal for an Allied Arts slate of City Council candidates in November.

Seattle Art Museum assistant director Millard B. Rogers is elected president of Allied Arts.

1958 Allied Arts–sponsored bill for State Arts Commission dies in the legislature.

President Eisenhower starts official countdown clock to the Century 21 Exposition on November 10.

Congress of the Arts elects John Detlie as Allied Arts president in December.

1959 State Legislature reserves 3 percent of construction cost for new state library building (now Joel Pritchard Building) for purchase of artworks, including a major Kenneth Callahan mural.

Dr. and Mrs. Clifford Phillips host "Fanfare for Fountains" to raise money for new city Cultural Art Fund on July 26.

Congress of the Arts elects Robert Jackson Block as Allied Arts president in December.

1960 Allied Arts hires Alice Rooney as its part-time executive secretary on March 21.

Allied Arts protests plans to demolish Pioneer Square's historic Seattle Hotel (nicknamed the "Sinking Ship Garage") in May and June.

Congress for the Arts revises Allied Arts articles of corporation and bylaws on July 17.

Allied Arts and Central Association (later Downtown Seattle Association) cosponsor Arts & Crafts Bazaar at Westlake Mall on August 12.

1961 Architect Nathan Wilkinson, Jr., is elected Allied Arts president.

Allied Arts–sponsored State Highway Advertising Control Act and authorization of a seventeen-member Washington Arts State Council (later Commission) pass the legislature in March. Governor

Albert D. Rosellini later appoints Allied Arts members John Ashby Conway, Cecelia Schultz, and Ralph B. Potts to the original panel.

Congress of the Arts elects Ralph B. Potts president of Allied Arts in November.

1962 Allied Arts revives "Operation Deadwood" to promote burying of utility lines on January 16. Allied Arts launches contest to identify "The Street I'm Most Ashamed Of." Kathleen V. Nelson wins with nomination of Spokane Street.

Seattle World's Fair opens for a six-month run on April 21.

Allied Arts sponsors a rare public reading by poet Theodore Roethke at the Seattle Repertory Theatre on October 14.

Seattle World's Fair closes on October 21, having served nearly ten million visitors and leaving behind the Space Needle, Pacific Science Center, the remodeled Civic Auditorium (which became the Opera House, and later McCaw Hall), and exhibition spaces.

Physician Clifford B. Phillips is elected Allied Arts president.

1963 Allied Arts rallies opposition to proposed repeal of Highway Advertising Control Act.

Central Association unveils plan to demolish the Pike Place Market on February 14.

Congress of the Arts focuses on the state of live theater in Seattle on June 12, as the Seattle Repertory Theater launches its first season.

Architect Ibsen Nelson is elected president of Allied Arts.

1964 Seattle referendum to ban racial discrimination in rentals and home sales fails on March 10.

Allied Arts holds public meeting on proposed demolition of the Pike Place Market on July 18.

"Friends of the Pike Place Market," cochaired by Victor Steinbrueck and Robert Ashley, is organized in September.

President Lyndon Johnson signs law creating a National Council of the Arts on September 3.

1965 Seattle City Council member Wing Luke, a key Allied Arts ally, dies in a plane crash in the Cascade Mountains on May 16, along with philanthropist Sidney Gerber and assistant Kate LaDue.

President Lyndon Johnson signs the National Foundation on the Arts and Humanities Act, creating National Endowments for the Arts and for the Humanities, on September 29.

Greg Falls launches first season of A Contemporary Theater (ACT).

1966 Norman J. Johnston, UW professor of architecture and urban planning, is elected Allied Arts president.

Allied Arts assists the Central Area Motivation Program (CAMP) in organizing inner-city arts programs beginning in January.

The Congress of the Arts is held at Mount Zion Baptist Church on December 4, and features discussions on how to make the arts more accessible to low-income and minority citizens. Guest speaker is Will Rogers, Jr.

1967 Allied Arts holds its annual meeting at the Pacific Science Center's Eames Theater on January 17.

Governor Dan Evans vetoes legislation to repeal highway advertising controls.

The Allied Arts Foundation is incorporated on May 17, and is later certified as a 501c(3) organization.

To promote historic preservation, Allied Arts leads City Council members and other civic leaders on a tour of Vancouver, British Columbia, on June 3.

Reform candidates Phyllis Lamphere and Tim Hill win election to the Seattle City Council, along with its first African American, Sam Smith, on November 7.

King County establishes an Arts Commission.

1968 Attorney Jerry E. Thonn is elected Allied Arts president on January 16.

Seattle City Council approves program to bury City Light power lines on selected routes in February.

Forward Thrust bonds for new parks, the Kingdome, and other public facilities pass on February 13, but a rail transit plan fails.

Seattle Chapter of AIA publishes a comprehensive urban design, "Action Better City," in May.

Allied Arts sponsors a ten-day independent film festival at the Pacific Science Center beginning June 13.

At urging of Allied Arts and AIA, City of Seattle creates Design Commission on October 1.

King County voters approve "Home Rule" charter for new government on November 5.

Allied Arts hosts publication party for Victor Steinbrueck's *Market Sketchbook* on November 21.

Allied Arts holds 15th Congress of the Arts at the Pacific Science Center on December 4.

Local corporations and donors organize United Arts Council (later Corporate Council for the Arts and now ArtsFund) to coordinate support of arts groups.

1969 Allied Arts occupies its first permanent offices in Pioneer Square's Globe Building on March 1. It celebrates by painting an adjacent parking lot (the future Occidental Park) green and hosting an outdoor party.

Allied Arts sponsors "The Lively Arts—A Trip in Multi-Media," a sixties-style happening, at the Opera House on May 18.

Pioneer Square Historic District is approved by the City Council in May and listed on the National Register of Historic Places.

Wes Uhlman is elected mayor of Seattle and challengers Wayne Larkin, Jeanette Williams, George Cooley, and Liem Tuai win City Council seats on November 4.

1970 Allied Arts elects architect Fred Bassetti president on January 18.

Second set of Forward Thrust transit and facility bonds fails on March 19.

Downtown Seattle from West Seattle, ca. 1969. Photographer unknown. University of Washington Libraries, Special Collections.

In a May 14 letter, Allied Arts urges the firing of City Light superintendent John Nelson for his opposition to underground wiring program.

1971 Allied Arts promotes new laws to permit outdoor cafes and other sidewalk improvements.

Allied Arts publishes first directory of the arts, listing 414 organizations and individuals in March.

New Seattle Arts Commission is established on June 1, replacing the inactive Municipal Arts Commission, with expanded powers and formal budget.

Friends of the Market launch signature drive for "Save the Market" initiative on June 14.

First annual Mayor's Art Festival, precursor of Bumbershoot, is held at Seattle Center on August 13.

Voters approve "Save the Market" initiative on November 2. Allied Arts is assigned a permanent seat on the Historical Commission.

Downtown from West Seattle, 2012. Photo by Roger Schreiber.

Allied Arts allies John Miller and Bruce Chapman win election to the Seattle City Council.

Seattle Design Commission approves creation of Occidental Park and expansion of Pioneer Place Park in Pioneer Square.

1972 Attorney Paul E. S. Schell is elected Allied Arts president in January.

Allied Arts and The Artists' Group advocate dedicating 2 percent of city capital budgets for acquisition of public art.

Allied Arts sponsors first "Survival Series" to promote patronage of smaller arts organizations and performances.

Allied Arts hosts an art auction at ACT on November 18—which will become the organization's main annual fundraiser for the next twenty-five years.

1973 King County adopts "One Percent for Art" ordinance to fund public art on February 8. Seattle adopts One Percent Ordinance on May 21.

Allied Arts issues "Proposal for the Performing Arts in Seattle" and advocates repeal of admissions taxes for performing arts groups, in

summer. Subsequent lobbying leads to City Council approving an additional $300,000 for performing arts, administered by Seattle Arts Commission.

Allied Arts holds benefit party at Kiana Lodge on Bainbridge Island on July 20.

City of Seattle establishes Landmarks Preservation Board.

Seattle voters endorse billboard controls.

City of Seattle repeals admissions taxes on performing arts groups on December 12.

Allied Arts reports record membership of 764.

1974 Allied Arts holds 20th annual meeting (formerly Congress of the Arts) at Ruby Chow's Restaurant and elects attorney Llewelyn G. Pritchard president on January 27.

State Legislature approves One-Half Percent for Arts statute.

Allied Arts launches unsuccessful campaign to preserve White-Henry-Stuart Building in downtown Seattle. It is demolished for Rainier Square and office tower in 1977.

Allied Arts reports membership of nearly 1,000 and a $20,000 annual budget.

1975 Allied Arts protests plans to replace Olympic Hotel, which are dropped, in January.

Mary Coney leads successful Allied Arts campaign for increased Seattle Arts Commission funding.

Allied Arts hosts brown bag tour of Port Gamble.

Allied Arts convenes conference on arts reporting and journalism on October 31.

1976 Allied Arts elects UW professor Mary Coney as its first woman president on January 25.

Third edition of Allied Arts' Directory of the Arts lists 681 organizations and individuals, in May.

Allied Arts hosts meeting of the National Council on the Arts.

Allied Arts and other groups take first steps toward organizing the Washington State Arts Alliance.

1977 Allied Arts stages exhibition "Flags, Banners, and Kites" at the Seattle Center Plaza July 10–24.

Allied Arts promotes establishment of "Tickets Tonight" booth at Westlake Mall.

Historic Seattle, a public development authority, commissions Victor Steinbrueck and Arne Bystrom to conduct a citywide survey of historic structures.

Charles Royer defeats former Allied Arts president Paul Schell to win election as mayor of Seattle on November 8.

Allied Arts reports 1,077 members.

1978 Former mayor Wes Uhlman addresses Allied Arts annual meeting, which elects attorney James Uhlir president, on January 29.

Allied Arts declares opposition to proposed new restaurant on the 100-foot level of the Space Needle on April 18.

City of Seattle enacts one-year moratorium on new billboards.

1979 Demolition of the White-Henry-Stuart Building begins.

Allied Arts holds its annual meeting in Pioneer Square's Central Tavern and elects attorney Paul Silver president on February.

Allied Arts hosts opening of the Pioneer Square Gallery of Decorative Arts on October 11.

Allied Arts hosts an Art Deco ball and architectural tour on October 13–14.

1980 Alice Rooney steps down as Allied Arts executive director and is succeeded by Mary Owen in March.

1981 Stockbroker Camille (McLean) Uhlir is elected Allied Arts president on January 25.

Allied Arts publishes its recommendations for a new downtown Seattle land use and transportation plan in October.

1982 Allied Arts hosts "Land of Oz" auction, celebrating Seattle's new "Emerald City" slogan at the Museum of History and Industry on February 2.

Dick Lilly succeeds Mary Owen as Allied Arts executive director on April 1.

Allied Arts launches "Art a la Carte" tours of artists' studios and "Last Friday" lecture series.

1983 Attorney Henry Aronson is elected Allied Arts president on January 16.

1984 Allied Arts recommends laws and regulations to retain and develop artists' housing and studio spaces.

Mayor Charles Royer and Victor Steinbrueck reach a compromise on the design of the new Westlake Park and adjacent Westlake Center shopping arcade and office building.

1985 Allied Arts elects architect Gerald Hansmire president in January.

Victor Steinbrueck dies on February 14.

City Council adopts new Downtown Seattle Land Use and Transportation Plan, but Mayor Royer delays implementation for eighteen months, triggering a high-rise building boom.

1986 Allied Arts publishes *Impressions of Imagination: Terra Cotta Seattle* by trustee Lydia Aldredge in April.

Allied Arts campaigns successfully for major public art to be included in new downtown Seattle Transit Tunnel, which opens in 1990.

Voters approve $29.6 million in bonds to build a new downtown Seattle Art Museum. The design by Robert Venturi ultimately costs $64 million.

Allied Arts leads successful campaign to block sale of Henry Moore's *Vertebrae* by the former Seafirst Building's new Japanese owners.

1987 Allied Arts elects attorney Margaret Pageler president.

Allied Arts and other groups campaign unsuccessfully to block removal of new state capitol murals by Michael Spafford and Alden Mason.

1988 Allied Arts and other groups form People for an Open Westlake and launch unsuccessful campaign to block construction of Westlake Center.

Allied Arts criticizes design of new Washington State Convention and Trade Center.

Allied Arts board member Cara Wells is hired as interim executive director, assisted by Richard Mann.

1989 Architect Lydia Aldredge is elected Allied Arts president on January 15.

Peter Steinbrueck and Margaret Pageler lead Allied Arts campaign for "Citizens' Alternative Plan" (CAP) initiative to reduce downtown building heights and densities, which passes on May 16.

Margaret Pageler and other "Vision Seattle" candidates lose bid for Seattle City Council seats, and Norm Rice is elected mayor on November 7.

Allied Arts establishes computer and desktop publishing lab for use by artists and arts groups.

With Allied Arts support, King County adopts new program to distribute excess Kingdome hotel/motel tax revenue to arts and heritage organizations.

Richard Mann succeeds Cara Wells as executive director.

1990 Allied Arts elects gallery owner Mia McEldowney as president on January 14.

State legislature adopts Growth Management Act of 1990 to promote greater comprehensive and regional planning, including cultural resources.

Alllied Arts campaigns to prevent demolition of the Blue Moon Tavern in the University District and the downtown Music Hall

Theater, a designated historic landmark. The Blue Moon loses its bid for landmark status, and the Music Hall is "redesignated" by the Landmarks Preservation Board on March 7.

Landlords of the Blue Moon abandon demolition plan and sign forty-year lease to preserve the tavern on May 4.

Redesignation of the Music Hall is voided and demolition begins in summer.

1991 Columnist John Hinterberger and former Allied Arts president Fred Bassetti publish proposal for vast South Lake Union park, later dubbed "Seattle Commons," in the *Seattle Times* on April 17.

Jonathan Borofsky's giant *Hammering Man* sculpture falls during installation at the new downtown Seattle Art Museum on September 21. It is repaired and installed one year later.

Mayor Rice authorizes Allied Arts vice president Walt Crowley to empanel a "Downtown Historic Theaters Advisory Group" to explore new strategies for preservation of surviving landmark theaters on October 30.

Former Allied Arts president Margaret Pageler is elected to the City Council.

Allied Arts committee on artists' housing, led by Jay Lazerwitz, incorporates as ARTSPACE on November 18.

1992 Writer-consultant Walt Crowley is elected Allied Arts president in January.

Clise Properties, owners of the Music Hall, win $1-million judgment against the City of Seattle for exceeding its historic preservation authority.

Mayor Rice champions establishment of "urban villages" in neighborhoods to meet goal of state Growth Management Act.

1993 Seattle City Council adopts most TAG recommendations for protection of historic downtown theaters on January 4.

Guerilla artists group "Subculture Joe" tethers a giant ball and chain on *Hammering Man* on September 7.

Downtown business district from Bell Street Overpass, 2012. Photo by Roger Schreber.

On behalf of the Seattle Arts Commission, Allied Arts auctions *Hammering Man* ball and chain on October 30.

Corporate Council for the Arts (now ArtsFund) issues economic analysis showing that the arts are a larger economic engine than professional baseball in Seattle.

Richard Mann resigns as executive director, and no new full-time director is appointed.

1994 Attorney Lish Whitson is elected president of Allied Arts in January.

Allied Arts holds its last annual auction benefit in March.

1995 Allied Arts supports compromise plan to reopen Pine Street to traffic through Westlake Park, which is endorsed by voters on March 14. Regional voters reject $6.9 billion Sound Transit plan in same election.

Allied Arts members are divided over proposed Seattle Commons plan, which fails in September.

1996 Voters reject revised Seattle Commons plan on May 21.

Regional voters approve smaller Sound Transit plan on November 5.

1997 Allied Arts elects architect Clint Pehrson president in January.

Allied Arts banquet at the Four Seasons Olympic Hotel on March 16 honors Samuel Stroum, Stimson Bullitt, Julie Anderson, Norie Sato, Safeco Insurance, and Walt Crowley.

Former Allied Arts president Paul Schell is elected mayor of Seattle. Peter Steinbrueck wins a City Council seat, and a Monorail initiative passes on November 4.

The US Navy turns over surplus Sand Point Naval Air Station property and structures to the City of Seattle on December 12, and Allied Arts begins exploring potential uses to benefit the arts.

1998 No record for this year

1999 Writer Alex Steffan is elected president of Allied Arts in January.

Allied Arts convenes "Constitutional Convention of the Arts" to press for increased arts funding and reforms on May 10.

Allied Arts spearheads creation of Sand Point Arts and Cultural Exchange (SPACE), which adopts strategic plan on September 18 to develop arts facilities and programs at Magnuson–Sand Point Park.

2000 Allied Arts hosts "Frivolity Ball" at new Consolidated Works art center in Cascade neighborhood on August 5.

2001 Philip Wohlstetter is elected Allied Arts president in January.

Allied Arts hosts "Sockeye Solstice" benefit at remodeled Grosvenor House on June 21.

Allied Arts launches "Beer & Culture" series to attract new members and explore new ideas.

Burst of the "dot-com bubble" and souring regional economy deflate Allied Arts Foundation assets and income.

County Council member Greg Nickels defeats Mayor Paul Schell on November 6.

Seattle and King County observe sesquicentennial of the Denny Party's arrival on November 13, 1853.

2002 Allied Arts sponsors Viaduct Wrecking Ball party on June 14, as part of new campaign for redesign of the central waterfront.

2003 Allied Arts annual meeting elects designer and planner David Yeaworth president at Banner Works on January 26.

Allied Arts–sponsored waterfront design charette unveils its ideas in December.

STIRRING UP
SEATTLE

Introduction

I N NOVEMBER 1851, OR BY SOME ACCOUNTS FEBRUARY 1852, A
cool, gray afternoon, rain sputtering all around, Seattle was discovered
by the Denny Party, named after Arthur Denny. There were ten adults
and twelve children. The women, so it is said, wept at the sight of the damp
scenery—abundant water, handsome mountain ranges to the east and west,
tall glorious trees—and little else.

Like most pioneers, those who came to Seattle were industrious, ambi-
tious, and hardy. They persevered and a city grew, centered in what is
now Pioneer Square and developed northward. Within twenty years there
were three thousand residents and a university. Two decades later calamity
struck: a fire swept through the wooden city, like Brunnhilde's immolation
in the closing act of Wagner's *Ring* cycle, destroying everything within some
sixty blocks. Seattle was rebuilt, this time using more durable materials,
making the Pioneer Square that we know today, a century later. Seattle was
a remote place then, and essentially as temperate as its climate—although it
has had its rebellious and tawdry bits.

Roger Sale, in his notable history *Seattle: Past to Present*, quotes poet and
critic Malcolm Cowley: "I spent the early months of 1950 in Seattle, where
everything was modern, including the excellent food in private homes.
Everyone seemed to be middle class and literate, no matter what his trade.
We lived on a street lined with picture-window houses that were owned, not
rented, by business people, skilled mechanics, and college professors. The

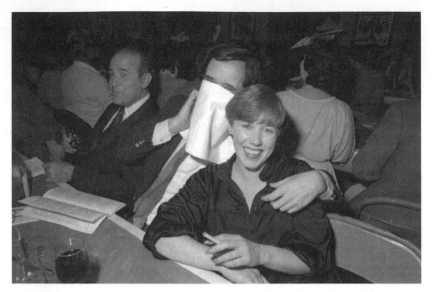
Ann Alexander and secret admirer at auction, 1981. Photo by Roger Schreber.

milkman, the dry cleaner for the neighborhood and the cleaner's wife were college graduates, as were many of the taxi drivers."

Sale himself described Seattle as a "soft city, made up of soft lights and hills and water and a sense that nature is truly accommodating. . . . There is no day in the year when it is too hot or too cold to work or get around and few days when one cannot be outside, in a boat, walking, playing golf or tennis or going fishing. . . . [It is] a bourgeois city, capable of sustaining middle-class virtues and middle-class pleasures . . . Seattle's colors are gray and green." Maxine Cushing Gray, a longtime critic, and editor and publisher of *Northwest Arts*, was less diplomatic: she called Seattle a "cowtown."

Undoubtedly, in the middle of the twentieth century, many Seattle residents were content with things as they were. And why not? Despite its cultural drawbacks and insularity, even its self-satisfaction, Seattle's remarkable setting made up for many deficiencies. Traffic was light. And there were mountains and water for recreation nearby. As the last place to be settled in the continental United States, Seattle didn't have many people.

But not every resident was content with a cityscape that had hardly changed in fifty years. They bemoaned the omnipresent parking lots and lack of urban finesse. The Norton Building and the Logan Building, built in

Mickey Gustin (*second from right*), Bill Ballentine (*right*), and guests at auction, 1981. Photo by Roger Schreber.

the late 1950s, were the first high-rise office buildings to appear downtown since 1930. Convinced that something was missing, there were those who wanted to push the city forward. And push they did for some forty years

John Ashby Conway, a member of the drama faculty at the University of Washington and a designer (notably of the Penthouse and Showboat Theaters on campus), a weekend restaurateur in Port Townsend (at The Farmhouse), and cofounder of Allied Arts, recalled, in 1985, in an account of the early days of Allied Arts, "Some kindred spirits—two architects, a museum director, two college professors, with occasional guests—used to meet at our Seattle home. Mainly beer was available by popular demand. . . . This nucleus became known as the Beer and Culture Society. All were concerned about the state of the city. The leading question became, why don't they do something, until we realized we had to take the lead. All were trained in some phase of the arts, all had good imaginations, all recognized Seattle's needs."

These genteel revolutionaries got busy: they wrote to all the leading arts organizations, asking them to suggest what the city could do to help their arts groups prosper—an issue that had not been addressed in the preceding hundred years. Conway continued, "It is one thing to 'grouse' about the

politicians, another thing entirely to do something about it. We realized we needed 'political clout' and proceeded to obtain it for ourselves." Thinking that they needed to include a large number of citizens, they added the Boy Scouts to their cause. By 1954, two years after the first meeting, the group formally became Allied Arts of Seattle. Luncheon meetings were held, to which public officials and candidates were invited. The fledgling organization formulated a statement of purpose that read, "The mission of Allied Arts of Seattle is to enhance the cultural livability of Seattle and to create a support network of people who care about the arts, urban design and historic preservation."

A Municipal Arts Commission was created the following year, mostly with members from Allied Arts. A Governor's Council on Art was founded. Allied Arts grew like lightening. By 1956 Allied Arts represented nearly sixty organizations. The commission recommended a thirty-five-point master plan, which included public funding of the arts; establishing a ballet company, repertory theater, and opera company; burying public utility lines; preserving historic landmarks; and planting trees. Allied Arts itself recommended forming a state arts commission, prohibiting billboards, building a civic center, and creating a world's fair. In the plan's few words, a blueprint for Allied Arts' future was formulated. Other ideas came along, such as saving Pike Place Market; expanding Allied Arts beyond Seattle; developing a public relations program for the arts; expanding exhibition and performance opportunities, and so on. Following in the wake of artists and architects came battalions of lawyers who proved useful in the battles to come.

The bylaws outlined eleven standing committees, including city planning, architecture and interior design, landscape architecture and gardening, literature, museum and galleries, music, painting, sculpture, theater arts, and dance. Later these evolved into additional ad hoc committees that were "more fluid and flexible" and met civic concerns as they arose.

In his address at the first Allied Arts Congress, or annual meeting, in 1955, founding president John Stewart Detlie said,

If in our time a great flowering of the arts comes to America, we believe that it will come through America's special genius for coordinated action. Allied Arts of Seattle was created in that belief. . . . [Compared with similar groups throughout the United States] we believe Allied Arts of Seattle to have the broadest base. . . . Why did this movement happen here at this time? It was the occasion of "dustbin" attitudes and the natural desire to

Auction guests, 1981. Photo by Roger Schreber.

grow as a cultural center as well as a commercial and sports center; it was the depressing certainty that in time our West Coast cities would surely become the same monotonous dreary monuments to indifference as many of our Eastern seaboard cities; it was the need for some dramatic counter-movement to cut through America's indifference to her cultural possibilities; it was because the arts needed a collective voice.

In 1960 Detlie left Seattle to take a job in Los Angeles as architectural chief of one of the largest design and construction firms in the world. His departure was a big loss for the city and for Allied Arts. Detlie had been engaged in numerous civic activities more than anyone else at the time, it has been argued. Five years later, on one of his return visits to Seattle, Detlie told Louis R. Guzzo of the *Seattle Times*, "You don't appreciate what great strides have been made here and how truly beautiful and splendid Seattle is until you have lived elsewhere for a time. . . . When you recognize the lethargy and disinterest that paralyzes other American cities you are doubly impressed with what Seattle has done."

At Allied Arts' beginning there was abundant energy, enthusiasm, and optimism for a number of projects in the civic landscape. The organization's members were soon seemingly omnipresent, and its trustees influential.

They were part of a rising tide of progressive politics, willing to commit themselves to the greater good, as they saw it, and formed, along with others, the soil that would nourish Seattle for decades and create a very different, forward-thinking city.

The organization was looked upon favorably by the daily press, but on occasion came in for criticism. In the late 1950s John Voorhees of the *Seattle Post-Intelligencer* wrote,

> Watching the growth of the Allied Arts in Seattle in the few short years since its birth has been fascinating and rewarding. . . . But at a recent meeting of Allied Arts . . . the writer noticed a deplorable tendency toward a great deal of talk and very little action. Talk in itself is not to be despised. . . . But too much of the talk at the AA meeting was of the self-praising variety, highly tinged with a suggestion that AA was responsible in large part for a renaissance of the arts in Seattle. Actually . . . "Renaissance" means rebirth and concerning a rebirth of the arts in Seattle, there just isn't any such thing as far as this writer can see. Even if there were, Allied Arts has been alive far too short to take credit for it.

Guzzo echoed those sentiments in the *Seattle Times* in 1957: "Allied Arts of Seattle, one of the most inspiring products of the city's cultural awakening, stands in danger of becoming another Yak and Yawn Club. . . . It has to rescue its former 'pulsating pace.'"

However, less than two decades later, Allied Arts had won the admiration of arts critic Mike Steele, who in 1974 was sent by his paper, the *Minneapolis Tribune*, to take a look at Seattle, a sister city. A key to the reason that Seattle works so well, he wrote, is "a tradition of citizen participation that began 20 years ago with the formation of a citizens' advocacy group call Allied Arts. From it have sprung other groups fighting other battles, but most certainly it was Allied Arts that . . . gave the push when needed." He quoted Paul E. S. Schell, then president of Allied Arts: "Those of us who cared about urban living and felt the decay and helplessness in Eastern and Midwestern cities look on Seattle as a possibility, a newer city without a crusty establishment controlling everything. There was an opportunity to get involved in a meaningful fashion."

Allied Arts' response to early criticism was another far-reaching program of the arts, including beautification, a civic center, and advancement of the performing arts. Some plans for the future were a little naïve, like the

"establishment of Seattle as a world center of the visual arts and crafts," but most of the ideas and projects planned, if wildly ambitious and optimistic, went to the heart of what it meant to be progressive, something with which Seattle had been unfamiliar.

A plan for the future was established that would carry the citizen advocacy group through the next three decades. That is what this book recounts. No history has been written about Allied Arts and its multifaceted agenda. It is time. Most of the people who were active are still alive, but their memories and energies in some cases are not as strong as they were. Many projects that Allied Arts succeeded in accomplishing or had a hand in accomplishing are now simply taken for granted. Which, when one thinks about it, is the way it is with a great city. Inevitable.

1 / *Alice Rooney*

LICE ROONEY ALMOST SAID NO TO ROBERT JACKSON BLOCK, then president of Allied Arts, when he offered her the job of executive secretary in 1960. "I have two children; I live in the suburbs and have no car." Block then asked two questions: "Do you have a typewriter? And phone?" Well, yes, she tentatively replied. In his customary fashion, Block barked, "What's the big deal? That's all you need. You're hired."

And so Rooney came to the fledgling organization that had been founded only six years earlier, and stayed for twenty years. "I was hired on March 21, 1960, part-time, with my pay not to exceed two hundred dollars per month. I worked at home; then nine years later, Allied Arts and I moved to an office in Pioneer Square [generously donated by the landscape architectural firm Jones and Jones] sharing space with the American Society of Interior Designers and New Dimensions in Music." Even now, some thirty years later, one does not mention Allied Arts without mentioning Rooney. Presidents came and went, some better than others, but Rooney was the glue that held it together, the den mother to a gang of individuals who prided themselves on their singularity, their independence, their bounty of ideas. Maggie Hawthorn, drama and jazz critic for the *Seattle Post-Intelligencer*, called Rooney "the information fountain, the practical arm for action and mother confessor." "Alice was the spirit and soul of Allied Arts," said Jerry Thonn, who had a long tenure as president of the organization. "She knew absolutely everybody in the city and always had something to contribute. She never usurped the presidency, which would have been easy for her to do, but she always saw

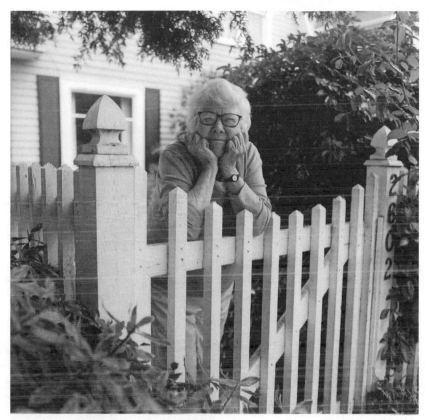

Alice Rooney, 2002. Photo by Roger Schreiber.

to it that we did the right thing." In other words, she was a mother hen for a lot of roosters.

The invitation from Block did not come "out of the blue," as the saying goes. After graduating from the University of Washington, Rooney spent three years in New York, where she gained considerable experience in advertising, including writing newsletters and radio commercials—"all those things," in Rooney's words. Back in Seattle, after a short flirtation with the notion of teaching ("I discovered I enjoyed everything about teaching except teaching"), Rooney drifted back into advertising, public relations, and marketing. One potential client was the Seattle Chapter of the American Institute of Architects (AIA), which was looking for a part-time staff person. Rooney attended some meetings, rather like an extended "how do you do." The year was 1950.

"I was twenty-four years old and heard the president [of the AIA] talk about the reason for doing things, having to do with Aristotle and Plato and aesthetics and whatnot instead of profit. I thought, 'This is for me!'" Rooney took the job, dividing her time between doing radio commercials and being executive secretary. In her time there, she met architects such as Fred Bassetti and Ibsen Nelsen, whom she would meet again at Allied Arts. After a few years, she was offered a full-time job at the AIA but quit instead to marry Bob Rooney and have two children, Robin and Scott.

Her children having nicely settled into a school routine, Rooney decided that she was in need of some distractions. She began to look around, first in Edmonds, then in Seattle. Some friends suggested that she try working either on the gubernatorial campaign of Al Rosellini or at Allied Arts, with which she had some familiarity because she knew John Detlie, the founding president. When Rooney began at Allied Arts in 1960, with her dining room as her office, there were one hundred members who paid two dollars annually for their membership. Rooney's first electric typewriter came six years later with a PONCHO (Patrons of Pacific Northwest Civic, Cultural, and Charitable Organizations) grant. Eventually part time became full time, and Rooney's dining room returned to its original use when Allied Arts acquired an office in the Old Globe Building. Rooney got periodic raises in her salary, although none ever came close to being adequate compensation for what she did.

Rooney got to work immediately. By the following year, in a letter to a prospective member, she listed what Allied Arts was up to: billboard control legislation; the establishment of the King County Arts Commission, the Washington State Arts Commission, and the Seattle Arts Commission, which Rooney called "a lively child"; an international writ-

Bob Block with Alice Rooney. Photographer unknown. University of Washington Libraries, Special Collections.

Alice Rooney

ers conference; and the Washington Roadside Council. By 1963, in a letter to a prospective member, Rooney ticked off accomplishments that included a critical review of the design of the second Lake Washington bridge that led to the state Department of Highways agreeing to consult with the Washington State Arts Commission on design issues; the passing of billboard regulation by the Seattle City Council; sponsorship of the "Street I'm Most Ashamed Of" Contest; and the annual Congress (what Allied Arts called its annual meeting of members), which opened a city-wide discussion of the future of the Seattle Center.

"It seems incomprehensible that when I started with Allied Arts in 1960 we had only 150 members," she wrote in what she called a "love letter to Allied Arts." "That didn't stop us from doing many things. . . . It didn't stop us from feeling we were right when we introduced legislation to establish the state arts commission or react angrily when a drive was started to fence in Seattle Center after the World's Fair and charge admission to the grounds. We were all convinced of the rightness of our taste when we disputed the cartoon qualities of the Seattle Park Department's plans for the Children's Zoo at (Woodland Park) and argued for the Bassetti design, which ultimately prevailed."

> *I saw my job as picking up the pieces, the things they really didn't want to do, as I say, the mundane things, to see if we could make them happen.*

Allied Arts was not always fully aware of the treasure it was getting—for peanuts. Rooney was strong, intelligent, straightforward, articulate, friendly, and a far-seeing diplomat. One might feel the velvet brush against the shoulder but rarely the iron behind it. It would have been easy to underestimate Rooney because her manner was so amiable. That would have been a mistake. It is no surprise that she is so well remembered today, and that Allied Arts prospered with her at the helm. Nothing and no one ever really replaced her.

Like many, Rooney was an admirer of Detlie, to whom Allied Arts traces its roots:

> He had that kind of comprehensive view of art and architecture. He was also famous because he had been a set designer for Paramount Pictures

and was married to the actress Veronica Lake. It was not surprising to me that he was a co-founder of what was called the Beer and Culture Society, which evolved into Allied Arts, with its view of wanting to create the kind of city that attracted people with passion and enthusiasm, who supported the arts and good urban design. Not all his ideas took hold, for instance, using water as a theme in all things. Detlie designed a fountain to be out in the middle of Elliott Bay. Nobody ever did anything about it. I always thought that was a shame.

The name Beer and Culture Society suggests "a kind of irreverence and humor associated with Allied Arts," said Rooney, "but they were very serious too. I don't think they knew a lot about politics, but they learned." For instance, there is no substitute for personal connections to lawmakers, be they city councilmen or state legislators. Any member of Allied Arts might be recruited to make phone calls, arrange meetings, or send letters, telegrams, or postcards. In 1961, Rooney sent a letter to a citizen encouraging him to lobby in support of bills for a state arts council and billboard legislation: "I'm enclosing some postcards. Use them yourself and pass them out to friends, guests, bill collectors, the milkman, anyone who will write to his legislators to support these bills."

Rooney remembers well how Allied Arts was considered in its early days:

It was known but not considered very powerful and certainly not a very large organization. I think we had maybe two hundred members. At the start Allied Arts had a kind of quality that caught people's attention. Later on, when I was there, we also became known for coming up with way-out kinds of solutions on occasion or taking stances that were not very traditional in a very conservative city—before Wes Uhlman became mayor in the early 1960s and 1970s. Seattle's mayors were usually businessmen. They had honest administrations but were not particularly interested in issues like the environment or social justice. So, for Allied Arts to come in and introduce elements of architecture, design, parks, that kind of thing, was a whole new element. It brought people together.

In the 1960s, Allied Arts joined the battle on two major issues: keeping billboards off the freeways and saving the Pike Place Market. With these ultimate victories, Allied Arts came into its own as a power to be reckoned with. Of the first, the billboard controversy, Rooney recalled,

It took a long time. It wasn't Barry Ackerley but Foster and Kleiser Billboard Company. The company never dreamed that a little tiny organization like Allied Arts, with the help of garden club ladies, the AIA, and landscape designers too, could possibly get anti-billboard legislation passed in 1961. It took a lot of time for us to do it. The other, of course, was starting Friends of the Market, which Victor Steinbrueck proposed in 1963 or 1964. We started having champagne breakfasts at the Market once a year. I always thought that was a very funny anomaly—champagne at the Market. But it called attention to what was going on. The city tried different kinds of compromises but nothing would ever suit Victor. Finally the famous initiative was started. At the time the mayor was opposed to saving the Market, as were the Chamber of Commerce, the Downtown Development Association, the director of the Seattle Department of Development. The only people who were for it were the people. It really was a great victory.

Rooney mused much later in a speech to a group of people in Bellingham who were in the process of forming the Whatcom County Allied Arts: "It seems to me that I've spent a good part of my life the last few years responding to a plaintive question—'What is Allied Arts'? The question has often been asked—plaintively—in connection with some ridiculous plan of Allied Arts to keep the city from tearing down the Pike Place Market or to use Pioneer Square for something besides warehousing and parking."

Allied Arts itself was composed of some fifty organizations, in addition to groups such as Friends of the Market and the Washington Roadside Council, which began at Allied Arts and spun off in their own direction. "Allied Arts," Rooney wrote in response to an inquiry from San Francisco, "has spoken long, loudly, and vociferously on many aspects of planning, design and city beautification. . . . We work through public opinion, through the press, through the city council and mayor, through the Municipal Arts Commission, which we helped start, through various legislative processes." She continued in a speech made in Bellingham before a group of people interested in forming their own Allied Art:

The confusion about what Allied Arts of Seattle is—and does—is very much lessened today, but I believe it arose because of the name Allied Arts, and the unique nature of this organization. Not many arts councils give their attention to the environment and the dynamics of the city. Most arts councils concentrate on the arts as such. . . . The genesis [of Allied Arts] . . .

Alice Rooney with Paul Schell at annual meeting, 1979. Photo by Roger Schreiber. University of Washington Libraries, Special Collections.

was an informal group of architects, teachers, artists, [and] citizens who loved the arts. They called themselves the Beer and Culture Society and as the story goes, they used to sit around and talk about what "they" ought to do. When the Beer and Culture Society realized that "they" were "they," they set about founding the organization. The founders of Allied Arts, however, had a very clear idea, I believe, on how to accomplish the goal set by thousands of people involved in the arts across the country: that is to make the arts so significant a part of people's lives that the arts would no longer be the first to have funding cut when budget crunches arise.

If the campaigns for the Market, against billboards, and for historic preservation were among the major efforts of Allied Arts in the early Rooney years, there was plenty else to occupy her energy and time. Not all of these efforts had a lasting influence, but they form an interesting angle on Seattle history. One was an arts and crafts fair at Westlake, with all the usual booths and craftsmen and organizations. It was modeled after the Bellevue Arts and Crafts Fair that was already well established on the Eastside. "By comparison, we were very small scale," she said. "In those days the whole

Alice Rooney

Westlake area was dreary and undernourished. However, the fair drew attention not only to Allied Arts but also to the state of affairs at Westlake. There was no follow-up, and craft fairs were essentially left to Bellevue, which did them so well."

Another project, in 1962, was a contest for "The Street I'm Most Ashamed Of," which was won by the entrance to West Seattle on West Spokane Street. "It is very different now, with the new West Seattle Bridge," she said. Then there was a closed-circuit film on John Kennedy coming to Seattle, in which Allied Arts was to participate in a benefit—a brainchild of civic leaders Kayla Skinner, Anne Gould Hauberg, and Joanna Eckstein, all Allied Arts trustees—that would help the Seattle Symphony Orchestra pay off its debt for its production of *Aida* [its contribution to the World's Fair] and give individual groups some money for their sponsorship. Allied Arts' share of the swag was about eighteen hundred dollars, some of which found its way to the future Seattle Repertory Theatre.

Theodore Roethke, poet-in-residence at the University of Washington, was arguably the most famous poet ever to live, and die, in Seattle. Allied Arts sponsored the only reading he did of his own work. "People filled the Seattle Repertory Theatre," Rooney said. "One of his conditions was that we keep the prices low so that we could get a lot of students. And so we did. We had a lot of students. It was very successful and a very exciting and interesting event. Since the reading was not intended as a fundraiser, we only charged just enough to make it all happen. It should have been followed up by doing similar things in the city, but it was not."

No one could offer a better primer of getting an Allied Arts in a city off to a good start than Rooney. The organization in Seattle was the inspiration for all sorts of others scattered throughout the state and the rest of the country, although sometimes by different names. It became a kind of code word for civic activism in urban America, but sometimes in small communities too. "Power to the people," as they used to say in the 1960s. Sounds quaint now, but it was incredibly effective.

Allied Arts was involved in a great many things, Rooney told her audience in Bellingham:

We became nationally known as advocates for the arts and the urban experience. We created a statewide committee to lobby for the first money . ever appropriated by the State of Washington for the arts. . . . We continued our interest in historic preservation, in billboards, in the amenities in the

urban environment. We continued to be the lobbying force for public funding through the Seattle and King County Arts Commissions; we created the first craftsweek in the country, a concept since emulated in Philadelphia, Washington, DC, and elsewhere in the country. It sounds pretty slick and easy now, but it took years to develop and grow. We had approximately one thousand members, arts organizations, individuals, and business firms. I was the only person paid out of Allied Arts funds. My two-member staff was paid by CETA [the federal employment program.] We were able to function because the trustees—God bless them—were so committed and gave so generously of their time.

If people are critical of Rooney's leadership, they are few and keep quiet because they know they are in the minority. Thus Rooney's recommendation to prospective Allied Arts groups to emphasize "truth and commitment" does not come as any surprise; these are perhaps the keys to her philosophy of public engagement. "Obviously there are many practical things you deal with on a daily basis. When you form a steering committee or elect a board of trustees, if I had to choose, I would choose the committed individual over one with money: people of influence, those with recognizable names, the professionals who can bring you to the cutting edge of what's going on in your community. Very often money follows a good idea." Rooney's advice to people interested in beginning an Allied Arts group of their own is "not to be afraid to deal with controversial issues, because if you deal with the truth—and are far-seeing—the issues you raise or the projects you propose or the changes you are suggesting may well be controversial."

After regulating billboards, many changes of president, saving the Market, historic preservation, and so on, Rooney wanted a change of pace, which turned out to be a prelude to her departure from Allied Arts. She was not unappreciated but was underpaid, and soon the organization—which writer Barbara Huston described as a ship without a sail after Rooney's era—would have to learn to navigate civic and political issues without her.

In 1976, Rooney went to Washington, DC, to be an intern in congressman Joel Pritchard's office in a program he had created.

He wanted people who represented different categories in the community, so I was the arts. He had a woman who was on the faculty of the UW School of Nursing, and she represented nurses. There were a whole bunch of such representatives of their professions. Pritchard would pay

Alice Rooney

for your lodging and leave you on your own. They loved it when I was there because they had no contact with the arts at all. I came with a long list of people I wanted to see—from people at the National Endowment for the Arts, GSA [General Services Administration], to the Department of Commerce —anybody I thought had influence or was important to the arts. Every day I would return to the office and tell them what I had done. We had a great time.

Around that time Rooney met Elena Canavier, head of the crafts program at the Endowment. Canavier was a friend of LaMar Harrington, then director of the Henry Gallery at the University of Washington, who mentioned to Canavier that Rooney was going to take a year's leave after her stint in Pritchard's office, and wasn't sure what she was going to do. Canavier called Rooney and asked if she wanted to write a newsletter for her. Without asking for many details, Rooney accepted. After a few months, Canavier left the Endowment to be a cultural adviser to Joan Mondale, wife of then vice president Walter Mondale. Rooney ended up writing draft responses to people all across the country who asked her how to organize their communities in regards to the arts.

In the mid-1970s Rooney became involved in creating a crafts week, something that would interest Canavier, who was planning a visit to Seattle. Allied Arts trustee Janice Niemi, whose multifaceted career took her from Olympia and the Senate to a judgeship in Seattle, was also involved. Galleries were asked to mount craft exhibitions, and crafts organization were asked to create projects or exhibitions. The event was a huge success and was rewarded with funds for another exhibit the following year. But Rooney was not there because she had returned to Washington.

Rooney was one of three finalists for the directorship of the Washington State Arts Commission. She was not named. Shortly after that, Rooney encountered a member of the commission, who asked her to lunch. She did not want to go, so she lied, saying that she had meeting in the Smith Tower. "I really don't lie very much, so I found myself over at the Smith Tower, even though I didn't have a meeting, looking at the directory. Here was an astrologer. I thought, that's what I'm going to do. I vowed I was going to change my life. So I went up to see this astrologer and he asked me if I wanted my chart read. I said, 'Why not?'" After a day or so, with Rooney's birth date in hand, the astrologer had a chart ready. She recalls his saying, "I see you are going to be offered a job." "I laughed. I just got turned down for one. This

was like the middle of June, and he said I would be offered a job the end of the month." "Also, you are going to do some traveling."

Rooney went away with the chart. Nothing happened on June 28 or 29. On the 30th, Rooney got a call from John Hauberg (then president of the board of the Pilchuck Glass School) proposing a meeting with her and Tom Bosworth (then director of the school). She assumed, since she had been in Washington, that they were going to ask how to get money from the Endowment.

They met in Hauberg's office in Pioneer Square. Bosworth's wife, Elaine, was there, as well as a couple of Pilchuck trustees. "John said Tom was taking a year's sabbatical in Rome, and would I be interested in the Pilchuck job. I said I had to think about it." But not very long. Rooney accepted. She also did some unexpected traveling—site visits for the Endowment. "I went back to the astrologer for another reading." This time he said that Rooney's daughter would get a divorce and have some problems. Neither happened.

Rooney stayed at Pilchuck for a decade, bringing her sense of order and civility and intelligence to the organization. Afterward she went to the Glass Art Society, from which she retired.

Allied Arts people have always loved to talk. "They also did things," Rooney said, "and I saw my job as picking up the pieces, the things they really didn't want to do, as I say, the mundane things, to see if we could make them happen. In other words, making it easy for people to do what they did best: to use their influence, to develop their ideas, to figure out solutions for things. It was really a wonderful time."

Rooney left Allied Arts because, in her words,

> twenty years is a long time, and my role in it had stayed pretty much the same. Issues were different, activities were different, but my role was kind of the same, and I decided I needed to go on and do something else. It was as simple as that. It was kind of hard at first, but then it really wasn't. It was time. I think you really can make a case that it's not good for an organization to be too dependent on one person. Some organizations do that with money. Then the person dies and what does the organization do—having lost all that time in learning how to be self-sufficient? I think the same thing can be true about dependence in other ways.

"I loved being considered the heart of Allied Arts, but I also needed to do something different, and certainly Pilchuck was very different."

Alice Rooney

2 / Pike Place Market, One of the Great Civic Battles That Helped Shape Seattle

This market is yours. I dedicate it to you, and may it prove a benefit to you and your children. It is for you to defend, to protect and to uphold, and it is for you to see that those who occupy it treat you fairly, that no extortion be permitted and that the purpose for which it was created be religiously adhered to. This is one of the greatest days in the history of Seattle, but is only a beginning, for soon this city will have one of the greatest markets in the world. . . . It is here to stay and there is no influence, no power, no combination, and no set of either political or commercial grafters that will destroy it.

> THOMAS PLUMMER REVELLE
> Seattle City Councilman
> Regarded as the Father of the Pike Place Market
> November 30, 1907

The Pike Place Market reveals the face of truth. Its roughness reminds me of Seattle's beginnings, its lusty past, the vitality that gave it national notice long ago. It is an honest place in a phony time. While the advertising, public-relations syndrome gains, the Market is a haven where real values survive, where directness can be experienced, where young people who have never known anything other than pre-cut meat, frozen vegetables, or homogenized milk can discover

some things that they don't see on television or in Disney's picture books and movies. They will also find out that most people are not well-dressed and others are not clean. This will do them good. The Pike Place Market is worth holding on to because it is unique in our area. And yet it does need help. It needs hammer and paint brush, not the black ball of destruction.

FRED BASSETTI, architect

Drastic changes are going on all around us. Our homes are in the path of freeways; old landmarks, many of rare beauty, are sacrificed to the urge to get somewhere in a hurry; and when it is over Progress reigns. . . . Hollow streets shadowed by monumental towers are left behind by giants to whom the intimacy of living is of no importance. The moon is still far away, but there are forces close by which are ready, with high-sounding words, to dump you out of bed and tear from your sight the colors of joy. And now this unique Market is in danger of being modernized like so much processed cheese. The Market will always be within me. It has been a refuge, an oasis, a most human growth, the heart and soul of Seattle.

MARK TOBEY, artist

Seattle's Pike Place Market deserves to live on, as a link with Seattle's past, a meaningful and much-loved part of its present, and a place of unlimited possibilities for its future.

VICTOR STEINBRUECK, architect

THE PIKE PLACE MARKET IS A CIVIC MONUMENT: A SYMBOL OF victory of the people, who voted in 1971 to preserve the whole of the market and the spirit behind it rather than leave it much diminished and alienated in the midst of faceless urban renewal. The power brokers of the day, including the business establishment, city hall, the daily newspapers, and even many of the merchants and owners in the market itself, were not in favor of the initiative.

In the days preceding the critical vote, the *Seattle Post-Intelligencer* proclaimed, "Seattle can have both a preserved Pike Place Market and urban rehabilitation through the defeat of Initiative No. 1." The *Seattle Times* was equally negative: "The facts are simply that the Friends of the Market initia-

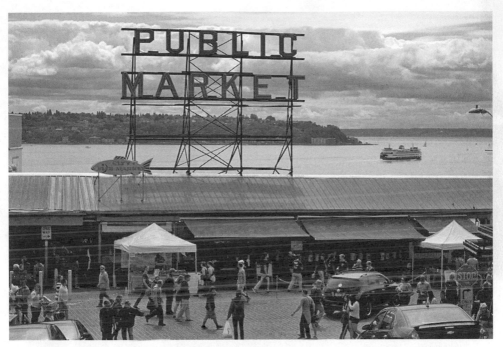

Pike Place Market. Photo by Roger Schreiber.

tive measure on the ballot November 2 will not 'save' the Market and that its passage instead will doom not only the Market, but the whole twenty-acre renewal project."

It seems amazing today, some forty years later, how right the Friends of the Market were and how wrong the others. The Friends of the Market was the leader of the forces behind the initiative, and the huge majority of people who voted overwhelmingly (76,369 to 53,264) for it. That vote established a seven-acre area for the Market, and a citizen commission to administer it, along with the city's Department of Community Development. Opposition to sustaining the Market on the Friends' terms was fierce—so fierce that John Hauberg, for instance, a major force in the business establishment of the day, forbade his wife, Anne, another major force in the life of the city, to campaign on behalf of the Friends. If she did, he said, she would never be able to accomplish anything again in the city. She campaigned anyway, but quietly.

The saving of the Market is a tale of different ideas and different goals that has been well told. The heroes were a group that called themselves

Pike Place Market, ca. 1982. Photo by Roger Schreiber.

Friends of the Market, one of two major groups that originated within Allied Arts, then led by architect Ibsen Nelsen, and developed an independent life, the other group being the Washington Roadside Council, which fought to get billboards taken down or at least regulated. Although the determined and outspoken Victor Steinbrueck quickly became the spokesman for the group, it was founded by Wing Luke and Robert D. Ashley. Many of the leading figures of the Friends were trustees of Allied Arts, such as Robert Block, Fred Bassetti, Irving Clark Jr., Peggy Golberg, Shirley (Turner) Collins, and Steinbrueck. The Friends and Allied Arts worked in tandem, but the fight to save the Market became more and more concentrated in the Friends, with Allied Arts taking on a supporting role. But the triumph of the Friends was also a triumph of Allied Arts and is considered one of its singular achievements.

The Market was founded to eliminate the middleman between farmers and customers. The 1920s and 1930s marked the Market's greatest period, with hundreds of farmers renting stalls to sell their wares. Half were farmers of Japanese descent, who lost everything or nearly everything with their internment in World War II. Many of them never returned to truck farming or the Market after the war. Other blows to the market included the growth of the suburbs, the increasing sophistication and development of supermarkets, and the advent of frozen foods. Business went downhill, and the residents who lived in the surrounding area got older and poorer. Buildings became shoddy. It is little wonder that city officials and businessmen thought that the Market was hopeless as an economic entity. Its virtues were hard to discern.

The heat of the battle came in the 1960s as the city and business establishments—fearful that the disease of the Market, which occupied prime real estate, would spread—sought to "rescue" the Market. Part and parcel of the rescue was the Central Association, a newly formed group of prominent Seattle businessmen. The Friends had a kickoff meeting at Lowell's Restaurant in the Market, the first of many such "meetings," usually accompanied by champagne served by Golberg's underage children. About sixty people came and heard all sorts of speeches. The press was in attendance. A steering committee was chosen and plans were formulated. In a few weeks, the Allied Arts steering committee became Friends of the Market, and Steinbrueck and attorney Robert Ashley, another major figure in Allied Arts, were elected cochairmen. Questions were raised about potential conflicts of interest between the city and various business interests, such as the Central Association. Arguments ranged about urban renewal versus preservation and about whether one could have the former without the latter. Ibsen Nelsen read the following statement: "The Pike Place Market must be retained, restored to a good condition, and every effort made to develop its potential, taking every care to ensure that its special charm and atmosphere is not lost."

With this statement of purpose, the Friends was launched. Allied Arts and its child, Friends, would work together, but the Friends would do the heavy lifting. At first the office of the Friends consisted of a post-office box and an answering service at the Grosvenor House. Volunteers were called forth and grew steadily in number. They proved to be invaluable in reaching the citizenry.

It is easy to express the glories of the Market now, but then they were not

readily apparent, for the Market was indeed a mess in need of millions of dollars in renovation and stimulation. Although the members of the Friends had strong ideas, exactly what they proposed to do had yet to be formulated. The essential idea of the Market arguably came out of Steinbrueck's *Market Sketchbook* of 1968—that the haphazard collection of buildings at the Market possessed a one-of-a-kind character. Nothing like it could simply be recreated in another space. By 1965, the Friends had opened a booth in the Market and were selling *Mark Tobey: World of a Market* and Steinbrueck's other book, *Seattle Cityscape*. All sorts of events were planned to raise the consciousness of the general public—as well as money.

Plans were afoot on all fronts. There were the inevitable studies—economic feasibility, sociology, structural issues. In 1966, a committee created at the behest of mayor Dorm Braman announced a design and planning team, with architects Paul Hayden Kirk and John Morse at its head. Another design team, from the firm now known as NBBJ, began to work at the behest of private investors. Calling itself the Central Park Plaza Corporation, and comprising prominent local businessmen, the group began to buy up available property, with the hope that the early investment would pay off handsomely. Working in cooperation with the Seattle Planning Commission and Seattle Urban Renewal Enterprise, they came up with a plan that was subsequently approved by the City Council. The plan called for 300,000 square feet of office space; a twenty-nine-story hotel; four apartment towers, each twenty-eight stories high; parking for five thousand cars, and a park. Oh yes, there would be a market, quite modest in scope, just 1.7 acres. The city would acquire most of the property by eminent domain, clear it, and provide the parking. Private investors would do the rest. Mayor Braman expressed concern about there being sufficient commitment on the part of private industry in developing the property. Too many cities in the past, he often pointed out, had cleared large swaths of property and then nothing had happened. Wing Luke, the widely respected city councilman, who died in an airplane accident a few years later, tried to bring all of the various viewpoints together. He did not succeed.

The reaction of the Allied Arts and friends to the plan, called Proposal 21, wasn't surprising. It was essentially negative, and Steinbrueck, who was spending a year in London, wrote in a letter, "As proposed, the Market can only be a shell of the things we want to save." The Friends issued a position paper: "A sincere and professional effort has been made by all concerned," but the plan "could have a brutal and overpowering effect

upon the intricate, social, and merchandising conditions in the Market." More small-scale buildings and places for the farmers had to be retained; there had to be more low-income housing and assurance that rents would not skyrocket. Ashley was unhappy, thinking that the Friends were being intransient. Braman stated, "The Pike Place Market is a dying institution, and, if allowed to die out, we won't have anything. I don't criticize these people [Friends of the Market] trying to save the Market, but I do think it is quite unrealistic to believe that we can leave it as it is. There has been a great change in the trend of shopping habits. Some people seem to think the Market can be fixed up or rebuilt on its present form and survive, but I rather doubt it."

In 1968, a statement by the Friends followed, asserting that the presence of huge apartment and hotel towers so close to the Market and associated parking could be ameliorated if they were located north and east of the proposed Market area, and if time were taken, "a measured pace," to study what it would take to achieve "a sensitive, humanly responsive" course of action. Some old buildings would have to come out, the statement continued, but they need to be replaced with other small-scale buildings "designed to maintain the wonderfully varied and exciting texture that we now find in such pleasant contrast to newer parts of the city which tend to be slick and crassly commercial." The mayor wasn't interested, at least at first. He told the downtown Rotary Club that these "nitpickers" would stand in the way of progress on the eighty-million-dollar project.

Meetings continued, and eventually another plan, called Scheme 23, with concessions to the Friends, was submitted to the Department of Housing and Urban Development (HUD). It was the first such plan that asked for monies for preservation and rehabilitation. More buildings would be saved under the new plan, and apartment buildings would be smaller in scale. Allied Arts called on the city to become owner of a 2.9-acre area that would be the site of the Market itself and requested that the city keep control of the architecture and the design of the whole.

Still, Steinbrueck and his allies were unhappy and launched a campaign for a petition to be signed by fifty thousand people, proclaiming "Let's Keep the Market!," which would be presented to the City Council. More than fifty thousand people did sign that petition. It was rushed to City Hall, and its proponents packed the council chamber during the hearings to discuss the Market plan. There were a dozen hearings over a month or so in which Steinbrueck played a Clarence Darrow role. Joyce Skaggs Brewster, in her compre-

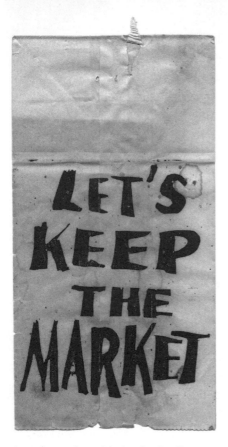

Save the Market Initiative election flyer on a paper bag, 1971.

hensive story on the Market wars published in the *Seattle Weekly* in 1981, wrote, "Steinbrueck made the hearings into real courtroom drama." Histrionics were the order of the day in the streets as well, including broadsides that used terms such as "Merchants of Greed" and "Urban Renewal to Murder the Market." The Council did not pay any attention: they approved Scheme 23 unanimously. That said, private discussion between opposing sides did not stop, and were reflected in the final draft of Scheme 23.

Led by the indefatigable team of Steinbrueck and Jerry Thonn, a well-regarded lawyer who did not grandstand, the Friends very quietly secured the placement of a seventeen-acre district on the National Register of Historic Places. This move meant that well more than half of the project was out of bounds for Scheme 23 unless it had the approval of the Council of Historic Preservation. City officials, including the new mayor, Wes Uhlman, protested, meetings were held, and the district was reduced to 1.7 acres. In December 1970, the Friends, along with Allied Arts, the Washington Environmental Council, and a handful of merchants filed suit to have the dimensions of the district restored. Unrelated to the Market wars, the local economy in late 1970 collapsed, drawing into question the glowing predictions of all of the private development in the twenty-some acres of office buildings, apartment buildings, and a hotel.

There was another round of negotiations between the Friends and investors. There were two plans—Scheme 23 and the NBBJ plan—along with different approaches. There were also negotiations between the city and Steinbrueck and Thonn. On May 15, HUD announced that it would fund

Four of Victor's drawings from the *Market Sketchbook*.

some form of the Market's rebirth. The Friends were not surprised and were ready with a response: a drive for twenty thousand signatures to put an initiative on the ballot. "It was a hectic and exciting time," said Thonn. In a few weeks, more than more than twenty thousand signatures had been collected.

The initiative would create a seven-acre historic district and a Market Historical Commission to manage the district in matters of design. The Pike Place Market Development Authority would own and develop land with the historic district, subject to veto power of the Historic Commission, on which Allied Arts was promised representation. Altogether the campaign and the ideas contained in the initiative made it unique in the country. The city responded with its own countermeasures, reducing the Market back to 1.7 acres. The national press chimed in, including the eminent architectural critic for the *New York Times*, Ada Louise Huxtable: "There is now a gung ho renewal scheme for massive 'improvement' of this juicy piece of 'underde-

veloped' Seattle real estate. The old arguments of obsolete plant and structural and fire hazards that worked so well for the bulldozer and brought 12 percent returns for a few shrewd and aggressive investors don't convince many people any more. The many have learned too much from watching the wreckers, and the results."

The city mounted its own campaign, aligned with the Central Association, which created a faux "citizens committee," with only an ostensible connection to its parent organization. Steinbrueck argued against them and produced copies of the minutes of their meetings, supplied by a friendly but anonymous insider. New to the scene was a young doctor, Jack Bagdade, and his fledging organization, Alliance for a Living Market. He was no fan of Steinbrueck, and argued that the image of the Friends needed changing. He called its freewheeling members "disciples of Victor Steinbrueck" and thought that their very lack of organization would spell defeat at the polls.

Despite Bagdade's reservations about Steinbrueck and the Friends' style, others became involved and worked with the group, due in large part to Thonn's quiet, diplomatic ways. It would not be the first—or last—time Thonn rescued an operation. The Alliance also soon realized that without Steinbrueck, the campaign for the initiative was not workable, because his name had become inseparable from the Market. One of the Alliance's central arguments was that market forces had changed considerably in Seattle, and the scale of Scheme 23 was not economically feasible.

Harriet Sherburne, who had plenty of political savvy and did not know the meaning of the word *rest*, was named campaign coordinator for the Friends. She worked hard and got dozens upon dozens of volunteers to do the same. Raising money to help the cause was always an issue. Tobey donated thirty Market lithographs. On opening night, so to speak, there was a party in the Highlands, but only one print was sold. Turning defeat into success, Sherburne used the market value of the lithographs as collateral to get a bank loan. Curiously, the Merchants Association at the Market never took a stand, knowing that its members would have to live there post-election.

The city and its allies made some more concessions, but this time they were declared to be too few. The city commissioned new studies, none of which was favorable to its own projections. That was good news to the Friends. What was uncertain was the viability of HUD financing in the event the initiative succeeded. Although they claimed otherwise, no one on either side knew what the federal agency would do.

Pike Place Market

In the weeks leading up to the election, campaigning was frenetic on both sides, with tours of the Market, a continuous stream of press releases, and all sorts of reporters and experts coming to town for a look. "It looked like a toss-up till the very end," said Thonn, "but during the last week when reports started coming in about our doorbelling, we were beginning to feel pretty good." By 10:30 p.m. on election night, it was clear who had won. The party went back and forth between the Brasserie Pittsbourg, a French-style bistro that was a favorite hangout of Allied Arts types, and the office of Allied Arts, both in Pioneer Square. Nelsen called the victory "a minor miracle," which it was. Steinbrueck said, "I feel better about Seattle. This is a people's victory." But saving the Pike Place Market was not Allied Arts' only triumph. As the campaign proved yet again, this motley group of freethinkers and romantics—this establishment thorn in the side of the establishment—could take on the established order. Allied Arts was in its prime.

Whatever the failings of the campaign to save the Market, they were few and unimportant. No one had much money, but the group had abundant energy, dozens of volunteers, and a multiplicity of ideas. The next step was wholly different: how to mold the run down Market into something economically viable without destroying its human character, making Tobey's lithographs appear of the moment instead of a wonderful past. The group also had luck on its side. Steinbrueck said at the election party, "I feel the city should accept this mandate from the people." It did, led by the new mayor, Wes Uhlman, who quickly came around. Others, from both business and city circles, followed. HUD money did not disappear but increased in exponential degrees thanks in large measure to Senator Warren Magnuson, who often greased the wheels in Washington. He was a formidable ally.

One argument that would surface repeatedly over the years to follow was whether new additions or renovations to the old buildings were true to the Market. The handsome Olson/Walker Building at Pike and Virginia, the first new structure to be built in thirty years, met with Steinbrueck's disfavor. He said it was too big, too costly, and would require rents too high for traditional Market activities. It was constructed anyway, and is much admired. Progress in tearing down and building up was deliberate. "We are moving at a cautious but aggressive pace," said Sherburne, who was extremely effective in managing the campaign for the initiative.

Twenty-seven projects were announced in a plan in the mid-1970s: buildings to be razed, buildings to be rehabilitated, a stairway to be built (Hill Climb Corridor), and a parking garage to be funded. Arguments about how

much housing for the poor should be constructed continued deep into the 1970s. Some said that it was a moral obligation. Others said that enough was enough. Among the structures that were to be saved were the Corner Market, the Soames-Dunn Building, and the Dunn Seed Building. The highly respected George Bartholick was the lead architect, but other architects weighed in, including Fred Bassetti, Karlis Rekevics, and Arne Bystrom.

By the late 1970s, the Market was becoming fashionable, with upscale hotels, condominiums, apartments, shops, and offices, none of huge dimensions—and even the produce was no longer that much cheaper than at the supermarkets. But just how fashionable the Market had become was subject to debate. There were those who argued for middle-class conformity and those who argued for what Bartholick termed "the continuity of discontinuity." There were the inevitable power struggles. A major dispute pitted the Public Development Authority (PDA) against the Market's Merchants Association, which represented about half of the Market's 150 vendors, involving rents. A serious confrontation was averted by Paul E. S. Schell (president of Allied Arts), Sherburne, and the calming influence of Thonn, who was chairman of the PDA board.

The major crisis at the Market came in the early 1980s, when the PDA sold eleven buildings to private partnerships under the umbrella of the Urban Group Investors, a group of real estate investors in New York. The PDA retained ownership of the land and ran the Market for a fee. The reason for the "collaboration" was that the PDA needed an infusion of cash, and the Urban Group was looking for a good investment: they wanted the buildings only for tax write-offs for which the Market was not eligible. Then the tax laws changed, and the Urban Group wanted to refinance the whole arrangement to maximize its investment, threatening to drastically raise rents and eliminate marginal businesses, which would change the nature of the Market. Peter Steinbrueck, a member of the Pike Place Historical Commission, said he that was "absolutely, lividly outraged" by the investors' demands, not only to raise rents but also to cut their expenses some 45 to 50 percent across the board. The Urban Group said that it wanted more profits from a three-million-dollar investment.

There are those who say that Thonn saved the Market a second time. With his usual modesty, he denies it and claims that his role was secondary. Instead, it was Peter Steinbrueck, son of Victor, who died in 1985. Peter likes to say that the Market, as well as Allied Arts, in which he became a trustee, were part of his early education. For eight years in the 1980s he served on

the historical commission, but resigned to do battle with the Urban Group, which represented a genuine threat to the well-being of the Market. The battle took two years of his life.

The tale of this second battle is a "long, complicated story," Steinbrueck said. It began when the Market needed additional cash for long-term capital needs. Funds it had relied upon dried up. It was important to keep rents modest, sustain the tenant mix, and meet the needs of the buildings. With little public scrutiny, the PDA, which managed the Market, signed a number of contracts that essentially sold title of the Market. "It seems inconceivable that these transactions were thought of as being legitimate," said Steinbrueck.

The crisis came when the tax code changed and what had been so beneficial to the investors was no longer so. They had no plan B. They thought the tenants weren't paying sufficient rent, Steinbrueck said, and thus pushed for more. To protect their investment, their lawyers proposed raising the rent in the form of an ultimatum: pay the higher rent or get out—which pushed everyone's buttons in Seattle. The situation had been brewing since 1983 and became public knowledge in 1989. The fat was in the fire. "I was distraught," Steinbrueck said. "We needed someone to take them on."

Steinbrueck resigned from the commission and organized a group to challenge the New York lawyers. "Throughout its history, the market was a public entity that did not allow for this kind of private initiative. This alliance was ready to fight not only the lawyers but also the PDA and the city, which had been 'complicit in the whole thing.'" Allied Arts was one of the key groups in the organization. There were multiple issues, Steinbrueck said, that could destroy the Market as such and turn it into a giant food circus.

Early on, the alliance decided to fight the fight through legal methods. At one time, there were ten lawyers working on the case pro bono, said Steinbrueck. Eventually that proved to be unwieldy, and Gordon Thomas Honeywell took the whole thing on, completely pro bono.

There were all sorts of "legal skirmishes, victories, setbacks, every maneuver we could think of," said Steinbrueck. The New York lawyers attempted to have the case moved to New York, but a judge there ruled that the case belonged in Seattle. The investors lost on every ground, with the final stroke declaring the contract void on October 31, 1992. The result of the case was that the laws governing the Market were strengthened.

And the Market is prospering, said Steinbrueck. A redevelopment plan is in the works, and it is outperforming downtown business interests. "The

Market is always under pressure to maximize profits with luxury condo-miniums and tourist attractions. It struggles every day to maintain the bal-ance of mixed uses and retain its historic character. . . . The Market is central to the city's core values and a great source of pride."

3 / Victor Steinbrueck

Realistic hope for the future depends upon public and private awareness, concern and civic involvement with a real commitment to human values above material considerations. It is to this commitment, and the vital part that it must play in building a good and livable city, that we must dedicate ourselves.

VICTOR STEINBRUECK

NO ONE IS MORE CLOSELY ASSOCIATED WITH THE PRESERVA-tion of the Pike Place Market than Victor Steinbrueck, architect, member of the University of Washington (UW) faculty, and Allied Arts trustee. There is a reason he was called the "patron saint" of those seeking to save the Market; he was also referred to as Clarence Darrow, to borrow an apt comparison from writer Joyce Skaggs Brewster, for his style and brio. It was his unrelenting voice that insisted on the complete renovation of the Market, which at the time was grubby and run-down—a disaster, really. The Market's charm, which is obvious now, was not clear in the 1960s when the battle raged so powerfully. Most everything about the Market was in terrible shape, including many of its patrons.

Imagination—vast quantities of it—was required to wipe away the accumulation of dirt to see the potential of the Market, both visually and economically. Steinbrueck had that, as well as the fierce courage to speak his mind and the determination to fight those who wanted to destroy the Mar-

ket to build roads, parking lots, hotels, apartments, and office buildings. He never wavered in his belief in the Market as an entity that deserved special attention. "Compromise" was not a word in his vocabulary. He led the fight because he believed in it so strongly, and eventually more and more came to see the rightness of his viewpoint.

At the Allied Arts' fourth annual champagne breakfast in the Market, in 1967, Steinbrueck was toasted before his departure for London, where he planned to spend a year on sabbatical from the UW, with his wife and children, in part to study and simply observe public markets in the United Kingdom. He said at the party, "I believe what is here, from very many viewpoints, has to be part of the city . . . [for] as the Market goes, so does Seattle."

A decade before the 1971 historic vote to save the Market, Steinbrueck, on the front lines, wrote in *Puget Soundings* that the "Market grew with such vigor and force that progress and neglect have not been able to kill it. An indifferent city may yet do so. Shopping centers and supermarkets have outgrown and outdated this exciting area but can never replace it. It flourished when most of Seattle rode the street cars and people could readily carry home full market bags."

Steinbrueck was rarely short of words, especially when the subject was his beloved Market. He compared analyzing the myriad qualities of the Market with "counting onions in a goulash. There are on hand and in view more people, more foodstuffs, more colors, more smells, more interrelationships and changing situations than one can comprehend. And you, too, are part of the scene. The freshly-watered, brightly-colored vegetable arrays are perhaps the most wonderfully visual part of the Market. Of course, one has to forget a little that sometimes the vegetables look so nice because they have been selected for front display, while some of the less attractive items are kept behind within ready reach for the next sale. Experienced shoppers find this merely a challenge." That said, Steinbrueck also liked the fresh fish and meat markets, "unassuming in appearance," and the specialty stores that sold things otherwise hard to get in the 1960s—but not everything. Horsemeat, once a Market staple, was a rarity in the mid-twentieth century. Steinbrueck's appreciation of odds and ends for sale was equally enthusiastic: "Salvage clothing, junk jewelry, flowers, antiques, odd lots, surplus items, nursery and garden supplies, shoe shops and many, many other sorts of interesting and uninteresting things." A bounty of crafts too.

It was this potpourri that so fascinated not only Steinbrueck but others as well, such as the painter Mark Tobey, who donated sketches of the Market

Victor Steinbrueck

Steinbrueck market sketch
(from *Market Sketch Book*), n.d.

that were sold early on to make money for the Friends of the Market, which Steinbrueck cofounded within the embrace of Allied Arts and which later emerged as a separate entity. Steinbrueck had all sorts of ideas for saving and making the Market a better place, such as a multilevel garage on the steep grade between the foot of Pike Street and Western Avenue. To suggest improvements, Steinbrueck wrote, "may be to gild the cabbage; however, physical facilities conducive to cleanliness, sanitation and safety are imperative. The color that is the Market should not be lost, and it should be remembered that much of this color is not fast—it is somewhat transcendental. . . . Only an architectural designer, most sensitive to and appreciative of the Market and its existing flavors and qualities, should be allowed to do anything in the Pike Place area. . . . One shudders to consider the probable results of a heavy-handed, maintenance-free, sanitary architectural development that might be achieved by people not emotionally involved with the Market."

Steinbrueck fervently believed that the Market should be recognized for its value to the Seattle community, as a contribution to the Seattle lifestyle, a

Victor Steinbrueck, n.d. Photo by Esther M. Fox. University of Washington Libraries, Special Collections.

unique shopping center, and a priceless tourist attraction. "It is an essential part of the growth of the center of our city, and not nearly as costly as freeways and expressways." These observations and ideas are readily apparent today, but in the 1960s they were radical. In the beginning, Steinbrueck did not even have the full support of Allied Arts, the parent organization. There were competing ideas about what to do with the Market, some more drastic than others. But Steinbrueck's perseverance held and eventually won the day. In 1967, he won *Holiday Magazine*'s Beautiful America Competition, one of the rare individuals to do so.

Technically, Steinbrueck was not a Seattle native. He was born in North Dakota in 1911 and moved to Seattle with his family two years later. Steinbrueck's father was working class—a railroad and shipyard worker, as well as an auto mechanic—but believed in education. At the UW, Steinbrueck studied fisheries, then architecture. After graduation he worked for a series of architectural firms, then opened his own office in 1938. Eight years later he joined the architecture faculty at the UW, where he remained for thirty years. Corridors of the establishment, such as the Men's University Club and the Rainier Club, were not a natural terrain for him.

In Steinbrueck's initial decade at the UW, wrote Jeffry Karl Ochsner in his long, thoughtful piece on Steinbrueck in 2008 in the *Pacific Northwest Quarterly*, the curriculum shifted from a Beaux Arts impetus to a focus on Bauhaus. According to Ochsner, "Students of the period remember Steinbrueck as focused on social issues in architecture—on how modern architecture might address the problems of ordinary people." Steinbrueck's ear was always tuned to the notion that people had a right to be heard.

Early in his career, Steinbrueck exhibited an interest in the development of Seattle's urban landscape and proceeded to author or coauthor various monographs on the subject, such as the *Guide to Seattle Architecture, 1850–1953*, the first effort to catalogue the city's architecture. Louis Guzzo, critic for the *Seattle Times*, called it "a very broad architectural survey to identify parts of our urban environment that constitute cultural documents or contribute to its visual appeal, elements which give the city its aesthetic character. The emphasis is on beauty, history and compatibility with the city's character."

Steinbrueck's life changed drastically following his heart attack in the 1950s (just as the lives of Robert Block and Peggy Golberg, Allied Arts trustees, were transformed by their bouts with polio in the same decade). Steinbrueck, who had previously been physically active, turned to sketching. Over the next several decades he published several books on Seattle and the Market: *Seattle Cityscape*, *Market Sketchbook*, and *Seattle Cityscape #2*. His first sketch was published in *Argus* in 1959. The subject of his fourth sketch, published a few months later, was the Market. It was his first brush with a subject that had fascinated him for so long.

Although he also played a role in designing the Space Needle, Steinbrueck does not have many actual buildings to his credit. "Perhaps more important than his design work," wrote Thomas Veith in a 1994 essay in "Shaping Seattle Architecture," was Steinbrueck's ability "to engage the interest of the average citizen in the city's architectural heritage" through his sketches. They are evocative, gentle, lovingly detailed, and usually accompanied by captions that go beyond the usual cutline of a few words.

Knute Berger, writer and editor, wrote in a perceptive piece on Seattle in 2011 that Steinbrueck's 1962 *Seattle Cityscape*,

> a collection of sketches that looked at the quilt-like fabric of the city . . .
> caught the essence of Seattle in its details. They didn't shy away from its
> complexity or its ugliness. If a view had unsightly telephone wires intruding on it, Steinbrueck didn't edit them out. What he created was a Seattle

handbook that encompassed nature, industry, modernism, Skid Road and funky houseboats. It was an informed, people's eye view. Steinbrueck paved the way for the kind of urbanism that is fashionable today. But it wasn't as simple-minded as thinking that higher densities and green buildings would cure our urban ills. Steinbrueck saw the beauty, history and complexities that are unique to this place. *Seattle Cityscape* is a book that dares to find our essence in streets and alleyways, not just in postcard views of Mount Rainier.

Ochsner credits some months in Detroit with refocusing Steinbrueck, from an interest in social issues to those of the built environment. "After his return to Seattle in late 1957, he increasingly addressed the fabric of the city, particularly the older historic fabric, which he saw as an embodiment of the history, life and culture of ordinary people." And he began to think of the "ruthless brutality" of freeways. In the 1950s there were not many who considered the social cost of these great, looming hunks of concrete that helped move people more efficiently. Steinbrueck was ahead of his time. He mourned the loss of a three-story Victorian apartment building of considerable charm on Eastlake in 1959, because it was in the way of a freeway that Steinbrueck mockingly called "the path of progress," and he also grieved for the Kalmar Hotel, at Sixth and James, which was torn down in order to pay "homage to the deity of the auto." Steinbrueck's *Seattle Cityscape*, Ochsner wrote, built the platform from which Steinbrueck would launch his "civic battles for preservation and urban design over the next two decades."

> *It is feeble-minded for a city to destroy its past and live only in the present as we are doing in Seattle.*

In 1965, Steinbrueck lamented the loss of Plymouth Congregational Church, which had been built just past the turn of the century. "Fine older buildings can give a quality of dimension in time as well as providing visual richness and contrast," wrote the architect in the *Seattle Post-Intelligencer* (*P-I*). "It is feeble-minded for a city to destroy its past and live only in the present as we are doing in Seattle." He also lamented the loss of the Bay Building on First Avenue, Broadway High School on Capitol Hill, the White-Henry-Stuart Building downtown, and the Music Hall Theatre. As they did in other campaigns, the man and Allied Arts fought side by side.

Space Needle rendering by Victor Steinbrueck, John Graham & Company, 1960. Century 21 Exposition, 1962, Seattle Collection/John Graham.

In the *Seattle Times* in 1977, Steinbrueck praised what had been accomplished in Seattle in terms of historic preservation. "The city has acquired an enviable national reputation for the quality of its preservation movement. It not only reflects credit upon some of the persons involved but also carried a responsibility to deserve that esteem." But there were problems of enforcement, of "private and public bunglings," and of the City Council overriding the decisions of planning commissions, sometimes because of political pressure. Little escaped Steinbrueck's eye. "I believe that a lot of people do care and should be aroused to save historic preservation from the destroyers and the politicians of City Hall."

Jane Estes, in her profile of Steinbrueck in the *P-I* the following year, called him "Seattle's most mobile monument," "a benevolent gadfly." She wrote, "Whenever the first steam begins to rise over a project that might threaten the preservation of the city's environment, this soft-spoken human-

ist is there, well-prepared to speak his mind." Steinbrueck's response: "I have a general concern about things that are happening to the city as far as the aesthetic quality and the social quality of our environment. That's what it's all about."

Steinbrueck always saw what had to be done, what had to be preserved. He was a purist. He was concerned about the fate of the Market and about preserving what he saw as endangered buildings: "I am still concerned about demolishing more buildings and the general upgrading that is taking place. It seems to me it is inconsistent with what everybody has worked for, including the Friends of the Market.... Most people wanted the Market preserved. They didn't want to upgrade it and they didn't want the kind of boutique direction that a lot of it has gone, the general upgrading and tourist orientation that is beginning to gain strength there."

Steinbrueck was concerned about buildings all across town—those of a grand, high style and those of modest neighborhoods. He did not believe that everything old was worth saving, but he noted, in an interview, "We have so little to look back on. That makes what we have much more valuable. Fires, construction projects, and other natural events have taken so much from us."

Steinbrueck was given plenty of awards in his lifetime. In 1978, Allied Arts nominated him for a Jefferson Award. The group's president, Mary Coney, wrote, "Victor Steinbrueck's role has been one of vigilance over the quality of the city's physical environment, to make Seattle a better place for people to live in and in which to raise their families. His crusade has been to raise the level of consciousness and appreciation of the city's environment among all who dwell here, and to enlist those who share his concern to continue the battle against threats to the city's beauty.... In the last few years, Victor has come to believe that our neighborhoods will save us and our cities."

Among Steinbrueck's buildings and sketches are three parks that he designed or codesigned: Capitol Hill Viewpoint (now Louisa Boren Park); Betty Bowen Viewpoint on the western edge of Queen Anne; and Market Park, near the Pike Place Market (now Victor Steinbrueck Park). At the dedication of the park bearing his name, in 1984, Jerry Thonn, longtime Allied Arts trustee and former president, who stood with Steinbrueck at the Market, said:

> The ten-year effort to save the Market was surely a grass-roots community effort in every sense of the world; it involved many talents, many hours,

Victor Steinbrueck,
October 1970. Photo
by Mary Randlett.

and great dedication by many, many people from many segments of the
community. There was, however, one person who was without question
the heart and soul, the philosopher, the historian, the true believer, the
servant and leader of the cause, and that was Victor Steinbrueck. . . .
Victor began to define the Market and its unique and humble character.
He sketched the Market. He brought visitors to the Market. He made
community and nation aware of the uniqueness and fragility of this com-
munity resource. He worked to place the Market on the National Register
of Historic Places. He picketed City Hall. He camped in the City Council
chambers. . . . Victor viewed the initiative not as a final step but as the
beginning of an ongoing process.

Steinbrueck died the following year.

4 / Seattle's Engagement
with Historic Preservation

I N JUNE 1978, THE UNITED STATES SUPREME COURT MADE A LAND-
mark decision involving Grand Central Station in New York when it
upheld the city's Historic Preservation Ordinance:

Over the past fifty years, all fifty states and over five hundred municipali-
ties have enacted laws to encourage or require the preservation of buildings
and areas with historic or aesthetic importance. These nationwide legisla-
tive efforts have been precipitated by two concerns. The first is recognition
that, in recent years, large numbers of historic structures, landmarks and
areas have been destroyed with inadequate consideration of either the
values represented therein or the possibility of preserving the destroyed
properties for use in economically productive ways. The second is a widely-
shared belief that structures with special historic, cultural or architectural
significance enhance the quality of life for all. Not only do these buildings
and their workmanship represent the lessons of the past and embody pre-
cious features of our heritage, they serve as examples of quality for today.
Historic conservation is but one aspect of the much larger problem, basi-
cally an environmental one, of enhancing—or perhaps developing for the
first time—the quality of life for people.

A major theme in the latter part of the twentieth century was historic

preservation, which came with a rise in consciousness of the importance of history in the urban landscape. In Seattle, saving and restoring old buildings was at first a battle between those who saw the value of historic buildings and those who disdained such architectural niceties in favor of parking lots, highways, and sterile buildings, the only consideration being profit. Slowly an understanding of the issues grew and a kind of momentum developed.

The city was a natural place to engage the progressive philosophy of Allied Arts. The Pike Place Market and Pioneer Square were among the earliest, and most celebrated, battlegrounds, but others were to follow, such as the ten-acre University Tract downtown, the historic theaters, Broadway High School, and other buildings, from fire stations to individual houses to hotels to office buildings. There were victories, but there were also massive defeats, such as the White-Henry-Stuart Building, Broadway High School, and Music Hall Theatre.

THE METROPOLITAN TRACT

The University of Washington's metropolitan tract in the heart of Seattle is prime real estate. Part of the land deeded to the university by Arthur Denny in 1861, the site was the early home of the UW. The campus moved to its present location on the western shore of Lake Washington in 1895. Wisely, the school retained ownership of the property. For decades the tract was managed by University Properties (Unico), which was criticized by some for being keener on maximizing revenue than on sustaining a remarkable urban setting of humane dimensions and historic importance. The majority of the ten or so buildings on the land in the post–World War II period were removed and replaced by faceless buildings. By the early 1970s the only original buildings remaining were the Olympic Hotel (now Fairmont), the Skinner Building, the White-Henry-Stuart Building, and the Cobb Building. It is only due to public intervention, in which Allied Arts was a major player, that these remain.

The first fight was for the preservation of the White-Henry-Stuart Building, a low-lying series of office buildings of handsome proportions with upscale shops on the ground level in one of Seattle's most civilized areas, on Fifth Avenue. Letters were written, memos sent alternatives, made in opposition to a forty-story office building to be built on a pedestal. The proposed building, at first called Commerce House, after the National Bank of Commerce, which was to be its lead tenant, eventually became known as

Streetcar and Seattle Hotel in Pioneer Square at Yesler Way and James Street, Seattle, ca. 1900–03. University of Washington Libraries, Special Collections, Barton Brothers Photographs.

Rainier Square, after Rainier Bank. It was designed by Minoru Yamasaki, who also did the neighboring IBM Building, which has been called "cold and unappealing." Yamasaki disdained the rest of the UW properties in the University Tract. He called the White-Henry-Stuart Building a "useless gesture because it has neither graceful proportions nor elegant materials," adding, "the White-Henry-Stuart Building and the Olympic Hotel block and Skinner Building do not enhance in any way the experience which should be fundamental to man during the time he spends in the city."

On May 22, 1974, Allied Arts issued a long statement:

> Allied Arts believes that the present design . . . would have a negative impact on Seattle's urban center. Allied Arts believes the currently existing White-Henry-Stuart Building, especially when considered in relation to surrounding street activities and buildings, does a great deal to create an

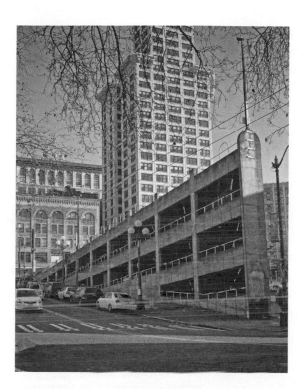

Sinking Ship: Seattle Hotel, 2012. Photo by Roger Schreiber.

extremely attractive, valuable streetscape, and would like to see as many of these qualities retained as possible. . . . The argument for retention of the White-Henry-Stuart Building is not simply a matter of retaining "in the core of downtown Seattle a historic structure a number of people admire." [As the Environment Impact Statement phrased it,] "Everyone recognizes the ways in which the Fifth Avenue side of the White-Henry-Stuart Building—which is not its most impressive side architecturally—is valuable in relation to the activities of Fifth Avenue and to the Skinner Building across the street. Such effects are rare . . . they should never willingly be given up. . . . The modern office building [Commerce House/Rainier Bank Building], with its free-standing tower sited on a sterile plaza, and its token piece of sculpture and planter-box landscaping, has done as much to destroy the human/pedestrian character of the central city as any form of urban blight, decay, misuse, or neglect."

Victor Steinbrueck, who did not hesitate to call a spade a spade, called the Yamasaki design "one of the most significant disasters in a modern American city."

Allied Arts believed that a pair of suggested alternatives would retain the integrity of the White-Henry-Stuart Building and its surrounding landscape: keep the Fifth Avenue side while allowing the construction of a major new high-rise office building. Neither was seriously considered by either Unico or the UW Board of Regents, Allied Arts alleged. A month later, Allied Arts followed up with a detailed letter to Jack G. Nupert, president of the board, critical of the regents' seeming lack of interest in any approach other than its own, which Allied Arts claimed made a "mockery of . . . [the public's] involvement and your ultimate decision." While economics are often used as the only valid basis for any action, in the case of Commerce House, one of the board's most distinguished regents, James R. Ellis, argued that the regents' plan would not earn the money suggested.

Two notable architecture critics did not mince words in critiquing the design. Wolf von Eckardt of the *Washington Post* called it "one of those slick, presumably Muzak-doused suburban concrete oases with potted plants, look-alike store fronts, fountains, chain restaurants, a skating rink and lots and lots of pavement." Ada Louise Huxtable of the *New York Times* was not any kinder, calling the project "a dreadful mistake aesthetically, with a cornball novelty . . . a murderer of all appropriate street scale and relationships . . . another cliché . . . strictly deadpan dreadful—gimmicks masquerading as graces."

Peggy Golberg, one of Allied Arts most fervent members, wrote to the *Seattle Post-Intelligencer* (*P-I*), "Immediate economic gain for the University of Washington and the National Bank of Commerce must be weighed against the historical continuity and sense of scale provided by retention of the White-Henry-Stuart Building." The Regents argued that there wasn't time to consider alternatives without endangering the financing or the major tenant, which by this time was Rainier Bank.

Allied Arts' effort was all for naught. With the exception of Ellis, the regents, backed by the downtown business community, voted unanimously in 1974 to raze the White-Henry-Stuart Building, a decision that Eckardt bluntly called a "shocker." The only good thing that came of the battle was that the ground had been prepared for the larger fight that would have ensued if the UW had wanted to tear down the Olympic Hotel. Without seeming to have listened to the protests over the destruction of the White-Henry-Stuart Building and its replacement, Unico began to develop the yawning plaza under the new building, reconfiguring the bottom of Rainier Square with shops, all of an upscale quality, that completely obscured the

cold, monolithic base of Yamasaki's building. The presence of the shops may not make one forget the gracefulness and character of the White-Henry-Stuart Building, but it helps. As Douglas Raff, an articulate and outspoken attorney long involved in matters of civic affairs, wrote in an open letter to members of Allied Arts and others, "The White-Henry-Stuart block was not the landmark the Olympic is. A repeat of the W-H-S battle over the Olympic would be much bloodier. The University can ill afford such a battle."

Later that year, David Brewster suggested in a long, front-page piece in the *Argus* (his journalistic watering hole before he founded the *Seattle Weekly*) that salvaging the Olympic was a lost cause, but added, "The unexpected furor over the Commerce House changed the Regents' approach. . . . Commerce House opponents regard the previous lost battle as just a skirmish for the big war over the Olympic. . . . My own feeling is that the battle was lost when jarring modern buildings like the Commerce House were approved across the street. The Olympic soon will be a sore thumb architecturally and economically, especially since the current management (Western International Hotels) has so little interest in historic hotels and the legislature has so little interest in subsidizing the University or Seattle preservationists."

Brewster did not fully take into account the forces, including Allied Arts, that were rallied to save the Olympic. The first victory was the regents' agreement that the situation was so complex that there should be no rush to judgment. The regents also promised "an open discussion" of all of the options—renovation replacement, or redevelopment in Allied Arts sought a graceful and lively remodeling of the hotel's interior, which would convert this acknowledged Seattle landmark into an "elegant historic hotel," as well as the construction of additional hotel facilities connected to the Olympic.

A group of concerned citizens, including representatives of Allied Arts, agreed to make a collective appearance at the hearing before the Landmarks Preservation Board in January regarding the Olympic. An impressive list of backers, including Senator Warren Magnuson, Representative Joel Pritchard, and Mayor Wes Uhlman, were lined up, as well as fourteen organizations, including the American Institute of Architects, Historic Seattle, Allied Arts, and the League of Women Voters. By April of 1975, the UW's chief consultant, Peet, Marwick, Mitchell, & Company (one of twelve firms that submitted proposals to conduct a study), asked to meet with groups and individuals interested in the Olympic. Among these were Steinbrueck; Victoria Reed, Allied Arts trustee and representative of the mayor's office;

Bruce Chapman, a rising young star in politics; Douglas Raff; and Betty Fletcher, a Seattle attorney who went on to be a noted judge.

To the good was the positive attitude of Chicago architect Harry Weese, who was charged with surveying the preservation potential of the building and its relationship to downtown. "Anything still standing is worth saving," he said in an interview with Polly Lane, real estate editor for the *Seattle Times*. "If we have to save the city we can't start with a bulldozer. We'll find out what the numbers show . . . usually preservation comes out best on the bottom line." But, he added, the hotel "has deteriorated quite a bit since I was here five years ago. . . . We [all the consultants] don't have a position. We'll let the facts help us learn."

Allied Arts was quick to issue a statement: "We urge a thoughtful study by professional consultants . . . open discussion . . . clear concern to avoid the problems associated with Commerce House. . . . [We are] willing to negotiate on details. The goal: an elegant hotel on the present Olympic Hotel site." The regents issued the usual assurances.

Years passed, and all sorts of plans were considered and dismissed, including demolition, but by then that approach had few advocates. Papers had been prepared to make the Olympic eligible for the state and national historic registers. Support was sought from the Seattle City Council and the Washington State Senate. The House had already issued its approval of the project—saving the Olympic and renovating it. All sorts of developers submitted proposals, including some from Chicago, San Francisco, and two local companies, one in Seattle (of which Paul E. S. Schell was a principal) and one in Bellevue. The regents then decided to renovate under the sophisticated direction of the Four Seasons Hotels, a chain of prestigious Canadian hotels. Under the Four Seasons' proposal, the UW would get a percentage of gross sales, and the hotel would have fewer and larger rooms, all of which would be rebuilt, as would the plumbing and mechanical systems. The renovation would take eighteen months.

However, Paul Silver, then president of Allied Arts, still had his concerns. In a letter to Seattle attorney Jerome L. Hillis, who had been helpful to Allied Arts in the past, Silver wrote that the organization had "shifted from all-out mobilization to our more usual posture of cynical distrust as we continue to monitor the situation." Silver thanked him and said he hoped that Allied Arts would not have to call again. The success of the restoration project is apparent to anyone: the Olympic boasts a splendid exterior, handsome public spaces, and generous rooms. The Georgian Room, the hotel's principal

dining room, is one of the most beautifully proportioned and decorated rooms in Seattle.

In 1983, Miriam Sutermeiser, an architectural historian and chairman of the Allied Arts Historic Preservation Committee, arranged to have lunch with Don Covey, president of Unico, along with prominent architect James Olson and Grant Hildebrand, on the UW architecture faculty, also trustees of Allied Arts. The purpose was to "open a dialogue between Allied Arts and Unico," particularly in relation to the Skinner Building and the Cobb Medical Center.

The issues were significant. In 1983, the regents had received a recommendation from real estate consultant Keith Riely, from whom it had commissioned a report on development alternatives for the Metropolitan Tract. Riely's conclusion was that both buildings should be demolished because if they were kept, "the university would find itself with several aging buildings and declining rental income." The Skinner Building, at the time, was eighty-eight years old, and the Cobb, one hundred four.

Allied Arts immediately raised another flag of protest. In a letter to the regents, Dick Lilly, executive director, wrote that the organization "is opposed to any alternative which includes the demolition of either the Cobb or Skinner buildings." Any high-rise replacement would obliterate the pleasant scale of the surrounding area with its big lobbies, big plazas, and big parking garages. Lilly asserted, "Without the buildings' character, the Metropolitan Trace could well become a monolithic, cold place, unattractive to pedestrians; the university's tract would then indeed lose its preeminent position as the heart of downtown." Steinbrueck, the leading and perhaps loudest voice for historic preservation in the city, said that the Cobb Building was a valuable historic structure. "We'll do everything to save it."

It was all about money, of course. The UW would earn more money from newer and larger buildings. Both properties were about at the end of the line, Riely said in an interview in the *P-I*. "It just isn't just preserving something. It's also preserving something that can be used."

Not only was the Skinner Building on the National Historic Register but the 5th Avenue Theatre housed inside it had undergone extensive renovation between 1978 and 1980, in very public campaign involving not only ordinary citizens but some of the city's most prominent businessmen. Henry M. Aronson, attorney and Allied Arts president, wrote Robert F. Philip, president of the regents, urging him "to look beyond the numbers to the character and human scale of the tract and downtown."

Under the lease between the University and Unico, the UW paid all of the capital costs of new buildings, deferring the bulk of its profits for years. Unico reaped most of the short-term gain. "It is clearly in Unico's interest to tear down and build anew," said one developer in the *Seattle Weekly*. "It is what keep developers in business." Unico refused comment.

That battle for the Skinner Building was won, and Allied Arts soon formed a coalition of historic preservation interests "to pursue alternatives to the proposed demolition of the Cobb Building" and sought volunteers, especially those with "expertise in architecture, real estate development, and the law." The following year Allied Arts sought to have the Cobb Building put on the National Register of Historic Places. As Herman Sarkowsky, a UW regent, noted, the nomination was the beginning of a campaign to preserve the building from demolition. The regents formally objected, although placement on the registry was not insurance against demolition. What registration would do, according to Mark Brack, the state's architectural historian, would be to increase awareness of the building's value. Brack went on to say in the *P-I* that the building was the last remaining building of a grand plan for Seattle's downtown designed by Howells & Stokes in 1907. Trained at the École des Beaux-Arts in Paris, the partners had launched their careers in Seattle. The Cobb is the only example of their early work still standing. In its day, it was considered to be one of the largest and most sophisticated medical buildings in the nation. Allied Arts won this battle at the state level, approval at the national level being considered a formality.

The tide of public opinion was turning toward historic preservation. The regents recognized that if any effort were made to tear down the Skinner Building—particularly with the 5th Avenue Theatre being at the heart of it—to build another high-rise on the tract, or to tear down the handsome Cobb Building, the fight would be enormous and bruising—and one that the regents would have a hard time winning. In the end, the proposal was dropped. Making money was important, but "being a good neighbor" (to use the term of Arthur Skolnik, a key figure in Seattle's preservation movement) was also important. Much had been accomplished in a few years.

While the Cobb Building is no longer a medical facility, it was saved and converted into luxury condominiums. In 2013, the University announced that it would not renew its contract of sixty years with Unico, and instead hire another company to develop part of Rainier Square into office buildings, and probably shops and apartments.

Historic Theatres

From the turn of the last century through the Great Depression, the United States went on a theatrical building frenzy, constructing thousands of astonishing theaters that served all sorts of purposes. Some presented vaudeville performances, which lasted as long as this was a popular entertainment; others offered movies and musical theater, concerts and burlesque. Even to be in such a place was worth the cost of admission. Where else could one go on a Saturday afternoon or evening and lose the noisy world outside so thoroughly? "They were fantasy structures, and they will never be built again," said Karen Kane, cochairman of the Allied Arts Historic Preservation Committee.

Seattle had plenty such theatres, about twenty of them, built on a grand scale in a vast array of styles by some of the most famous architects of the day. Among these were the Palomar (originally the Pantages), the Alhambra, the Orpheum, the Coliseum, the Paramount, the 5th Avenue, the Metropolitan, the Music Hall (originally the Fox), the Colonial, the Blue Mouse, the Wintergarden, the Embassy, the Roosevelt, and the Granada, to name those concentrated within a few blocks in downtown Seattle. Then came the Depression, World War II, the 1950s, changing tastes and customs, and the disappearance of large screen movie theaters. One by one the grand theatres were torn down, with people hardly making a fuss. Less than one hundred of them remain across the country. By the 1970s only five of any consequence were left in Seattle: the Coliseum, the Paramount, the 5th Avenue, the Music Hall, and the Moore. Sometimes the Eagles Auditorium is included on that list, although it was never a theater; after extensive renovation, it is now home to the ACT Theatre. The Coliseum—the first theater built in the United States just for movies, in 1915, and the largest west of the Mississippi—is gone except for its magnificent, highly ornamented façade of glazed white terra-cotta, which makes a striking presence on Fifth Avenue. Today it houses a retail store.

Dating from 1926 is the 5th Avenue, with an interior auditorium modeled after the Imperial Palace in Beijing. It is flamboyant, full of delicious exaggeration and color that couples Baroque and Rococo Renaissance sensibilities in a Chinese manner. Once a movie and vaudeville palace, it was closed in 1978, then rescued by a dozen or so prominent Seattle businessmen, as well as various groups and organizations, and reopened two years later, with Helen Hayes and Ethel Merman starring in the opening-night show.

Music Hall Theatre, April 5, 1939. Photo by Webster & Stevens. Museum of History & Industry, Seattle.

Now a nonprofit group owns and operates the theater, filling it with touring musical theater as well as locally produced shows.

Built in 1907, the Moore is the oldest theater in the city and privately owned. Although there have been some touch-ups, the interior is dowdy, in need of a good scrub—not to mention complete refurbishing. The Moore's superb acoustics and cheap rentals—mostly music but also diverse entertainments—have saved it from the wrecking ball.

The Paramount, with its luxurious interior, went in and out of bankruptcy court in the 1980s. Potential investors would show an interest in taking over the place, then they would vanish. The task of making the theatre economically viable was daunting. The Seattle Symphony looked at the theater as a potential concert hall in 1990, but Cyril Harris, an acoustician

Engagement with Historic Preservation

Olympic Hotel, Seattle, ca. 1929. Photo by Webster & Stevens. Museum of History & Industry, Seattle.

favored by music director Gerard Schwarz, said that, in spite of its glamorous décor, the space was not suitable for unamplified music, and so the symphony abandoned its suit. Eventually Ida Cole, a newly retired executive at Microsoft, took an interest in the building, secured money from her rich colleagues and others, bought the building, and restored it. Now a nonprofit group presents a wide variety of shows—dance, music theater, rock concerts, spoken theater, symphony concerts, and so on. Like the 5th Avenue, the Paramount is a highly successful theatrical venture.

The 1929 Music Hall, practically across the street from the Paramount, for all of its sumptuous gloss in a fanciful Spanish Baroque style, was a more difficult enterprise as a workable theatrical space. In 1967, the vast auditorium underwent extensive refurbishing to accommodate tables on the main

floor for dinner theater. Its success was limited. The hall's owners wanted to tear down the theater and put up first an office building, then a hotel. There were other suitors as well, none wanting to save all or part of the theater. Allied Arts launched a major battle to save the building in some form, even if only its white terra-cotta façade, like the Coliseum's exterior. In doing so, Allied Arts became a lead proponent for preservation. The battle went on for years—in and out of court and the Seattle City Council chambers, periodic rallies, endless letters and legal briefs. Allied Arts worked hard to find investors interested in the theater. Ultimately, it did not succeed.

Walter S. Tabler, the attorney for the Clise family that had owned the theater since the 1930s, wrote in a 1991 petition that the record was "rather voluminous." Indeed. Part of that record demonstrated consistent losses. In 1974, the theater was designated a Seattle landmark. However, in 1983, the owner decided that the theater could not be made economically feasible and requested that the designation be removed. Controls were instituted on what could be done to the building physically, then removed, then reestablished. The Landmarks board ruled that the Music Hall was a "significant" part of Seattle and "embodies the distinctive characteristics of an architectural style—Spanish Renaissance/Moorish Revival, from the fourteenth and fifteenth centuries. Five years later, the Clise family, which claimed to have "made repeated efforts to cooperate with Allied Arts and the Landmarks Preservation Board," attempted to obtain a permit to demolish the theater and construct a hotel. The request was denied.

One of Allied Arts' ideas for an alternative use for the building was as a theater-hotel complex—although such a combination had its own difficulties, each with their individual demands on the space. At the time there was no precedent for converting a movie palace auditorium into a hotel lobby. Even the preservation of the façade presented difficulties. Tax benefits also seemed to be problematic.

In 1989, Karen Kane, chair of the Allied Arts Historic Preservation Committee, sent out a plea for action on the preservation of the Music Hall and announced a rally at the Paramount Theatre. Six committees were to be formed: fundraising, legal and environmental action, direct action (picketing, leafleting, etc.), feasibility planning (assembling a winning proposal for preservation and reuse), media relations, and legislation (a citizens' initiative). Tom Graff, cochair of the Allied Arts Downtown Committee, wrote that Allied Arts, Historic Seattle, the Washington State Historic Trust, and a myriad of other groups and individuals were prepar-

Rainier Square, 2012.
Photo by Roger Schreiber.

ing to appeal any decision by the Department of Construction and Land Use that failed to save the Music Hall's exterior and majority of its interior. "'The Music Hall is Seattle's first and only historic structure to be recognized as an 'official city Seattle landmark,'" he wrote, "while simultaneously being stripped of all the legal control that ordinarily protects such local landmarks."

In 1991, in the last few months of the theater's life, Allied Arts struggled to come up with an investor or set of investors who would take over the theater and the property. The city council seemed interested in offering some tax incentives to a willing purchaser. "If we want to save some of these historic theaters, they need some help," said Graff. In July of that year, councilwoman Sue Donaldson offered a compromise, proposing that the Clise family not tear down the building if the council approved economic subsidies for historic theaters—essentially the transfer of development rights. The owners of the Paramount were particularly interested. But the Clise

Coliseum, 2012. Photo by Roger Schreiber.

family was skeptical of any last-minute deal. On October 10, the Paramount offered the family a new deal, but it wasn't good enough.

In the end, Allied Arts lost this battle. In a letter to Paul Kraabel, president of the Seattle City Council, Mia McEldowney, president of Allied Arts wrote, "I am writing on behalf of Allied Arts of Seattle to express outrage at the manner in which the Council is concluding landmark proceedings on the Music Hall Theatre. As you know the Music Hall is a real treasure of this city. It is a unique part of a dwindling heritage of grand and elaborate historic theaters and as such cannot be replaced. An untold number of volunteers have contributed hundreds of hours of time in an effort to preserve the Music Hall specifically and landmark structures in general."

An Allied Arts position paper came four days later, covering the same territory: the council "should seize the occasion and engage in a serious initiative which would enable owners of historic theaters to realistically meet goals of financial viability," including "transfer of development rights, tax relief, incentives for private investment, creative forms of public subsidy." All to no avail. Nothing met the demands of the Clise family. To A. M. Clise, president of the Clise Agency, a pioneer Seattle real estate company, Kane wrote, "There will be no further litigation." There had been many appeals, all of which had cost Allied Arts not only considerable emotional energy but

also legal bills. The Clise Agency held an auction in the fall, with everything up for grabs. The wrecking ball was not far behind.

Even before the theater came down, Allied Arts issued a statement calling for an emergency task force on what it called the "landmark theater crisis." An ordinance would be prepared to implement a council resolution to help keep historic theaters economically viable, and an advisory group to address the needs of the city's remaining historic theaters. At the end of October, mayor Norm Rice asked Allied Arts to convene a Theatre Advisory Group (TAG) to work with his staff "in exploring long-term actions to secure Seattle's theatrical heritage." Actions would include a transfer of development rights and a modest assessment of business taxes. The creation of TAG, comprising a broad range of individuals and viewpoints, was an extension of the 1986 Mayor's Downtown Historic Theater Task Force Report.

In capitalizing on the concept of the transfer of development rights, in which a nonprofit can sell, or transfer, development rights to a for-profit company, TAG helped ACT secure the old Eagles Auditorium building and create a handsome two-theater complex on the edge of I-5 on Union Street. It is arguably the most important achievement of the group.

Not a year later, TAG submitted a ten-point plan to prevent a repeat of the Music Hall experience. "We cannot rewind the Music Hall's sad history—but we can and must be assured that it is never replayed at any other downtown historic theatre," wrote Walt Crowley, an Allied Arts president and chairman of TAG, in a letter to Rice. "To this end, TAG submits this report to you, the City Council, and the people of Seattle."

BROADWAY HIGH SCHOOL

Broadway High School was once a vital part of Capitol Hill—the first high school in Seattle, the first community college, the first public adult education program—stretching along Broadway in a quiet and humane way. It was not architecturally important, but it was physically imposing and had a historic role in the history of the city. However, by 1969 plans were afoot to raze the entire five-story structure, built in 1902, to make way for a new Seattle Central Community College. The high school had not functioned as a high school since the 1940s. Although the handsome auditorium, built nine years after the school as an adjunct, was scheduled for demolition as well, the college changed its mind and raised the money to retain it, and it

Broadway High School, 1908. Photographer unknown. University of Washington Libraries, Special Collections.

stands today on a grassy knoll, isolated from the rest of the campus. It is a poignant reminder of what was.

In the 1970s Allied Arts and Steinbrueck launched a major attack on the demolition plans under the banner of "Save Old Broadway High." " This building should be preserved," wrote Allied Arts in a letter to the college board. "The high school is a familiar landmark, a symbol of the past, and a link with the past. It has broader cultural roles which can be fulfilled only if the structure is saved."

In 1974, sixteen architects and planners wrote an open letter to the citizens of Seattle that was published in the *Seattle Times*. Among them were some of the city's most distinguished citizens, a number of whom were trustees of Allied Arts: Ralph D. Anderson, George R. Bartholick, Arne Bystrom, Grant and Ilse Jones, Ibsen Nelsen, Folke Nyberg, Art Skolnik, J. Peter

Engagement with Historic Preservation

Broadway Performance Hall (formerly Broadway High School), 2012. Photo by Roger Schreiber.

Staten, and Victor Steinbrueck. The letter stated, "While it [the school] is not a great architectural monument, it represents within the context of Seattle's history a highly important landmark. The building is the most important of the few remaining stone buildings in Seattle. The care exhibited in its workmanship, the excellence of its detailing, and the architectural period it represents will never be repeated. . . . To destroy the building would be an act of urban vandalism of the first order." Citizens were asked to write letters of protest to the Committee to Save Broadway High School, care of Betty Bowen at Allied Arts. They did so, flooding the office, according to an internal memo.

Bowen wrote governor Daniel J. Evans in September 1973: "Allied Arts is deeply concerned with the proposed razing of old Broadway High School. It is a distinguished Victorian building whose consequence has grown over

the years. . . . Its like will never be built again. . . . Regardless of the dignity and authoritative presence Broadway High School lends its area, it seems incredible in these times to spend an enormous sum for demolition and replacement. . . . Surely with the wholesale demolition of buildings across the land it is time to save some remnants of our past."

Two months later, Evans replied, using data provided by the college based on an environmental impact statement it had commissioned. Initially only economics were taken into account, the conclusion being that razing the building made the most sense. However, Evans added that "from an environmental standpoint, the facts are not yet all in" and promised a decision that would be a balanced account of all of the factors, including "the historical significance of the building," the "uniqueness of the architectural style," and an assessment of the facility, old or new, as "an integral part of the neighborhood." Alternatives were suggested—three altogether—that had different formulas but included retaining the exterior walls. They were predictably more expensive, and the college reaffirmed its earlier decision to raze the entire building, adding that the "cultural role is better served by other buildings in Seattle."

Allied Arts quickly alleged that the alternatives presented by the college were slanted to make razing the building the best solution, justifying "a decision that has already been made." Allied Arts suggested a new study be made, this time with an architectural firm that had "experience with the restoration of older buildings," and suggested architects, well-known in Allied Arts circles, such as Ibsen Nelsen, Ralph Anderson, George Bartholick, Fred Bassetti, Al Bumgardner, and Arne Bystrom. "[The school's] cultural role as a link between the past and the present can only be realized with the original building."

Mayor Wes Uhlman threw his hat into the ring by asking Skolnik, manager of the Pioneer Square Historical District at the time, to help save the school by trying to secure some kind of landmark status for the building. There were charges and countercharges, including one that Charles H. Odegaard, executive director of the State Advisory Council on Historic Preservation, was meddling in the process for political reasons. He denied the charge.

In the spring of 1974, the Seattle Landmarks Preservation Board drafted a program ordinance designating the school building as a Seattle historic landmark. Allied Arts sent out a letter to its members, urging them to contact members of the city council: "We cannot stress the urgency of this

message enough. Show the council that we cannot lose another important building to demolition—that we care." The Seattle City Council considered the measure and decided on a 5–4 vote to approve the ordinance. Some of the votes were surprising. Phyllis Lamphere voted against it, but Sam Smith voted for it, which earned him the enmity of some members of the African American community—his constituency—who wanted the building razed.

Fitzgerald Beaver, editor-publisher of the *Facts*, a Central Area weekly, wrote, "I don't consider Sam Smith as doing anything to help the Central Area. It's obvious he has a touch of racism in him. He's just as bad as anybody else. Anybody who would vote to designate this building [as a historic landmark] is voting against progress, against educational opportunities for minority students." The vote made the building the first designated landmark in the city. A court test was to follow to determine whether a city could designate a state property a landmark and whether the temporary restraining order preventing demolition should become permanent.

In an editorial, the *Seattle Times* called Broadway one of Seattle's most valued links to an earlier era. "Far too many of Seattle's historical buildings have been reduced to rubble already, due largely to the absence of push behind an official comprehensive program for the preservation of the city's landmarks. As the city's first major high school, surely old Broadway deserved to be saved as a cherished symbol of Seattle's colorful past."

Even some of the school's students were blasé about the issue. Allied Arts put out one of its rallying cries for support when the college's paper, the *Collegian*, declared that no one had paid any attention to the students' needs. The same edition also launched an attack on Steinbrueck.

Success was not at hand: the wrecking ball arrived and the building was destroyed. "Battered and bludgeoned from every angle by the tools of destruction," a story in the *Seattle Times* intoned, "the memory-filled structure seems unwilling to give up all the symbols of its glorious academic and athletic past."

Skolnik said that effort to save the school had failed because the head of the college made a case to the African American community that preservation could be equated with second-class status. It became an unintended social issue. Ed Banks, regarded as a longtime observer of the Central Area, was quoted in the *Seattle Times* as saying, "We are hurt and we are disappointed because we are not talking about tearing down the building. . . . We are talking about equal types of facilities at the north and south campuses." There was little talk, he continued, of "historic business" on the street.

In the midst of major struggles for historic preservation, there were other buildings that did not get the attention of headline writers or the full-bore involvement of Allied Arts, although members fought the usual battles with their usual weapons, some more successful than others. Here is a partial list:

THE BAY BUILDING. On First Avenue, on land originally owned by Arthur Denny, this imposing building was a link between Pioneer Square and Pike Place Market. It was erected in 1890 and was designed by Elmer H. Fisher, who designed more than fifty buildings in Seattle, including the Pioneer Building in Pioneer Square. The Bay Building was considered an outstanding example of the Victorian Romanesque style. When in 1974 Harbor Properties first announced that it intended to demolish the building, as well as the nearby Seneca and Victoria Hotels, for financial reasons, Allied Arts vacillated: to object or not to object. Finally, it objected, saying that to destroy the building would be a "calamity." Some prominent names in architecture were consulted to render judgment on behalf of Harbor Properties. Their conclusions, supported by an independent study commissioned by the city council, were pretty damning. The heavy lifting was done by an Allied Arts' ad hoc Committee to Save the Bay. Among its arguments for preservation was that once the Bay Building "falls to the wrecking ball, the domino effect will occur with the rest of this avenue." Steinbrueck argued that all of First Avenue should be included in a historic district. Lee Elliott, a strong advocate for all sorts of historic preservation, said, "[First Avenue] is the most historic street in Seattle and we feel it should be preserved." Members of the city council were divided but eventually agreed that the building should come down—and so did a good share of First Avenue.

FIRE STATIONS: The striking old fire stations of Seattle are often appealing to the people in their neighborhoods. When no longer viable as facilities for fire departments—charm can go only so far—some were saved, with the help of Allied Arts and Historic Seattle, as part of the architectural community. They include Fire House No. 18 in Ballard, No. 23 in the Central Area, and No. 25 on Capitol Hill.

VOLUNTEER PARK CONSERVATORY: In 1978, James Uhlir, president of Allied Arts, wrote mayor Charles Royer, expressing Allied Arts' concern about the significance of the Volunteer Park Conservatory "as a historical landmark as well as a personal landmark and resource for the citizens of

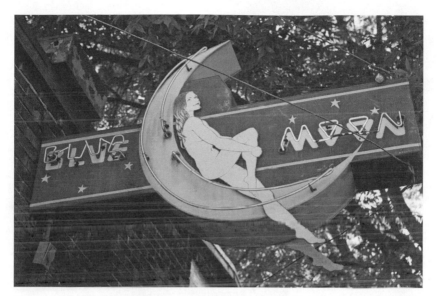

Blue Moon Tavern, 2013. Photo by Roger Schreiber.

Seattle." The city allocated four hundred thousand dollars in funds. That, followed by a private fund-raising campaign in which Allied Arts played a role, and the building was saved.

BLUE MOON TAVERN: Although it is unlikely Allied Arts members spent much time at the Blue Moon Tavern, with its 1920s brick façade and neon beacon, they recognized its importance in the cultural fabric of the city and took steps to ensure its continued existence as the only structure of the era to survive—namely by supporting the tavern's nomination for landmark status. Allied Arts argued that the building stood as a "unique and immutable landmark signaling the western front of the University District." The tavern had been there since 1934, nine years after the building itself was constructed. Some cosmetic improvements had been undertaken, but not many, thus preserving the gritty ambience.

The tavern's patrons represented a kind of bohemia that had fled the bourgeois sensibility of the city. In the 1950s they were beat and in the 1960s, counterculture. It was the old left merging with the new left. All sorts of notables, mostly literary, spent time there. Some fondly remember that the Blue Moon was "a place to let off steam without being penalized," to quote Jack Leahy, who wrote an entire novel in a back corner. Some of the more

famous patrons were Victor Steinbrueck, Theodore Roethke, Richard Hugo, David Wagoner, Dylan Thomas, William T. Cumming, Jack Kerouac (or so legend has it), and Allen Ginsberg. Carolyn Kizer, a Roethke student with a Bullitt in her background, who went on to win a Pulitzer, wrote in the *New Republic* in 1956, "Blue Moon is a grubby oasis, just outside the University's one-mile sahara. Here the juke box roars, Audrey the waitress slaps down schooners of beer, and poets, pedants, painters and other assorted wildlife make overtures to each other." Senator Warren Magnuson liked the description so much he entered it into the Congressional Record.

BETTY BOWEN'S PAIR OF HOUSES: Two 1870 frame houses at Eighth Street and Madison scheduled for destruction caught the eye of the indomitable Betty Bowen, an Allied Arts trustee passionately committed to historic preservation. In a matter of days, under the auspices of Allied Arts, she raised thirteen thousand dollars to pay for the cost of moving them, to buy liability insurance, and to find a place to put them temporarily. Bowen wrote charming letters to a lot of her friends. Who was going to say no to Betty? But she was not successful in getting the Landmarks Preservation Board to have the houses declared a landmark. All of her efforts were for naught. With a sigh of defeat, she returned the money to anyone who wanted it back. Alas.

5 / Betty Bowen

<p>THOSE WHO KNEW BETTY BOWEN REMEMBER HER WELL EVEN though she died more than thirty years ago. She was famous, or infamous perhaps, for prodding people to do her bidding—saving the environment, maybe birds, maybe old buildings, helping needy artists—and for connecting disparate elements of society. By the sheer force of her ebullient personality, Bowen was readily at home with all sorts of people. She knew everyone, or so it seemed, and she never hesitated to call late at night or early in the morning with a request to do something she wanted. Chitchat and gossip were not her game: she got to the essence of her message quickly, sometimes beginning in the middle of a sentence, then hanging up abruptly with a goodbye. Some called these calls "marching orders."</p>

Emmett Watson, a columnist for the *Seattle Post-Intelligencer* in the days of Bowen's reign, wrote, "She's a gadfly, a prodder. I guess she calls me three-four times a week to lecture me on how I haven't enough in my column about the good things in Seattle. I haven't done enough to save the polar bear, code words for I am not doing enough. I call her 'Mary Worth' because she is always advising."

Alice Rooney, who ran Allied Arts for twenty years, has a similar recollection. "You dreaded those morning phone calls. You listen to her for half an hour and come away convinced that you hadn't done enough on behalf of what Betty wanted done." Walt Evans, a columnist for the *Seattle Post-Intelligencer*, and later the *Seattle Times*, labeled those calls "racing monologues." Novelist Tom Robbins said in a piece in the *Seattle Times* in 1973:

To know Betty Bowen is to know her on the telephone. She rings you up, see, and she doesn't ever say "hello," she just starts in talking about whatever is on her mind. . . . You know at once that it is Betty. Her voice is like a satin boot filled with champagne . . . confident and comfortable, but at the same time very elegant and sparkling. She rather bubbles when she talks and her bubbles are reinforced with warmth and compassion and intelligence. And her voice is frequently punctuated by her famous laugh: a devilish, Aunty Mame cackle. . . . Anyway she speaks her piece, makes witty remarks, laughs, teases you about how naughty you are, and then says, "Goodbye, darling," and hangs up . . . leaving you bemused, bewildered, intrigued, interested. I must have spoken with Betty Bowen four hundred times on the phone and never have I had the opportunity to say "good-bye" on her. My life's ambition is to hang up on Betty Bowen before she hangs up on me.

Bowen was given various titles: "an important catalyst to the arts and social causes," "one of the most amusing people in Seattle," "an overzealous press agent." In her diary, Bowen wrote, "Whatever I am, I am not a doodler." Painter Morris Graves, one of the icons of the Northwest School, once said, "At a time when it was fashionable to buy Monet reproductions, she got people with money to buy living artists"—both known, such as Mark Tobey or Graves, both close friends, or unknown. "Betty opened doors for us," said artist Leo Kenney. "She was the runner between our garrets and Hunts Point and Broadmoor (or Washington Park, the Highlands, Medina). She had magic powers."

Historic preservation was her chief concern with Allied Arts. In a memo to her Allied Arts Historic Preservation Committee, in the year of the American bicentennial, Bowen wrote, "Despite the increased awareness of the importance of saving landmarks from every point of view, they continue to be destroyed at an increasing and terrible velocity. . . . One can believe the theory . . . that buildings of human scale, distinctive style or flavor, no matter how humble, with appealing detail or decoration, are an embarrassment to the builders of many of the anonymous, interchangeable, outsize structures being built today and that developers, often unconsciously, are bent on their destruction."

She was a meteor in the sky, brilliant and fast, before it went out because of a brain tumor that claimed her life in 1977. She was not yet sixty. As Mary Coney, then president of Allied Arts, said upon Bowen's death, "It is difficult

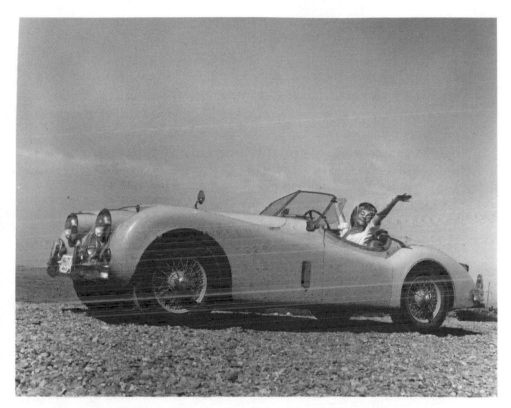

Betty Bowen, September 1965. Photo by Mary Randlett. University of Washington Libraries, Special Collections.

to get a clear picture of what Betty Bowen did within and without Allied Arts because her interests, her contacts and knowledge, were so wide-ranging." As chairman of Allied Arts' Historic Conservation Committee, Bowen wrote letters to everyone, anyone who had an iota of influence, from national figures, such as US senators and presidents of major corporations and congressmen, to mayors and city officials to local businessmen and cultural figures and, of course, the media—publishers, editors, writers.

In 1971 Henry Moore's *Vertebrae*—massive and elegant—was installed on the plaza of the Seattle First National Bank, as the building was then known. Henry J. Seldis, art critic for the *Los Angeles Times*, came up and wrote a long, thoughtful Sunday piece on the city, undoubtedly prompted by a Bowen phone call. He wrote to her, "It was good to see you again and to know that your rambunctious self hasn't changed at all. That last paragraph

of my column (quoting Tobey) was written strictly for you: 'Our homes are in the path of freeways. Old landmarks, many of rare beauty, are sacrificed to the urge to get somewhere in a hurry, and when it is all over, progress reigns, queen of the giants to whom the intimacy of living is of no importance.'"

Bowen sent an article on architecture and urban design in Birmingham, Alabama, to Seattle City councilwoman Phyllis Lamphere, chairman of the planning committee, who responded, "The concepts about urban design, historical preservation, quality of public improvements, et al., are extremely difficult to advance at a very rapid rate. I need all the ammunition I can get and was therefore delighted with the material which you sent me."

John Canaday, chief art critic for the *New York Times*, wrote Bowen, "There wasn't anything we could do about the American Paintings [exhibit at the Seattle Art Museum] or Tobey's eightieth. Jets or no jets, Seattle is still a long ways off. . . . I'm leaving for five weeks in India (vacation, not assignment) on February 20, so if you have news stories during that time, such as the Seattle Art Museum burning down, connect with Hilton Kramer." Bowen's letters could be long, short, amusing, straight, often hyperbolic, even flirtatious, and those from her vast constituency equally so.

To philanthropist Virginia Bloedel, best remembered, along with her husband, Prentice, for the creation of the Bloedel Reserve on Bainbridge Island, Bowen wrote, "By now you may know that the Landmarks Commission met last week and failed to designate the Patterson houses (built in 1870) as landmarks. Defeat, I can stand, but I weep for what their loss will mean to Seattle as two (a matched pair!) of the few remaining remnants of the city's second wave of construction. The weeks and months that have gone into the effort to save them, to help give Seattle a heart and memory, reinforces the fact that much must be done. And as ever with Allied Arts, onward is the word."

In a call to action to various community leaders to help save historic houses, Bowen wrote, "Since World War II the destruction of our historic landmarks has been wholesale and ferocious, denying Americans their right to continuity, to memory, to a sense of place." A year prior to her death, she wrote an apology to arts patron Kathryn Haley in Tacoma, "This is a disgraceful time to answer your darling note. I was flat for almost two months and since then I have been up and down and running madly to keep behind."

She could sweet talk anyone. In 1966, Douglas Welch, much-loved columnist for the *P-I*, wrote, "I love to get letters from you. What do you want a picture of me for? Why don't we just fly away together to the end of the

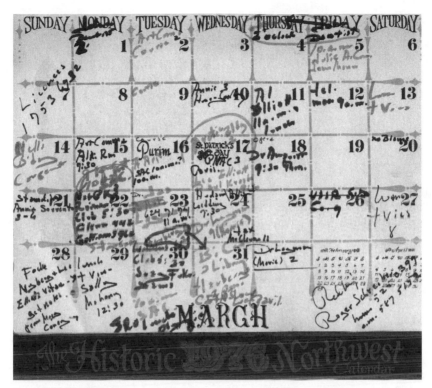

Betty Bowen calendar page, March 1976. University of Washington Libraries, Special Collections.

earth?" Four years later, mayor Wes Uhlman wrote, "Thank you so much for the praise! Zounds—I'll never wear anything but my gray suit and blue tie again—didn't know it caused such a reaction." And Bagley Wright, civic leader and philanthropist, wrote to her in 1971, "I remain your constant if cynical admirer." To C. K. O'Rourke at Weyerhaeuser Company, Bowen wrote, "You were an absolute lamb to see me. The visit, if only for your charm, was worth the cancellation of a standing hair appointment. . . . I can't tell you what it meant to me to see a real face and have a real thought presented to me. I must tell you that had it not been for turning for advice and counsel to [art dealer] Don Foster, who I think is smart and adorable, I probably would not have dared breast the walls of the big W citadel."

In the "blunt" category is the beginning of a long letter to Herbert Zimmerman, dean of administrative services at Broadway High School, which

Allied Arts desperately tried to save from the wrecking ball in the mid-1970s: "Allied Arts of Seattle would like to comment on the draft Environmental Impact Statement you sent to us on December 3 [1973]. Allied Arts supports the retention and remodeling of the existing Broadway High School structure and does not feel that the draft statement has dealt with this issue honestly. The statement appears to us to be an unwieldy advocacy statement prepared to justify a decision which has already been made."

Since World War II the destruction of our historic landmarks has been wholesale and ferocious, denying Americans their right to continuity, to memory, to a sense of place.

Bowen could be admonished too, even in a gentle, affectionate manner. From Bruce Chapman, who had just won a seat on the Seattle City Council, "Now, sweetheart, I want you to really get in and help. For one thing, these people do not understand the importance of sign control. We have my vote, but it turns out there are eight others. What are we going to do about them? Why don't you put on your sexiest perfume and come down to lobby? Of course, you may lobby me anytime and anywhere. Signed, Your humble and obedient public servant."

She also wrote position papers and gave speeches, such as this one in 1976:

> As with liberty, the price for Historic Conservation is eternal vigilance . . . vigilance, which so far at least, requires the gifts of time, courage, perception, high intelligence, and willingness to put up with endless boredom as well as to work against not only well-organized antagonists with highly-paid staffs to represent them, but unawareness, indifference, and even fear. Often, if the latter is overcome, the victory has been too late. . . . We know, as we watch the landmarks fall around us—Broadway High School, the Societe Candy Co., the old Ballard City Hall—which hostile forces demolished for fear someone would take note of their importance.

Bowen could wax eloquent:

Our committee has run from one fire to another in the form of answering economic impact statements, appearing before a steady, apparently unquenchable stream of hearings, committee meetings and working on reports, task forces and legislation. Its other main function has been to build an informed constituency within the community and to develop an awareness of the importance of historic conservation generally and specifically. . . . We hold meetings in a variety of situations like Mt. Baker Clubhouse, Carnegie Library in Ballard and old Ballard Fire Station. . . . We have presented lectures on Victorian furniture and glass . . . have had a historic tour of Port Townsend, with plans of restored Port Gamble and Coupeville. . . . [Among] our most successful has been the presentation of courses on Historic Conservation at the University of Washington and Seattle Pacific University. . . . Another effort to preserve the very heart of downtown came not from our committee, which has had its hands full in other areas, but from a valiant band of other Allied Art members and citizens. That was the effort to save the White-Henry-Stuart Building and its neighbors. Until recent years, Fifth and First avenues presented Seattle and its visitors with two vastly different experiences. Fifth Avenue was a cosmopolitan, humanely scaled area of stunning shopping, an ensemble of handsome buildings at University Properties, a pleasurable walk to Frederick & Nelson [now Nordstrom's]. . . . Fifth Avenue [began] to go piecemeal from the time the exquisite Metropolitan Theatre was razed for the Third Reich drive-in that demeans the Olympic Hotel [now Fairmont Olympic].

Bowen was a dreamer certainly, but one grounded in reality, in part led by sturdy business types, literate and informed, who readily gave her good advice in an effort to help her cause. Joseph Cebert Baillargeon, chairman of Seattle Trust and Savings Bank, wrote a long, thoughtful letter to Bowen in 1976, with some caveats about preservation. "The financial aspects of this sort of restoration are nothing that can be reduced to formula, and one of the most common misconceptions is that there is some magic financial analysis that ensures lenders and borrowers that their project will be a success. Nothing could be further from the truth. Restorations of venerable buildings are acts of faith and hope, and sometimes charity; consequently, our role must be considered parallel and complementary to the role of the contractor and developer."

Allied Arts was known as a comfortable habitat for blithe spirits, of which Bowen was a prime example. She was passionate about the causes and peo-

ple with whom she was associated. And she was concerned about her legacy, keeping seemingly every scrap of personal correspondence—postcards, notes, letters, backs of envelopes, and cocktail napkins—from close at home to far-flung places, often written on hotel stationery of famous hotels such as the Imperial in Tokyo or the Gritti Palace in Venice, valentines from notables such as their imperial majesties, the Emperor and Empress of Japan, every manner of invitation from here and there—a veritable catalogue of Seattle's history over a thirty-year period. Some scraps of paper have no date or other identification, but they had resonance for Bowen, for instance, this from the eighteenth-century British statesman and writer Edmund Burke, "Freedom is not lost to evil men who wish to seize it, but by good men who have ceased to care." All are in Bowen's papers at the University of Washington Libraries, Special Collections.

Bowen could also be tart, and often had nicknames for people: for instance, Maxine Cushing Gray—longtime critic for the *Seattle Post-Intelligencer* and *Argus*, editor and publisher of the fortnightly *Northwest Arts* in the last decade of her long, fruitful life, and a major force in the Seattle Art scene who was often on the barricades with Allied Arts—was the "tweed hornet." The name was so apt, it stuck with Gray until the day she died, a decade after Bowen.

She was born Betty Cornelius in 1918 of pioneer stock and was reared in the Skagit Valley, perhaps one of the reasons for her enduring affection for and affinity with that area and the artists it nurtured. Her great-grandfather and great-grandmother were among the first white settlers in the valley, and he helped dike the Skagit Flats. "The belle of the Skagit Valley," as Bowen was sometimes called, immigrated to Seattle to attend the University of Washington, majoring in English and studying art with two of the eminent painters of the day, Ambrose Patterson and Walter Isaacs. Bowen skipped from one job to the next, working in the classified-advertising department at the *Seattle Times* and later as a reporter, where editor Herb Robinson, who became a friend, remembers her as "elegant, polished, utterly feminine, but nonetheless a clown." She worked for the *Seattle Star* in the 1940s, quitting only weeks before it folded; then KIRO, which had an office in the Olympic Hotel, what Bowen called a "broom closest"; then back to the *Times*.

Bowen found her real calling when she discovered public relations. In 1954, she was hired by Richard E. Fuller, founding director of the Seattle Art Museum, as a part-time public relations person. "I don't know why I was hired," she said in an interview in the *Times*, "probably because I was

acquainted with a wide variety of people. And, of course, everyone knows of my passion for art." She also did business at Trader Vic's, a fashionable restaurant and caterer in its day. The restaurant had two main dining rooms; the one where Bowen held court was the place to be, with or without her. When one young journalist found himself and his date in the other room, he casually dropped Bowen's name in some familiar way in front of the waiter and was immediately shown to a table in the prime room, with an apology. Bowen rarely entertained at home—a charming, craftsmen-style house perched on the southwest slope of Queen Anne Hill that she shared with her husband, Captain John Bowen, "my gallant captain," who was only occasionally in town because he was the skipper of the largest transcontinental cable-laying ship in the world, the *Long Lines*. When Bowen knew that her husband was going to be in Seattle, her business and social appointments were abruptly canceled. No one complained. How often does one get to have repeated "honeymoons," she was fond of saying.

Bowen could assemble groups at the drop of a hat, such as a benefit exhibition to raise money for an ailing Ward Corley, a young and talented painter dying of liver cancer in 1961. In short order, the *Times* reported, an exhibition opened, and everybody in town who had an interest in art showed up for the opening. Collector and philanthropist Virginia Wright said, "Betty's the one to call if you want to get the word out."

Charles T. Michener, editor of the stylish, short-lived magazine *Seattle* (1964–1971), wrote a perceptive profile of Bowen in 1970. On her whims and wherefores, he said, "I tend to agree with Emmett Watson's appraisal: 'Behind that impish, busy charade is a genuine reverence for life. I think Betty's a very serious person who hates things like big buildings and freeways that shrink people, things like insecticides that hurt life.'" "Her 'public relations' . . . facility leaves something to be desired," Michener continued, but "in the real sense of public relations—that of providing the glue that makes so much stick that might otherwise come apart—. . . I find Betty without equal."

Even those who disagreed with Bowen on various issues would not malign her because of her openness and sincerity. "My friends sometimes tell me that I'm too easy to take advantage of," she told Michener. "But my father always used to talk to everyone, and my mother always fed the tramps who came to our door during the Depression. I just grew up thinking that was the way to be." "If you could sign your name to moonlight," her loyal friend and ally Mark Tobey once wrote her, "that is the thing."

Betty Bowen Outlook. Photo by Roger Schreiber.

In his tribute to Bowen, Watson wrote the day after she died, "What is there to do but weep? At this stunning moment, what is there left but to grieve for the loss of this woman whose reverence for all life was the epitome of her own." In addition to the many stories about Bowen, even now, she is remembered twice over. First, with the Betty Bowen Viewpoint at the western end of Highland Avenue, with a sweeping view of Elliott Bay, and artworks by eleven of her favorite artists. The viewpoint is a block up the street from the house Bowen shared with her captain. The pocket park was completed in 1981, under the supervision of one of her stalwart friends, in and out of Allied Arts, Victor Steinbrueck. And second, with the Betty Bowen Award for emerging artists, funded by an endowment created in the months following her death through the generosity of her famously well-connected and wealthy friends, and now administered by Seattle Art Museum.

Betty would approve.

6 / Preserving Pioneer Square

P IONEER SQUARE IS REGARDED A MAJOR VICTORY FOR PRESERVA-
tionists. Buildings that were once dilapidated and rundown have
been restored; highways and mega-parking lots have been banished;
and although they change, there are still plenty of businesses and galleries
and coffee shops that attract customers. But the story of the preservation-
ists' victory is not without its setbacks and disappointments. A major defeat,
early on, was the loss of the Seattle Hotel, a remarkable building shaped like
a ship that was demolished for a parking lot.

"They tore it down—one of the great historic landmarks of the city,"
said architect Ibsen Nelsen, then president of Allied Arts, in an article in
the *Seattle Times* in 1965. "And look at what replaces it: an automobile-park-
ing structure. It looks like a sinking ship—a ship slowly sinking into the
asphalt." Ideas have come and gone about what to with that oddly shaped,
triangular piece of property in the heart of Pioneer Square, but the ugly con-
crete garage is a blight on the neighborhood—a cautionary tale of what can
happen when preservationists are ignored.

Seattle's history, barely a 150 years old, is linked to Pioneer Square. In
1852, a small party of settlers abandoned Alki Point in West Seattle for a
more commodious setting on the eastern waterfront of Elliott Bay. Some
of the choicest waterfront went to Henry Yesler, who established the first
steam-powered lumber mill in Puget Sound. Logs for the mill were felled on
First Hill, then a lush forest, and skidded down on Skid Road, what is now
known as Yesler Way. Fortune came quickly to the new city, but on June 6,

1889, at First and Madison, some glue that was being heated over a stove in a basement cabinet shop boiled over, caught fire, and engulfed the entire building. During the next few hours, the twenty-five-block area that constituted downtown Seattle was destroyed.

Unfazed, or so it would seem, Seattle rebuilt, using brick and stone instead of wood. Streets were widened, and water mains improved. Seattle's first general store, saloon, bank, and church were all located within a two-block radius. Many streets in lower downtown (which were Doc Maynard's old holdings) were raised as much as eighteen feet, making the second floor of many buildings the new first floor. The original first floors, now underground, much later became Underground Seattle, which Bill Speidel made into a major tourist attraction in 1964—and helped revitalize Pioneer Square at the same time.

After gold was discovered in Alaska, Seattle became a boomtown. Gradually the developing businesses and finer retail stores moved north, around 1910 or so, and Pioneer Square went into a long decline. Hotels became cheap boarding houses, and many other buildings were abandoned. What had once been prosperous became rundown, as derelict as the people who lived there—"totally defunct," according to architect and Allied Arts trustee Victor Steinbrueck. By the 1950s and 1960s there was considerable pressure by downtown business interests to develop Pioneer Square by razing it for parking lots or new buildings, or even freeways. But there was also a growing realization by the more far-sighted citizens that the area had intrinsic value in itself, once it had dusted itself off.

Among the earliest people to see the virtue of restoring Pioneer Square was architect Ralph Anderson, a member of Allied Arts, who is credited with creating the Northwest style of architecture. In 1962, he moved his office to the Square and subsequently bought 108 South Jackson and restored it. He invited leading interior designers, such as Allen Vance Salsbury, and Speidel, to move their offices there, and made the third floor into a penthouse apartment.

At the time, Anderson said in an interview, most of the people who bought property in Pioneer Square had no interest in the buildings themselves, only in the property they were holding for future sales. After the success of 108 South Jackson, people took notice of what those old buildings could become, and began to look upon Pioneer Square differently, as a place to restore, not exploit. Some buildings were torn down, but others were saved, trees were planted, historic lighting installed, stylish apartments built, alleys rehabilitated.

Pioneer Building, 2013. Photo by Roger Schreiber.

Anderson went on to buy other buildings, such as Grand Central, and pulled in investors such as Richard White, who founded Foster/White Gallery, and Alan Black, a member of the well-known Seattle timber family. Virginia Wright, one of the city's leading philanthropists and art collectors, as well as a trustee of Allied Arts, established a first-class art gallery on Occidental Avenue. Anne Gould Hauberg, another philanthropist, art collector and Allied Arts trustee, got her group of well-connected and influential women, the Committee of 33, interested in what was going on.

What was likely the city's first French bistro opened its doors in the basement of the Pioneer Building, one of the grand old edifices in the Square, lovingly restored by Anderson. Established in the early 1970s by Francois and Julia Kissel, Brasserie Pittsbourg was a favorite watering hole of Allied Arts members and all sorts of other examples of urban chic. The place was simple but authentic and fun, decorated by Michelle Durkson Clise with French art posters and gleaming copper pots. One always saw people one

Occidental Mall, 2013. Photo by Roger Schreiber.

knew, or barely knew, but knew well enough to say a breezy hello or maybe float a kiss. It was a "really cool place," said Paul E. S. Schell, an Allied Arts president who made many contributions to Seattle, including helping restore Pioneer Square. Allied Arts nominated Anderson for the Governor's Award in 1973, "for significant contributions to the arts and to historic preservation . . . long before historic preservation became a popular byword and while others were talking about the problems."

Allied Arts' first office (after Alice Rooney's dining room) was in Pioneer Square. "Our presence there gave impetus to the whole effort to restore Pioneer Square," said Rooney, executive director of Allied Arts. "We were a part of a movement. We were good citizens." Patricia Baillargeon, an Allied Arts trustee, wrote Norman J. Johnston, Allied Arts president, in 1967: "Allied Arts board members should be brought up to date on pending laws regarding historic preservation. . . . One assumes it [the bill to establish a historic landmarks commission, which was before the legislature] will have no trouble being passed, but at this juncture, I think the Allied Arts board should be alerted so that if there is any trouble they can all rally around on

a moment's notice." And "rallying around on a moment's notice" was one of Allied Arts' specialties.

Arthur M. Skolnik, chairman of Allied Arts Historic Preservation Committee for a time, remembers well the process of saving Pioneer Square from further decay and demolition. His first official post was manager of the Pioneer Square Historic District; then he served as Seattle conservator, the first in the nation to hold such a post; and then he became Washington State conservator. Working out of the office of mayor Wes Uhlman, an ardent friend of Pioneer Square, Skolnick considered Allied Arts trustees as "chums." "They were cool, the main advocate for the district. We thought

Occidental Square, 2013. Photo by Roger Schreiber.

alike. Whenever I needed a letter, I could get one from Alice [Rooney]." Very quickly the district became popular with the Historic Trust [in Washington, DC], but in Seattle, acceptance was still a struggle. One of the challenges, Skolnick recalled, was the downtown business establishment's desire to concentrate all urban activities uptown of Pioneer Square. There was an effort to get Occidental Avenue closed from Yesler to the Kingdome, but in the end only two blocks were closed—one of which is now Occidental Park. Designed by noted landscape architects Ilse and Grant Jones, its creation was one of the signal achievements of Allied Arts in Pioneer Square. Allied Arts' Urban Environment Committee, headed by Anderson, proposed the park in 1970 and spearheaded the effort, persuading the city and the Model Cities Program to provide funding.

The tide was turning, not only in terms of the visual appeal of historic preservation but also in terms of an "economically viable form of architecture," said David Hewitt, president of the Seattle Chapter of the American Institute of Architects, a frequent ally of Allied Arts. In a letter to members of the Seattle City Council, Fred Bassetti, a president of Allied Arts and an

influential architect, encouraged the council to approve the creation of the Pioneer Square Historic District: "An ordinance of this type has long been needed in order that Seattle's historic district not be wholly lost. We have seen some destruction in recent years while at the same time substantial private restoration and improvement work has been under way. But it is not too late." Allied Arts' Historic Preservation Committee played a significant role in the formation of the district, which was established in 1970.

The ordinance had roots that went back to the late 1940s and the formation of the Pioneer Square Businessmen's Association, which dropped "Businessmen's" from the name in 1956 in order to broaden the scope of the organization. Upon the passage of the historic preservation ordinance fourteen years later, the association declared its support. "We look to . . . [the city] for protection of the old buildings." The goal of the association, it continued, was to link itself with the preservationists and the city to "produce economic viability while respecting and enhancing our historic legacy."

Mayor Uhlman lent the prestige of his office to Pioneer Square early in his administration and continued his support throughout his tenure. He put city offices into buildings, promoted the economics of restoration, and encouraged public improvements. His appointment of Skolnik was only one example of his commitment to preservation. Skolnik, now living in Massachusetts, was one of the Northwest's most public and articulate voices regarding historic preservation.

A 1973 landmarks preservation ordinance was followed the succeeding year by a revolving fund for the acquisition, restoration, operation, and disposition of historically significant properties throughout Seattle; the Historic Seattle Authority was the administering agency. The program ran into legal problems and did not last long.

Pioneer Square is a living organism, with changes both good and bad. Although laws were enacted to encourage historic development, not everything came up roses. In 1979, Uhlman criticized then mayor Charles Royer for downgrading the importance of Pioneer Square. Uhlman said in a speech at the time, "[It] will be forgotten and treated like the tail of the downtown dog."

By the late 1980s, Uhlman's prediction seemed prescient. "The harmless, poorly clad winos who curled up in doorways or stood in mission lines for a free meal" had been replaced by "a new, meaner breed of street people," wrote Don Duncan in the *Seattle Times* in 1988. "Because of the stabbings, the rapes and the murders, some business owners are leaving the area's

office buildings, with regret." Donna Schram, who moved her research business to Freemont, said in the *Times*, "One thing that really bothered me is that Pioneer Square has become a large bathroom. There is only one public bathroom in the area; so people use doorways and alleys as urinals. . . . I had the feeling of anarchy . . . a feeling that there wasn't any control. I think the police were about as visible as you can expect in a small area. But the problem is so monumental you can't expect foot patrols, mounted police and car patrols to deal with it." Fingers pointed in every direction—from Washington, DC, to the courts, the police, the sale of fortified wine, and the existence of too many Skid Road missions and halfway houses in a small area. And fewer and fewer people actually lived in the Square.

Still, as Skolnick noted, "Pioneer Square is fantastically successful. It will never again be the center of Seattle's commerce, but its renovation—its privately funded renovation at that—is as significant to Seattle as its birth after the Great Fire." The Square is constantly evolving, with the good and the bad, the poor and the rich inevitably intertwined. By day the Square's population has changed from one group to another, the latest being a high-tech group of professionals. At night, there is still a lot of club activity, but also drug dealing and street fights. Fortunately, businessmen are rediscovering the Square and investing substantial funds to create good housing. Those most responsible for preserving Pioneer Square were always aware of its complex nature, and, indeed, they celebrated that complexity. Like the pioneers before them, they were clear-eyed optimists

7 / Fred Bassetti

FROM THE OUTSET, THERE WERE ARCHITECTS AT ALLIED ARTS AS well people who were deeply involved in architecture and urban planning. They were young, had talent, zeal, and ideas, and were concerned about the future of Seattle, which in the 1950s was about to become the city we know today. First and probably foremost among these was John Stewart Detlie, a charming, charismatic architect who may have come up with the nickname Beer and Culture Society, a witty disguise for deep purposes that lay at the heart of what would become Allied Arts. Others were to follow, such as Victor Steinbrueck and Ralph Anderson, pioneers in historic preservation, and Ibsen Nelsen, a man of humane ideas and persuasive diplomacy. It was Nelsen, along with Peggy Golberg, who recruited one of city's most prominent architects, Fred Bassetti, to assume the presidency in 1970.

Bassetti, who died late in 2013, was not a stranger to Allied Arts. He was there at lunch in the early 1950s, when Detlie had presented his ideas to Bassetti and "maybe five or six" others about a new organization to be called Allied Arts. "It started slowly and went on and on," Bassetti recalled. The Market had not yet been saved from developers. There was no public support for art. Billboards and utility poles marred the landscape. Arts organizations were small-scale or nonexistent. Detlie and John Ashby Conway, a professor of stage design at the University of Washington, were the mainstays of the fledging organization. "I was not active in the beginning," Bassetti said, "not at all, actually. I went to some of the very early meetings. Then,

one day, Peggy and Ibsen, over lunch, prevailed upon me to get active, and I was president for two years."

Born in 1917 of Italian and Norwegian parents, Bassetti grew up in the Mortimer Heights neighborhood, what is now known as Tukwila. Bassetti considered himself a "country boy." Steinbrueck, who later became his friend and ally in the urban scene, led the young Bassetti on Boy Scout hikes. Bassetti's father published an Italian-language newspaper, the *Gazzetta Italiana*. When Bassetti was fifteen, his family sent him to Turin to visit his grandmother and to learn some Italian and get some culture. With a little of both under his belt, Bassetti returned to graduate from Garfield High

Fred Bassetti, 2009.
Photo courtesy of
Catherine Bassetti.

School—the family had moved to Denny-Blaine—and then the University of Washington. As a boy Bassetti was always building things, and he thought he would become an engineer. That field of study turned out not to be a natural calling for him, however, and, after a date with a friend in the architecture department, he switched fields. Among his new classmates was Roland Terry, who became a noted residential architect in the Northwest.

After World War II, Bassetti went to Harvard University and got a master's degree in architecture. It was a fortunate time and place for him: I. M. Pei was a classmate—"the best in the class"—and his teachers included such celebrated people in the field as Marcel Breuer and Walter Gropius. Shortly after graduation, Bassetti worked for a brief period at the Cambridge office of the great Finnish architect Alvar Aalto. As Bassetti put it, "I learned and gradually got better, started my own office postwar after a year with Naramore Bain Brady & Johanson [later NBBJ], and practiced in Seattle for about fifty years. The office is still going, known as Bassetti and Associates." There were houses large and small, famous clients and big buildings downtown, for instance, the Jackson Federal Building, Seattle Municipal Tower (formerly the AT&T Gateway Tower), and the Children's Zoo at Woodland Park. In 1978, Bassetti designed the American Embassy in Lisbon.

While at NBBJ, Bassetti won first prize in a competition at the *Seattle Times* sponsored by the American Institute of Architects. He described his project as "a small house, about 900 square feet. That was the limit. You

couldn't make it larger than that because houses were in great scarcity after the Second World War." A couple saw the drawing and called on him to design "a special house for them." Bassetti gave notice and asked architect John L. "Jack" Morse if he could rent space and a drafting board in his office. Morse "was sympathetic" to the young architect, Bassetti remembered.

After a few years, Bassetti was still scrambling, as he put it, doing porch designs, French doors, one thing leading to another, and going "backwards" in terms of finances. So, one day he walked into Pacific National Bank and decided to borrow a hundred dollars. That, he thought, would carry him for another few weeks.

> I walked up to the counter and asked if I could see somebody about getting a loan. They brought me a man named Jack Henry, or John Henry, who was an assistant cashier. He looked at me and said, "What can I do for you?" I said that I was wondering if I could borrow a little money. Suddenly, without thinking, I blurted out two hundred dollars. He loaned it to me. A week or two later, he walked into my office and asked if I could design a house for him. I'm sure, he thought, the loan would be more secure if I had some business, that he might have some chance of getting his money back! That was the first house I ever did, one that was actually built. Must have been 1949. He was a very nice guy who helped start Metro, which cleaned up Lake Washington, and became a prominent man about town.

In 1962, Bassetti's firm was still struggling. "The only commission it had was the Yamasaki Science Center for ten thousand dollars," he told *Seattle Times* columnist Emmett Watson. "I don't mean the Science Center itself. Somehow the model of the Science Center got damaged and we were hired to fix it. Then we hit it big. For the next few years we had contracts to design some $200 million worth of buildings. Then came the Boeing crash in 1969, and we lost it all overnight."

Bassetti had strong ideas about architecture, and about cities in general. He liked to quote his old friend Ibsen Nelsen with whom he spent many lunches: "Ugly buildings, streets, and neighborhoods are excellent backdrops for ugly behavior." Although Bassetti didn't disdain high buildings— he had designed enough of them—he knew full well the kind of concrete canyons they can create, a special kind of ugliness.

In 1966, Bassetti wrote an article in *Puget Soundings*, the excellent monthly magazine of the Junior League of Seattle, decrying the slavish fol-

lowing of fashion or trends, especially by clients whose primary knowledge of architecture, he said, comes from *Better Homes and Gardens*. "A dominant trend in building designs today is what architects call 'Miesan modern': glass walls, no shadow lines, stark and often forced simplicity. This is a trend begun by Mies van der Rohe and extolled by the critics. . . . Judge for yourself if this fashion has anything to do with people. In the hands of an artist, a spark of life is often present . . . but the hundreds of all-glass banks that have copied it are merely banks with glass walls. Another major trend is often called 'brutalist.' Its hallmark is rough, unpainted concrete, which, when used in a responsive way, is a material of great versatility, but becomes tedious and dreary when outward effect is sought."

> *My memories are of endless meetings," Bassetti says of those days, "but it is true as things went on, lots of things occurred. My wife tries to get me to relax and be more moderate, but I think we should all stand up and be counted on those things. Why be so quiet? It's our city.*

Bassetti is a humanist. "Everything really depends on heart, character, inspiration," he said. "Who would go to Paris if it weren't beautiful? Or to Venice! Good God! I don't know why the politicians don't realize that, why beauty is so important. Who would go to the movies if they didn't have some beautiful women to look at, or handsome men?" A constant refrain throughout Bassetti's public life has been "the need to humanize our cities. Seattle must make the city more congenial to people. The city is people. Chinatown in San Francisco is not buildings but 100,000 people. Seattle must survive as a core city because it supports the whole area. None of the suburbs can exist as a cultural entity."

In his long career, Bassetti fought—in an "articulate, candid, and uninhibited" way, according to that most unfettered of journalists, Ed Donohoe, who had a column, "Tilting the Windmill," in the *Washington Teamster*—for balance and scale in architecture and urban planning. To fellow architects on the different side of the aisle in 1968, Bassetti asked in a fiery letter, "Can we not learn . . . to proceed slowly, respecting our ties with the past, however tenuous, knowing that the uses of the past should influence our develop-

ment of the future? The old buildings—even those without architectural merit, the vast majority—will enhance whatever we build in our time."

In 1968, the Seattle Chapter of the American Institute of Architects, which Bassetti chaired, unveiled a year-long study called "Action: A Better City." It was an ambitious plan that looked at public transportation, the Market, Pioneer Square, Westlake Mall, Lake Union, public parks, and Elliott Bay. It called for the establishment of a fifty-two-acre park in the Denny Regrade, not far from the Commons proposed in the 1990s. In his introduction, Bassetti wrote with customary passion, "Seattle, a favored spot, haunted by memories of an Indian past, a lumbering past, a fishing past, by the ton of gold, by fire, remembering corruption and zeal of reformers, remembering Chinese riots, vigilantes and strikers, the town with guts enough to build two World's Fairs, the airplane place, with two kinds of waters, with hills and trees; Seattle, the place in the upper left-hand corner, is your place. . . . Much about Seattle is right, but an equal amount is wrong—who can rest

Fred Bassetti

until the balance is improved. . . . The nearer we approach a truly human city, the nearer we may come to truly civilized behavior." In her essay on Bassetti on HistoryLink.org, Marga Rose Hancock, former acting director of Allied Arts, wrote, "Many credit the civic conversation that *Action: A Better City* helped ignite as a major influence in the city and the plans and buildings that shaped it."

Bassetti had a long list of leadership roles that he played in the civic life of the city, including Forward Thrust, the Seattle Landmarks Commission, the Seattle Design Commission, and Allied Arts. What could have been a more perfect fit than Allied Arts, with its multiple activities, all designed to make Seattle a better place to live and work, and Bassetti, with his concern for human scale in planning, his support of artists, and his appreciation of the need for low-cost housing and historic preservation.

Bassetti's accomplishments as Allied Arts' president were astounding. In his first month in office, he strongly objected to a garish, badly designed Holiday Inn at Seventh and James. Six month later, the corporation gave up on that design. Bassetti urged six lanes on I-90 instead of ten. And as the months rolled by, he continued the tradition of champagne breakfasts in the Market to support the preservation of the Market; lobbied for legislation that would allow eating and drinking on Seattle streets, which was enacted; continued the fight to save Broadway High School, which ultimately failed; saved the old fire station in Ballard; joined in a critical report of the architecture and design of the Port of Seattle, chaired by Ralph Anderson; appointed a committee to study Fort Lawton, which eventually became Discovery Park; inaugurated the Survival Series of chamber ensembles; began opposition to skybridges in the central business district; planted trees at the Market; decided to sponsor a Joffrey Ballet residency, along with Pacific Northwest Ballet in its most nascent state; formulated plans for Occidental Park in Pioneer Square; cosponsored with the Henry Gallery an exhibition of art in public places; published *Art Access*—a directory of arts organizations; continued to support Friends of the Market, which was born and nurtured under the umbrella of Allied Arts; began with the American Institute of Architects a conference on public art, which some consider the beginning of publically supported art; and sought to influence the development of South Lake Union.

In the late 1960s, when the future of the Pike Place Market, as we know it today, was in jeopardy, Bassetti was among those who opposed, in a gesture of defiance to the establishment, a thirty-two-story apartment build-

ing, parking for five thousand cars, and over 300,000 square feet of office space. Such buildings would have made the Market "a refugee—isolated and set adrift in an alien environment," to borrow a telling phrase from Jack R. Evans in his small but informative tome on the market, *Little History of Pike Place Market*. From today's vantage point, one sees only the rightness of Bassetti's position, not the danger it held to his professional life, as he opposed the very people who had the means to provide him with lucrative contracts. "My memories are of endless meetings," Bassetti said of those days, "but it is true as things went on, lots of things occurred. My wife tries to get me to relax and be more moderate, but I think we should all stand up and be counted on those things. Why be so quiet? It's our city."

About Bassetti, David Brewster, a leading journalist over several decades, as well as a publisher, civic leader, entrepreneur, and all-about gadfly, wrote a fitting testimonial. "In those early days of Seattle reform politics, starting in the late 1960s with the effort to save Pike Place Market and to toss out the greybeards of the City Council, Bassetti was a key figure, along with his great architectural buddy, the late Ibsen Nelsen. They were early, loud, persuasive voices for urbanism and urban planning and Seattle owes a great deal to their advocacy. There was more at stake than saving old treasures like the Market and Pioneer Square, funding the arts and making streets pedestrian-friendly. Bassetti was a leading advocate for the kind of humane modernism that lay just outside the more severe modernism of the European heartland."

8 / Marching to the World's Fair and Seattle Center

THE WORLD'S FAIR AND THE SEATTLE CENTER CELEBRATED their fiftieth anniversary in 2012, with the customary speeches and fireworks. The World's Fair and the simultaneous creation of a civic center were seminal events in Seattle in the past century. They marked an awakening of the city's potential and a watershed in its cultural life. Professional theater and opera by resident companies burst upon the scene, dance came a decade later, and the Seattle Symphony, a part-time endeavor, began to transform itself from a pedestrian regional orchestra into the orchestra that it is today. Art exhibitions organized for the Fair were a revelation to those who had been exposed only to Northwest and Asian art. All sorts of art exhibition spaces were to follow. It was remarkable that the collective consciousness of the city not only had the ambition to create a World's Fair but also the determination to do so on a level well beyond a glorified clam bake. This was a coming-of-age for the city and its citizens. "I'm now convinced," wrote editor-writer Knute Berger in 2011, "that 1962 was a major turning point in Seattle history. Not because what was predicted then for 'Century 21' came true—much of it did not—but because events of the year shifted the perception of Seattle from a port city in the wilderness to a city on the cutting edge of change, finding its place in the world. The year left us a legacy of seeing ourselves more clearly."

The beginnings came in the early 1950s, just about the time the Beer

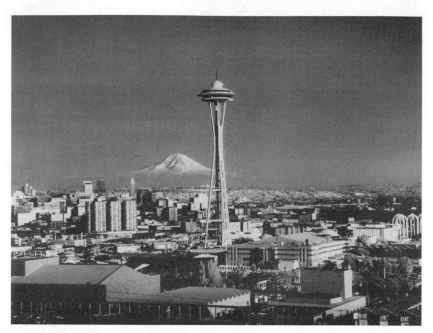

Aerial view of Century 21 Exposition grounds, with Mount Rainier in background, 1962. University of Washington Libraries, Special Collections. Photo by Seattle Convention and Tourist Bureau.

and Culture Society, that group of irreverent architects and lawyers, professors, and the well-connected, began to hold meetings about what to do with their beautifully situated but culturally unsophisticated Seattle. In 1954, the group gave themselves a more dignified name—Allied Arts of Seattle. Several new ideas for civic development circled the city at once, primary among them a statewide fair to mark the fiftieth anniversary of the Alaska-Yukon-Pacific Exposition of 1909. Very soon the notion was transformed into a Century 21 Exposition that would look to the future instead of the past. The state got involved for five thousand dollars, and civic leader Edward E. Carlson was appointed chairman of the commission. Another group was formed with the intent of creating a civic center at which cultural and community activities could be held. Seattle businessman Robert Jackson Block, a former president of and key figure in Allied Arts until his death, was appointed chairman of the Civic Center Committee by mayor Allan Pomeroy in 1954. Its mission was to come up with plan, and after two years it did.

Several locations, both inside and outside Seattle, were considered. The first bond issue of several to come before the public was the proposal to buy land for an arts center on First Hill, including a "concert hall/opera house." The lower Queen Anne area, where the Seattle Center is presently located, was going to be for sports. The two activities seemed incompatible. Block issued an urgent plea in the *Seattle Times*, "Time has never been so important to backers of the civic sports and arts centers. The First Hill area, which has been chosen as the best available site for the arts center, may be lost to us if it is not purchased soon by the city. The Civic Auditorium [later converted to the Opera House, now McCaw Hall], where we propose to build a coliseum as the hub of a sports center, may be restricted through rezoning of residential lots to business use. Seattle's community facilities for sports, cultural activities, convention and public administration functions," he added, "are most inadequate. The founders and early settlers of Seattle moved entire hills to make a city. Certainly we can solve the financial and organizational problems which a civic center would entail."

A building permit had already been issued for an apartment complex at Terry Avenue and Cherry Street, where the arts center was proposed. The First Hill site was estimated to cost four million dollars, and the Queen Anne site, two million. The "opera house/concert hall," with a seating capacity of 3,500, was projected to cost an additional $2.5 million. The total was projected at $8.5 million, although eventually it went substantially higher, with the addition of a five-hundred- to eight-hundred-seat theater and parking facilities. "We have packaged these elements together for a bond issue," said Block. Since the Seattle City Council was reluctant to move forward, the committee decided to launch an initiative effort to get the arts center on the ballot. Unfortunately, there was a competitor for the funds: $4.5 million were wanted for a new building for the Seattle Public Library. Together the two projects exceeded the city's ceiling on bonded indebtedness for civic improvement. Block was not overly concerned. He urged all parties to go forward with their individual campaigns. The financial issues, he said reassuringly, could be resolved at a later date. At its Second Congress, or annual meeting, Allied Arts approved the double package with some fanfare, but to no avail. Neither succeeded at the ballot box.

Carlson invited Block to a meeting to discuss their ideas—a civic center and a World's Fair. Block immediately agreed that the two efforts should be joined together, which resulted in what would be called "a civic center disguised as a world's fair." A new committee, with thirty-nine members, was

City and Seattle Center from Queen Anne Hill, 2012. Photo by Roger Schreiber.

formed. It was called the Civic Center Advisory Commission, and Carlson was appointed chairman by Governor Arthur E. Langlie.

Among the new committee's first decisions was where to locate the fair/civic center. Many sites were considered, among them First Hill, Fort Lawton (now Discovery Park), Sand Point Naval Air Station (now Magnuson Park), Green Lake, Woodland Park, Newport Bay, lower Queen Anne, Lake Sammamish, and Union Bay. Historian Murray Morgan quoted Carlson, saying, "There are two facets to this project. One is long-range development for the city, and the other is to do a job as far as the world's fair is concerned. There is real justification if, out of the fair, the city and the state can get some permanent buildings. Time moves rapidly. If I had to make a decision as to the most important aspect of our work, I would sacrifice other things in order to get some long-range benefits. . . . It seems ridiculous that a community would undertake the expense and the effort to build a fair and then afterwards to tear down all the buildings."

Among the first decisions the commission made was to jettison the projected golden anniversary of the 1909 Alaska-Yukon-Pacific Exposition in 1959—there wasn't sufficient time to plan it. In 1956 another bond issue

Marching to the World's Fair

was put before the public, this time for $7.5 million, with $2.5 million for land (thirty-five acres, later expanded to seventy-four) and $5 million for facilities that would include the conversion of the Civic Auditorium into a 3,500-seat opera house, then called an "opera house/convention center"; the construction of an 800-seat theater; parking; and landscaping.

Members of Allied Arts and scores of others, under Block's leadership, were deeply involved in selling the issue to the voters. Allied Arts, when needed, was a constant supporter on the local and state level, particularly in the face of doubters (of which there were plenty), and was free with

Pacific Science Center and Yamasaki Arches, 2013. Photo by Roger Schreiber.

advice in terms of site location and the scale of the Fair. In the spring of 1957, the voters voiced a collective yes, and the Civic Center Advisory Commission was created. One of its concerns was that the Fair "be for the enduring benefit for the city, state, and the nation." The state legislature subsequently approved funds for new buildings.

Consideration had to be given to what buildings to preserve, and the Civic Center Auditorium, the National Guard Armory (now the Armory), and the Memorial Stadium were chosen. The rest of the houses and buildings on the seventy-four-acre site would have to be torn down. There were few objections. Considering the cost of building a new opera house/convention center, it became readily apparent that converting the auditorium into an opera house would be a much cheaper alternative. B. Marcus Priteca, of movie theater fame, and James Chiarelli, a Seattle architect, would be in charge. A few objected, most notably Seattle attorney Alfred Schweppe, who charged, among other things, that the bond issue did not say "remodel," so monies from it could not be used to covert the six-thousand-seat auditorium into a three-thousand-seat opera house. He brought three lawsuits. He lost on all counts. Shortly after the last case was settled, Century 21 and the

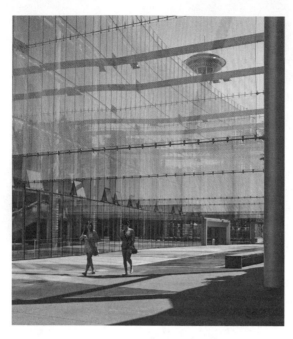

McCaw Hall. Photo
by Roger Schreiber.

World's Fair Commission agreed to postpone the opening of the Fair to the spring of 1962 to attract more exhibitors. Ultimately more than sixty nations were represented.

What became the symbol of the Fair, and eventually of the city, was a six-hundred-foot tower originally sketched by Carlson on a cocktail napkin that was inspired by a television tower with a restaurant at the top in Stuttgart, Germany. A tripod of paired legs (the Eiffel Tower in Paris has four) was designed by Seattle architect and Allied Arts stalwart Victor Steinbrueck, who had been called in to act as a design consultant, along with John Ridley. No public money was forthcoming, so leading businessmen and private money took over. Contributions were made by Bagley Wright, David E. Skinner, Norton Clapp, John Graham, Jr. (who also contributed to the design of the Space Needle), and Howard Wright, Sr., and Howard Wright, Jr. The two construction companies of Graham and the Wrights (both family enterprises) jointly built the Needle. The men called themselves the Pentagram Corporation. Wright's grandchildren now own the tower.

Soon houses and buildings were torn down to make way for the Fair. Construction of the Coliseum (which became the Key Arena), designed by Seattle architect Paul Thiry, was begun; a design by Tokyo architects Hideki Shimizu and Kazuyuki Matsushita was chosen for what was called the

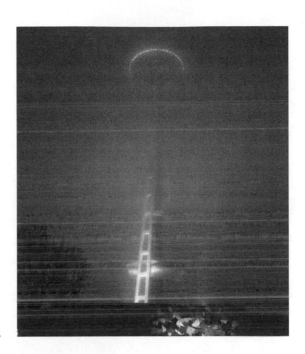

Space Needle in fog.
Photo by Roger Schreiber.

International Fountain; ground was broken for the Monorail and the Space Needle; a two-million-dollar contract for an amusement park was signed. The Seattle Center Playhouse, future home the Seattle Repertory Theatre, was begun, as well as the renovation of the Civic Auditorium into the Opera House, which would be the home of the Seattle Opera (born of the World's Fair), as well as the Seattle Symphony. The Pacific Northwest Ballet came a decade later. The striking all-white United States Science Pavilion, designed by Minoru Yamasaki, the most notable piece of architecture associated with the Fair, rose in the place of several dozen structures that had been demolished.

High culture was well represented. The performing arts were in the Opera House (the original "convention hall" designation was gently but firmly pushed aside by Cecilia Schultz, an impresario of the old school and Allied Arts trustee) and the Playhouse (soon to be the home to the Seattle Repertory Theatre and later the Intiman Theatre after the Rep moved to the newly constructed Bagley Wright Theatre). They were filled with some of the most important artists and groups of the day, all organized by Harold Shaw, an impresario once associated with Sol Hurok. Shaw later became a leading artists' agent. Art exhibitions concentrated on contemporary work by important American artists, most of whom had not been seen in Seattle

previously, as well as old masters. The art was a revelation to most people living in Seattle—an epiphany that would have short-range and long-range implications. Seattle had seen first-class musicians and dancers in the past, but they had mostly been imported. The World's Fair stimulated people who lived here to begin and sustain their own institutions. Shaw was criticized by some for being too highbrow, but he brushed aside the criticism. He knew what he had accomplished, all in barely more than a year, which in the world of booking major talent is very little time. In other facets of the performing arts, there was some criticism of scantily clad showgirls. It would seem there was a problem of not enough sex or too much sex, wrote Paula Becker in her three-hundred-page account of the Fair, titled *The Future Remembered: The 1962 Seattle World's Fair and Its Legacy.*

Naturally, a major hurdle was finding money to fund the whole enterprise. The original $7.5 million from the bond issue would barely pay for the original plan, but it was a start. In the end, more than $80 million was raised, according to Joseph Gandy, Seattle attorney and auto dealer, who succeeded Carlson as chairman, in an article in that superb little magazine published by the Junior League of Seattle, *Puget Soundings*. Another $2.5 million came from the city's general funds, an additional $14 million in land and buildings, and $3 million from the state for the Coliseum, money that was returned postfair, and there was also a grant of $7.5 million that did not have to be paid back. For the science pavilion, "the most extensive science exhibit ever assembled," the federal government authorized a total of $21.5 million. Private capital contributed nearly $37 million.

Millions of people across the globe visited the Fair, spurred by the public relations campaign of the indefatigable Jay Rockey that secured, among other things, two *Life* magazine covers. The Fair energized the city. The six-month event, run so successfully by Ewen Dingwall, had hardly opened when discussions began about postfair possibilities for the grounds and the buildings on it. What to do was a matter of opinion, although the city had already decided that the World's Fair would evolve into something that would last and would be called the Seattle Center. But details were murky. Allied Arts had concerns about the space being commercialized, which, if nothing else, notified city officials they were being watched.

One of the most controversial proposals was to keep the fence around the grounds, an idea to which Allied Arts strongly objected. Wheeler Gray, a Seattle attorney and chairman of Post-Fair Unlimited, a nonprofit organization chartered a few days after the Fair opened in 1962 to look after the

Fair, asserted that Allied Arts' fears about the fence around the Fair were premature. Perhaps, but the issue pinpointed a civic concern: not to forget the integrity of the Fair. Post-Fair Unlimited was founded by sixteen civic leaders, including Carlson, who were dedicated to keeping attention on the region after the Fair closed and to "achieving maximum long-range benefits from the fair," according to a story in the *Seattle Post-Intelligencer*. Gray said, "We have scheduled our first planning sessions . . . [and] no one has said anything about retaining a fence, charging admission or creating a permanent amusement park. We don't know ourselves what we will propose. Our primary aim is to promote fullest use of the facilities and grounds in the center. It should be a non-commercial operation, run as economically as possible. . . . One of our largest problems will be financing a year-round program for the center. . . . However, when it comes to a practical discussion of fences and admission charges, you have to admit you can't make a flat rule against them."

Two councilmen, Charles M. Carroll and J. D. Braman, said that they would support an amusement park proposal. Frederick S. Street, president of Frederick & Nelson, the leading department store of the day, and a key figure in the Fair, said in a statement in 1962 in the *Seattle Times* that "money-raising activities that can be conducted on the site can make everyone secure" and that an amusement park, if properly developed, "would be like adding another industry to our economy." Of course, that never happened.

In a statement issued in June 1962, Allied Arts called on the mayor and the city council to observe the intention of the 1956 Civic Center bond issue, "which provided for the acquisition of land for a center, a concert-convention hall, and a multi-purpose auditorium to be used for young people's programs, musicals, lectures and recitals." The statement continued, saying that there was no mandate for the center to be operated on a commercial, profitable, or self-sustaining basis. Other points in the Allied Arts statement included the removal of the fence around center grounds and the general admission fee, that the center be left in the city's hands, and that rental fees be reasonable. Allied Arts asked the council to hold a hearing on those issues.

Allied Arts was not the only organization to be concerned that the Seattle Center would be transformed into a hurdy-gurdy amusement park or "Coney Island West," to borrow a phrase from Louis R. Guzzo, columnist for the *Seattle Times*. So was the Municipal Arts Commission, forerunner to the Seattle Arts Commission. "I am not alone in pressing the alarm button,"

Chihuly garden and glass, 2012. Photo by Roger Schreiber.

Guzzo wrote, "It is easy to fall under the spell of a world's fair atmosphere and to believe it can be sustained forever. . . . But the 'Never-never land' is only a temporary delight. Sooner than later, its glitter would wear thin and its sweets dull. . . . Seattle needs an imaginative top-quality amusement park, but it should go somewhere other than in the new center."

The idea of turning the fairgrounds into an amusement park died fairly early on, although a series of carnival and rides occupied a corner of the Fair at the foot of the Space Needle for nearly fifty years. In the summer of 2012 came something very different: an astonishing three-exhibit powerhouse by glass artist Dale Chihuly, funded by the Space Needle Corporation.

The future of the Seattle Center has been the subject of discussion and controversy for most of the past half century, with even Disney World, the consulting arm of Disney, coming up with a very grand and very expensive plan ($335 million) to reconsider the center in the 1980s. It did not succeed. There were other plans as well. Margaret Pageler, a president of Allied Arts,

thought that "one of the worst mistakes of the Disney planners was that they didn't start their study by finding out what features of Seattle Center people really cared about and will insist on saving." Such a survey indicated that most people liked the center as if it was, despite the fact it operated at a substantial loss. Money was authorized and private money found for general maintenance and for new projects such as the Bagley Wright Theater; the Seattle Children's Theatre; the Phelps Center (the administrative headquarters and rehearsal space for Pacific Northwest Ballet); the transformation of the Opera House into McCaw Hall; the great, sweeping lawn anchored by Alexander Liberman's *Olympic Iliad*, a giant, ebullient sculpture in lipstick red, funded by arts patron Virginia Wright and others; and the Experience Music Project, a tribute to native son Jimi Hendrix in particular and rock music in general, funded entirely by Hendrix fan Microsoft cofounder Paul Allen. Despite grand plans, redevelopment occurred slowly and piecemeal. The need for money was, and is, ever-present.

Many of these developments occurred without Allied Arts' help, except for the occasional position paper and nudge of support. The organization issued a statement in 1970 that outlined many of the ideas that eventually took root. An important one requested that preference be given to resident organizations in renting center facilities. Allied Arts also advocated for a greener center.

There was one notable exception to Allied Arts' surefootedness: Pentagram's proposed addition of a sixty-thousand-square foot structure for meetings and dining at the one-hundred-foot level of the Space Needle in 1978. Allied Arts, led by Victor Steinbrueck, fought that proposal with everything at its command. The battle raged in the press and city council chambers, from King County Superior Court to the Washington State Supreme Court. In the end Pentagram won. Today the fight seems irrelevant in that the eye quickly travels beyond the one-hundred-foot level, making the addition a matter of little consequence to the whole. Not many people seemed to care about it at the time, and no one does now. The architectural integrity of the Needle remains intact, and people continue to flock to the restaurant and observation level at the top and the souvenir shop at the bottom.

At the beginning of postfair life, Block asserted that the city had to think "boldly and vigorously." Ideas were always plentiful, even grandiose, but money was not. Yet the center has continued, growing, changing, step by step, and has never looked fresher or more imaginative.

9 / Robert Jackson Block

MANY OF THE BRIGHTEST AND MOST IMAGINATIVE VOICES IN the Seattle landscape for the past half century were born elsewhere, but Robert Jackson Block—a trustee with Allied Arts from its earliest days until his death in 1996, president in 1960, and founding president of the Allied Arts Foundation—was a native. There was no one like him in the city. He was a congenial and generous host, and his dining room was filled with all sorts of people almost every night, well before the concept of inclusivity became fashionable. Block was a prime mover in efforts to clean up Lake Washington in the 1950s and played a major role in the citywide effort to create what is now known as Seattle Center and its forerunner, the 1962 World's Fair, which transformed the cultural life of the city. He helped engineer the first $7.5-million bond issue that authorized the city to buy land for the World's Fair and subsequently the Seattle Center. He could be irascible and provocative, combative—a curmudgeon, according to one friend—but no one ever accused him of being boring, to borrow a phrase from his widow, Mary Lou Block.

Block had an impressive resume. He attended Lakeside School, then Stanford University for two years until the imperatives of World War II beckoned. He was a writer-photographer for what he called "a primitive paper" and edited *Bomb Rack*, both published by the US Air Force in the South Pacific. He planned to return to Stanford after the war, but his father, Max, lured him away from academe with an offer of five hundred dollars a month to help manage the family chain of shoe stores, founded by his

grandfather in a Pike Place Market stall. "It was a bribe," he told Michael Conant in a 1989 *Seattle Post-Intelligencer* profile. "In those days $500 a month was like $5,000 a month now." In his twelve years with the company, 1946–1958, it expanded from twenty stores to forty-two stores in six states. Block became CEO in 1954. After the company was sold, Block went into investment banking, acquiring Columbia-Cascade Securities Corporation, which merged in 1977 with National Securities Corporation; he was president and chief executive officer until his retirement in 1993.

Bob Block. Photo courtesy of Ernalee Thonn.

Among his most telling comments was his attribution of his family wealth to propelling him to get involved. "I was born with silver spoon in my mouth. I had the best of everything. I thought I, and others like me, could make significant contributions." And so came Allied Arts, along with the March of Dimes; the American Jewish Committee; the Pilchuck Glass School, of which he was a founding trustee; chairmanship of Cornish College of the Arts; the Seattle Parks and Recreation Board; the Multiple Sclerosis Society; the Seattle Public Library Foundation; the Seattle Psychoanalytic Institute; Temple De Hirsch Sinai; the Seattle Arts Commission; the YMCA; the King County USO Committee; the Metro Campaign Committee, of which he was cochairman and the Civic Center Committee, which he chaired.

After Block joined Allied Arts, he wasted no time making his mark. He helped sponsor a thirteen-part television series on KCTS on the state of Seattle's arts and urban environment. He led the organization to save the Seattle Hotel, a remarkable-looking building in the heart of Pioneer Square, shaped like a triangle, that had been slated for demolition to make way for a parking garage. The effort failed, and the garage is still there, as obscene as ever. The first Westlake Mall Arts and Crafts Bazaar was held. Most importantly, Block hired Alice Rooney as a part-time executive secretary, who stayed twenty years, eventually becoming full-time executive director

and the soul of the organization. With Alice at the helm, Allied Arts became more orderly. "Allied Arts runs on a lean fuel mixture," Block told Jean Godden, then a columnist for the *Seattle P-I*, in 1985. "I took office in 1960. That year, we raised dues from one dollar to ten dollars."

Block's friends were fond of saying things like, "Bob did not merely enlist in these various causes, he tackled them with relentless commitment." Llewelyn G. Pritchard, a former Allied Arts president and longtime friend, said, "He asked the tough questions, connected to people in different constituencies. He always spoke his mind in a very clear and cogent manner and did not suffer fools gladly."

Block was deeply involved in Democratic politics, both local and national. It was once said of him that he was on a "first-name basis with nearly everyone in political life." He and Mary Lou's annual fall brunch at their spacious house on Capitol Hill, to which dozens of people were invited, was called "the start of the liberal season in Seattle" by Allied Arts trustee Carol Barnard Ottenberg. The couple also often hosted meetings of the Allied Arts board of trustees and threw parties to foster good will for a particular cause or simply to foster goodwill for the organization. One party they did not give at their house was Block's seventieth birthday party, which was thrown at the Rainier Club for four hundred people.

In the late 1990s, Allied Arts hosted a banquet to give awards, "Allied Arts Honors," to various notables in the city. There were six categories, three of them named after crucial figures in the organization, including Alice Rooney, executive secretary and director for twenty years: "Generous Service to the Arts"; for Victor Steinbrueck, credited with leading the charge to save the Pike Place Market: "Tenacious Civic Activism"; and for Block: "Visionary Leadership in the Arts."

Among Block's most important contributions was his involvement in what was known as Metro—the Municipality of Metropolitan Seattle— formed to reduce water pollution in King County. The group's first meeting was held in 1958. At the time, fourteen towns in the county discharged twenty million gallons of raw sewage into Lake Washington. Although pollution was Metro's first issue, transportation and planning were also on the agenda. Seattle lawyer James Ellis is remembered as the father of Metro.

The first attempt by a civic campaign to approve a bond issue to provide sufficient monies and a regional governmental body to administer them was defeated at the polls. The second attempt, Block said in an interview, was a widely distributed poster of five Block children (Mary Judith was not

yet born) looking forlornly at the badly polluted Lake Washington, a health hazard to people as well as wildlife, with the sentence "We said to hell with facts and figures—let's go with guts." That successful campaign was among the first of people's initiatives to change the course of public discourse in Seattle, and the livability quotient for which the city earned a national reputation.

Metro spurred Block's interest in regional government in order to eliminate waste and the unnecessary duplication of services. "I was very depressed at the duplication in government, law enforcement, alcohol treatment, the courts, streets, and sewers," said Block. "What we have is government by Band-Aid." He was elected to a kind of a freeholder body—"I have always been good at getting nonpaying jobs"—that rewrote the King County Charter, replacing the old three-man commission with a county executive and a county council.

In those days, Seattle had numerous leaders we loved, loved to hate or hated to love, and Robert fit beautifully.

Block attempted public office several times, all of which were unsuccessful: port commissioner, King County executive, and twice the Seattle City Council. In 1964, the polls for the council race indicated that he was ahead. Then a well-financed campaign at the last hour accused Block of being a Communist because of his association with the American Civil Liberties Union. At the time, such an accusation was in itself the kiss of death. "Bob Block has done a lot more good by not being elected," said Jerry Hoeck, a Seattle public relations man, who helped sell the concept of Metro to the voters. "He's the catalyst and the yeast that makes things happen. Bob's never been afraid to get out in front, no matter what the odds."

Interwoven among all of these activities were two major blows. The first came in 1952 when Block was struck down by polio. He spent several months in an iron lung, alongside Peggy Golberg, who became a close and lasting friend. Although the effects of the disease plagued him the rest of his life, for Block "it was always thumbs up," said his old friend Ancil Payne, president of King Broadcasting, in a *Seattle Times* story. "He refused to complain. He'd have no part of it." Payne remembered visiting Block the last week of his life, when he was barely able to breathe yet yelling about who should be governor. "Nothing ever quieted Bob completely. He loved Seattle. He loved conflict." The second major blow came in 1961, when Block's beloved wife

Bob Block with Mary Lou Block at his stepdaughter's wedding, 1979. Photo courtesy of Mary Lou Block.

and mother of his six children, Dorothy, a remarkable individual in her own right and active in community affairs (*Seattle P-I* columnist Douglas Welch liked to call her "Green Eyes") died of a brain tumor.

Among his many civic contributions, Block is remembered for his role in the 1962 World's Fair, which eventually became the Seattle Center. A couple years after the onset of polio, Block was encouraged by his wide circle of influential friends to take on the chairmanship of the Seattle Civic Center Committee, which was the first chapter in what became the Seattle Center and the World's Fair. Allied Arts, led by Block, took an active part in that campaign, stirring public interest and support.

In 1960 Allied Arts came up with an interesting idea, which Block, then president, had the assignment of selling to the Municipal Arts Commission, the predecessor of the Seattle Arts Commission (now the Office of Arts and Cultural Affairs), as a "project of projects." Block said, "The general idea is to make a city-wide survey to determine what sites are available or could be made available for fountains, sculptures, murals, small parks, especially landscape areas—or even theaters, museums, etc." The important factor

was "to sensitize people to do themselves what we would like to do with their money. . . . The survey might take a couple of years or more to complete, but it would be worth every hour spent on it." The survey ultimately never took hold.

Unquestionably Block's enduring legacy was his cofounding of the Allied Arts Foundation in 1968—along with Jerry Thonn, who did the legal work—and largely financing it. It is the only regional foundation completely dedicated to the arts. Over the past nearly forty-five years, it has funded dozens upon dozens of groups—just about every small- and medium-size organization, even a few large ones. It also acts as a funding conduit for groups that have not yet received their tax-deductible status from the Internal Revenue Service. Every former president of Allied Arts becomes a trustee. Unlike Allied Arts itself, the foundation is still fully functioning, making all sorts of grants to groups and individuals.

Its original mission, according to Thonn, was to act in a supportive role to Allied Arts of Seattle, which had 501c(4) tax status, by providing tax-exempt status for fundraisers; to make small grants to artists, giving particular attention to the proposal's relationship to the overall Allied Arts mission, artistic quality, and the likelihood that the small grant would make a difference; to provide umbrella status or a financial conduit for organizations and individuals without 501c(3) status, for which the foundation charges a ten-percent administrative fee and represents a steady source of income. Foundation president Karen Kane calls this last category "sponsorships." The tax reality was that gifts to Allied Arts were not tax deductible, because of its lobbying activity, which consequently inhibited all kinds of giving. Thus the need for the foundation's 501c(3) status, under which gifts are tax deductible.

Allied Arts Foundation's mandate has not changed dramatically. It still helps those for whom funding from more conventional sources is either difficult or impossible. It acts as a conduit for private donations and grants from the National Endowment for the Arts, Washington State Arts Commission, 4Culture (formerly King County Arts Commission), and the Office of Arts and Cultural Affairs. It is an umbrella organization for those not ready to stand on their own, for which it receives a fee. There is also repeat business, said Kane, with groups that do not want to take the time or trouble to get tax-exempt status and who come to the foundation periodically in order to qualify for grants. The foundation awards to individuals as well. On occasion it initiates projects of its own—for instance, the planting of trees

on Seattle streets; the Betty Bowen Viewpoint on Queen Anne Hill and the sculptures that were commissioned for it; and the publication of the book *Impressions of Imagination: Terra-Cotta Seattle*, which documents Seattle's architectural heritage.

In its thirty-five-year history, the foundation has dispersed more than $400,000 in direct grants and pass-through support to dozens of individual artists and small arts organizations in the Northwest. Some were large and established, such as the Seattle Symphony, the Seattle Repertory Theatre, Cornish College of the Arts; others in the next rank of size include the Intiman Theatre, the Artists Trust, On the Boards, and the Pratt Fine Arts Center. The list of small organizations is long and impressive, covering every art form—and some barely imagined. The sad part of looking at the list now is seeing how many of those groups are no longer in existence. They included organizations such as the Philadelphia String Quartet, Empty Space Theatre, Alice B. Theater, Co-Motion Dance, Friends of the Rag, New City Theater, Marzena, Allegro, Whistlestop Dance Company, 911 Contemporary Arts Center, and Greywolf Press. Individuals who have received grants include Robert Davidson, Maxine Cushing Gray, Karl Krogstad, Lorenzo Milam, Mary Randlett, and Robert Sund.

Every year the foundation makes grants in the visual and performing arts to graduating seniors from thirteen Seattle-area high schools. The amount of the award is small, but recipients also get a "recognition certificate," which can be used as leverage to secure other grants. The foundation also makes money available for hospitals to create a cart of art supplies that is taken around to patients, especially children. "That has become a staple," said Kane. Over the years, the foundation's assets have grown because of major gifts from Block and other major donors, such Mary Elizabeth Gleed, an ardent arts supporter. The endowment now stands at about $235,000.

After a lifetime of struggle with his health, Block died in 1996. At his funeral service, Payne remembered Block as

> a token member of the business community, an iconoclast, a liberal with
> a conservative economic philosophy, a leader never short of opinion or
> breath. . . . From time to time he might have been wrong, but he was never
> in doubt. I was asked by a reporter how an individual such as Robert
> could have been a leader in a "laid back" city like Seattle? I explained that
> before the days of yuppies, guppies, and double lattes, Seattle had a saltier
> character and more readily responded to strong opinions and activist

Robert Jackson Block

concerns. In those days, Seattle had numerous leaders we loved, loved to hate or hated to love, and Robert fit beautifully. . . . He was never a cuddly father figure. . . . Robert Jackson was a happy warrior. He loved the conflict and the battle. His courage, his enthusiasm, his constant denial of pain or frailty, his optimism for life—all set great and good goals we should establish as our own. We mourn his death and we praise his life. Nothing is more beautiful than the love that has weathered the storm of life. Rest happily, Robert.

10 / *Creating Stable Arts Organizations*

MOST WOULD AGREE THAT THE SEATTLE WORLD'S FAIR WAS A watershed in the development of Seattle's cultural institutions. Before the Fair, in 1962, there had been no resident professional theater, ballet, or opera. The Seattle Symphony Orchestra was a part-time ensemble of not-great distinction; it gave only fifty-five concerts a year in the mid-1950s, compared with well more than one hundred in the current season. Since 1891, the Ladies Musical Club brought great musical talent to the city; until it withdrew from presenting because of financial difficulties, there was no older musical organization in the city.

Community Concerts, based in New York, presented music, dance, and drama at a reasonable cost in cities large and small across the United States, including Seattle. Many celebrated artists appeared on the national series at the beginning of their careers. In the 1950s, for instance, Community Concerts presented in one Seattle season the Seattle American Ballet Theatre, the Symphony Orchestra of Florence, and violinist Zino Francesecatti, among others. Traveling opera companies had Seattle on its itinerary, and there were a few who tried to make a go of it, such as the Northwest Grand Opera Company. They were short-lived. There was a lot of theater—the caliber of which is not known—in Seattle around the turn of the century. There was also Theatre Northwest, a place for playwrights to test their new material. Allied Arts often sponsored opening-night parties as benefits for itself

Pacific Northwest Ballet, *Serenade*, 2010, choreography by George Balanchine. Photo by Angela Sterling, courtesy of Pacific Northwest Ballet.

and as a way of ensuring that the house was full.

There was, of course, the Seattle Art Museum, in an art deco building in Volunteer Park that was designed by the noted Carl Gould, that had a small but first-rate collection of Asian art, particularly Japanese, and a miscellany of Northwest and Old Masters. There were the Henry Gallery and the Burke Museum, both on the University of Washington campus, and the privately endowed Frye Art Museum, which exhibited only representational art. And there were a handful of art galleries, some of them superb, such as the Otto Seligman Gallery (of which Francine Seders Gallery is the direct descendent) and the Zoe Dusanne Gallery. There were four artists who dominated the landscape: Mark Tobey, Morris Graves, Guy Anderson, and Kenneth Callahan. According to art collector and philanthropist Virginia Wright, the Contemporary Art Council, based at the Seattle Art Museum, was founded because of the World's Fair, for the sole purpose of exhibiting contemporary art. The University of Washington produced noteworthy opera, with the English-born Stanley Chapple as the director of a mix of professional and student performers. Also on campus was a distinguished

chamber music series called Friends of Music. All of the notable ensembles of the day appeared on the series. There was no professional theater, except for traveling shows. There were, however, widely admired productions at the Penthouse, Showboat, and Glenn Hughes Theaters on the UW campus. Like Chapple's productions, these attracted large audiences, both town and gown.

So, the city was not wholly barren of art, as some were fond of saying. Ask Patricia Baillargeon, among the early trustees of Allied Arts, whose family has a long history of musical philanthropy in the city. East Coast connections have long been a badge of sophistication in Seattle, and Baillargeon has hers, with ties to Eleanor Roosevelt and the pioneering Rockefeller Panel on the Performing Arts in the mid-1960s. What Seattle did not have, according to Baillargeon, were adequate places for the performances of resident companies, "bricks and mortars," to use her phrase. Two important theaters fell to the wrecking ball of commerce. The handsome and acoustically alive Metropolitan Theater was torn down to make way for a drive-in entrance to the Olympic Hotel, now the Fairmont Olympic. And the Orpheum Theatre, home to the Seattle Symphony until the Opera House was built, was subsequently demolished to make room for the Westin Hotel. Fortunately, the Moore Theater, a mid-size house, along with a handful of others, avoided destruction. But the roots for a lively arts scene were in place, Baillargeon concludes, with people open to a myriad of possibilities: "You can't create something out of nothing. There was plenty of activity supported by the city's residents."

Early trustees of Allied Arts were among the most prominent figures in Seattle's cultural life. By design they represented all of the arts in one form or another. Among them was a woman who dressed in a grand style. Her name was Cecilia Schultz. In many ways, Schultz was typical of the quality of trustees in those early years—informed, enthusiastic, willing to work, open to new ideas. She was so important to the city that in 1965 Allied Arts dedicated a suite in the old Opera House as the Cecilia Schultz Room. Schultz was among those who worked hard to get "convention center" stricken from the name of the Opera House.

Schultz had a long run, bringing the best of the best to Seattle, where she had resided since the 1920s. Under various auspices, from the 1920s to the 1950s, beginning with the Seattle Musical Art Society, she presented chamber music concerts and morning musicals, and later matinees and opera teas at the Olympic Hotel. She managed the Seattle Symphony for a

few years, and presented composers in concerts featuring their own music. Her debut as a major impresario came during the Depression, when she presented the baritone Lawrence Tibbett at the Civic Auditorium, which became the Opera House. She took over the Moore Theater, not so rundown then, and managed an artists series for fifteen years. Throughout that time, Schultz ran her own affairs and underwrote all of her concerts. Never did she run in the red. No one in Seattle has since equaled her.

But that was all in the first part of the twentieth century. Not many remember her today, and the Cecilia Schultz Room vanished when the Opera House became McCaw Hall. The Seattle of earlier times was provincial in many ways. Sir Thomas Beecham, the English conductor who spent a couple years on the Seattle Symphony podium, found the city stultifying. Yet Schultz set a standard of artistic excellence coupled with financial acumen. She was no fool when it came to art or commerce.

One wonders whether Schultz would agree with the negative assessment leveled at Seattle audiences by publisher-editor-critic Maxine Cushing Gray, another major figure in the postwar Seattle arts scene, often an ally of Allied Arts—but not always. Gray wrote in the *Argus* in 1961, "The antagonists to solid accomplishments here in the performing arts are formidable: Northwestern complacency, compounded of our geographical isolation and the accessible beauties of our environment; the tendency to let the sensual comforts of music, particularly the orchestra, and the small pleasures of handcrafted objects in the home provide sufficient exercise of our sensibilities. We choose to avoid the jarring experience of thought-provoking plays, the effort and chance involved in seeking out the offbeat but often rewarding performance."

However challenging presenting the arts can be—the streets are littered with those who have tried—building cultural institutions is another matter altogether. Allied Arts exerted less a direct influence than a peripheral one in the creation of Seattle Opera, Pacific Northwest Ballet, Seattle Repertory Theatre, and A Contemporary Theatre. The Seattle Symphony and Seattle Art Museum predate Allied Arts. Ralph B. Potts, onetime president of Allied Arts, claims that he and the Allied Arts were prime movers in the creation of the Seattle Repertory Theatre. Bagley Wright, the founding president of the Rep and its chief financial backer in its early years, emphatically denies that Potts, a rather self-serving lawyer, had anything to do with the founding of the Rep. Period. A fact sheet put out by the Rep that first season gave credit to Allied Arts—not necessarily Potts—as among those who had helped give

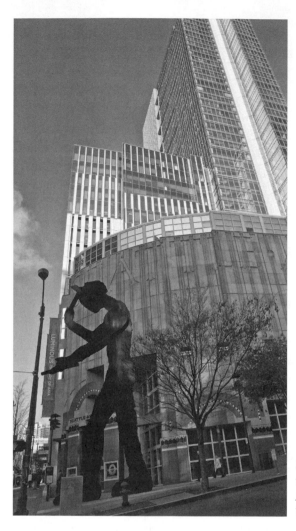

Hammering Man (by Jonathan Borofsky) and Seattle Art Museum, 2013. Photo by Roger Schreiber.

life to the theater. Century 21, one of the organizations behind the creation of the World's Fair, indicated that it would underwrite the Rep's first season. Ewen Dingwall, who managed the Fair, sought someone with brains and a deep enough pocketbook to run the theater. That was Bagley Wright, who did so for years, not only as executive director but also as principal patron. According to Louis Guzzo, who wrote an arts and entertainment column for the *Seattle Times* in the early 1960s, Allied Arts was among a handful of groups whose help was sought in scouting for an artistic director, along with Wright and Robert Block, another Allied Arts president. A fly in the ointment was the objection of some city council officials who did not want

Creating Stable Arts Organizations

to give the Rep priority treatment in the early years of the new theater, saying the theater was built by all the people and therefore should be open to all the people. That point of view, under which no company could survive, did not prevail.

In 1964, Ibsen Nelsen, then president of Allied Arts, wrote Wright a friendly note at the end of the Rep's first season, offering congratulations. "As you know, Allied Arts has a special regard for and interest in the Repertory [Theatre] and would like to support it from every possible way to help guarantee its success and continuance as a living and vital part of our cultural life." Undoubtedly Wright liked Nelsen's idea that Allied Arts would support the notion that the city would provide the building (which became the Playhouse and later the Bagley Wright Theatre) rent-free.

Seattle Opera was born in the aftermath of a production of Verdi's *Aida* during the World's Fair. In a very short time, the fledging company was up and running with a board of trustees and a general director, Glynn Ross, who was born in Iowa. Ross came up the hard way and learned opera in the US Armed Forces, among other places. He mounted shows in Italy, and learned the vagaries of singers and artists as a stage director. Ross was not shy; he was a huckster in many ways, but knew he had to get people's attention to survive. He did that by extraordinary means—and a little hard money. He wanted attention, and he got it. Allied Arts was among those whose good favor the opera company sought as it tried to create a summer festival, beginning with Wagner's *Ring* cycle and to be expanded to a full season of performances in a festival house in Federal Way. No one ever accused Ross of not dreaming big enough. The festival was Ross at his best and worst—best in that he was reaching for the stars, and worst in that the dream had no relation to any kind of financial reality.

In 1976, Sandy Lorentzen, festival administrator, wrote Allied Arts executive director Alice Rooney, asking for a "joint sponsorship along with the Seattle–King County Visitors and Convention Bureau" of a hearing to gauge public support for the idea and the possibility of a thirty-million-dollar bond issue to support the festival. The Festival in the Forest, as the idea was called, was given an extraordinary hard sell by Ross. He skipped normal channels of arts funding, an approach that initially succeeded, and was followed by all sorts of cries from other arts groups that played by the rules. Festival press materials of 1974 stated, "A completed theatre could become a reality." The inevitable controversy ensued. Asked to comment, Mary Coney, then president of Allied Arts, said that no one was disputing the quality of the

Benaroya Hall, 2013. Photo by Roger Schreiber.

Seattle Symphony on stage (location unknown), 1908. Photographer unknown. University of Washington Libraries, Special Collections.

Creating Stable Arts Organizations

opera company or its right to ask for such money. Allied Arts' concern was that individual arts organizations had to put the whole ahead of the individual, regardless of local concerns. The following year was the beginning of a shift from outright enthusiasm for the project to healthy skepticism.

Gregory A. Falls, founding artistic director of A Contemporary Theatre (ACT), wrote in a letter in 1977, "There is no support for the festival from either arts professionals or the public." Very soon, all the glossy financial projections of the festival that were coming from the opera were discredited, as was the idea. Allied Arts did not play any kind of leading role in the festival, but was part of a general community that was at first enthusiastic, then skeptical, then wholly negative. It was the beginning of the end of Ross's career in Seattle.

Dance was the last of the arts to secure a permanent position in Seattle. There had been plenty of major ballet companies to appear on Seattle stages, including the American Ballet Theatre, but they were all imports. Local dance got its start with the creation of the Pacific Northwest Ballet Association, which began in the warm embrace of the Seattle Opera. (Thank you, Glynn Ross.) The initial efforts of the organization were not only to present concerts and fund a school but also to pursue the creation of a regional dance company and school. The association became known by sponsoring summer residencies for City Center Joffrey Ballet at Pacific Lutheran University in Tacoma. The residency was a way for the Joffrey, which was based in New York and had never enjoyed the benefits of a rich patron, as did the New York City Ballet and American Ballet Theatre, to keep its dancers employed. Seattle was a sentimental favorite because Robert Joffrey was born and reared in the city and received his initial training from the redoubtable Mary Ann Wells at Cornish College. Gerald Arpino, the company's associate director and artistic director after Joffrey's death, came to Seattle with the US Navy and met Joffrey. In addition to performances, the company held lecture-demonstrations and seminars throughout the state as well as in Oregon and Idaho. The residency lasted from the mid-1960s to the mid-1970s, until lack of financial support caused it to have to cancel future performances. Allied Arts was active in the support of these summer residencies, including sponsoring and cosponsoring performance nights. Allied Arts got a percentage of the box-office take.

Pacific Northwest Ballet traces its official beginnings as a ballet company to 1972, when it hired Janet Reed as its artistic director, or ballet mistress. Because Reed was a member of New York City Ballet, the ballets of George

Balanchine were part of the repertory from the beginning. Reed didn't stay long. Melissa Hayden, another star dancer from City Ballet, followed, then abruptly departed, causing a brouhaha. In the summer of 1977, Kent Stowell, ballet master of the Frankfurt Ballet, was hired to run the company. He was also a product of City Ballet, as was his wife, Francia Russell, who was to run the school. Russell staged the Balanchine repertory. Soon enough trustees recognized her intelligence and vast knowledge of ballet, not to mention her close connections to Balanchine, that she became coartistic director with Stowell. Although the two were not formally founding artistic directors of the company, they were in the sense that they made the company a major presence in the American dance landscape, against overwhelming odds. They retired shortly after McCaw Hall opened in 2003.

Allied Arts also played a minor role in the activities of the Seattle Art Museum. Of course, no one played a major role at the art museum until 1974—except for Richard E. Fuller, who gave his money and his life to the institution that he founded with his mother Margaret in 1933. For forty years, Fuller was the unpaid president of the museum and its principal benefactor. It is his collection of art that formed the basis of the museum for some fifty years.

However, in the 1970s and 1980s, Allied Arts hit the museum with two bad ideas. After Fuller retired from the museum in 1974, the institution was struggling with financial and leadership issues: how to define itself in the post-Fuller era, and where to find a space in which to exhibit modern art—at the Seattle Center or the old Times Building or in a new museum all together in Westlake Mall. In 1976, Allied Arts issued a position paper that called for the creation of a visual arts center and ignored the museum all together. The center was to include exhibition space, invitational and juried exhibits, a curator, educational programs, and a critic—making outside independent reviews irrelevant. Financial support would come from the One Percent for Art Program, which Allied Arts had helped to create, and the National Endowment for the Arts—in direct competition with not only SAM but also and/or, an avant-garde space. The plan died a quick death. It was not one of Allied Arts' more thoughtful moments. They were out of touch with the realities of the art world in general, and Seattle in particular.

The organization also fought the removal, in 1987, of the thirteenth-through eighteenth-century Chinese camels, rams, and ceremonial figures that stood at the entrance of the Volunteer Park facility. The idea was to pro-

tect them from pollution. The marble camels were to be moved to the grand staircase of the new museum downtown, which was scheduled to open in early 1991. The various, and smaller, marble statuaries were to be moved to the Garden Court of the museum in Volunteer Park. Lydia S. Aldredge, president of Allied Arts at the time, said in a statement at the time that the camels were "symbolically and historically associated with the Volunteer Park museum" and that the plan to remove them "appears to be a move to strip the museum of a significant and appropriate section of its collection." Allied Arts argued that the research on the figures commissioned by the museum had been inadequate and ill-considered. "They deserve more reverence and preservation effort than the museum is currently making." In Allied Arts' defense, the period was rife with paranoia about what the museum intended for the Volunteer Park museum. Certainly there were influential trustees who would have liked to abandon the park entirely, but there were other well-placed trustees totally committed to Volunteer Park who would have never agreed to such an action. The dispute never quite surfaced publicly. The compromise called the old building the Seattle Asian Art Museum, which is now one of three facilities of the museum, along with the downtown Seattle Art Museum and the Olympic Sculpture Park.

Allied Arts had a short-lived association with the symphony, which was among the oldest and largest organizations in the city. It seems formidable now, but it wasn't always, as is vacillated between near-bankruptcy and artistic success. However, it was all the time gaining a steady rise in prestige and remains central to the cultural life of Seattle.

It was typical of the times that city officials, as well as the county, kept Allied Arts in their Rolodex. It was a two-way street. For instance, in 1980 Allied Arts trustee and president at one time Paul Silver wrote mayor Charles Royer (whom the organization had not endorsed, preferring Paul E. S. Schell, a former Allied Arts president) regarding the issue of charging admission to Bumbershoot, the city's Labor Day arts extravaganza at the Seattle Center. In the early years, Bumbershoot was free. Then money problems began to appear, and it was obvious that the status quo was no longer adequate to pay the bills, so the idea of charging admission surfaced. Silver said that, while the quality of the festival needed to be improved, he wasn't sure how to pay for it. "The financing of Bumbershoot has declined, while costs have obviously gone up. The result has been a reduction in quality. An example is the absence of a juried visual arts exhibit. Seeking more money from the Seattle Arts Commission is not a good idea, so charging admission

is a good alternative. Try it for a year, see how it works, and we will go from there." The city accepted the idea in spite of the usual wails of protest.

A major effort on the part of Allied Arts and others was to remove the five-percent admissions tax on all nonprofit resident performing and visual arts organizations, small and large. In 1973, Allied Arts organized an ad hoc committee on the performing arts to eliminate the city tax. The group documented the financial problems of achieving high-quality artistic performances and making them available to the entire community. Mayor Wes Uhlman supported the proposal, and councilman Bruce Chapman, a onetime Allied Arts trustee, lent his intelligence by way of advice in the planning stages. Eventually the entire council, except Liem Tuai, voted for the proposal.

An open letter was sent to various arts supporters and was signed by Glynn Ross, Milton Katims, W. Duncan Ross, and Gregory A. Falls—the artistic directors of the four major performing arts groups. The only other signature was that of Paul E. S. Schell, who represented Allied Arts. The letter urged friends of the arts to write and talk with "your representatives at those levels of government, asking them to consider the role of county and state government in support of the arts. . . . And you can help even more by increasing your own personal commitment to our community arts companies."

Allied Arts also argued in a report, as early as the 1971–72 season, that the city, through the Seattle Center, "penalizes the Seattle Symphony, Seattle Opera and Seattle Repertory Theatre both artistically and financially because of the inequitable scheduling of events in the two houses (Opera House and the Playhouse): To make room for other tenants requires that the symphony and opera shuffle rehearsal locations to other sites. All of the groups must bear the artistic and financial costs of removing their sets and shell to accommodate other tenants." The situation at the Opera House got worse when the Pacific Northwest Ballet began to mount performances at the Opera House, then got better with the construction of a large rehearsal space for the symphony in the complex. According to a statement by Allied Arts, "The size of the rentals charged to nonprofit, resident companies as well as well as taxes and fees for personal services are significant. . . . The symphony, opera, and Rep are also hampered by inadequate and incomplete facilities in the Opera House and Playhouse."

The letter called for a complete renovation of the electric, lighting, sound, and staging systems in both houses; the installation of a mechanized

orchestral shell in the Opera House; the establishment of a priority system in rehearsal and performance scheduling in both houses and a reallocation of the costs necessitated by the accommodation of other tenants now borne by the three groups; the elimination or reduction of all rentals, taxes, and fees paid by these groups, or a subsidy paid to them; direct subsidy by the city in the amount of 5 percent of their gross operating budgets." The issue was finally resolved when the symphony moved to the new Benaroya Hall in 1998 and the Opera House was converted into McCaw Hall.

Wayne Johnson, arts and entertainment editor of the *Seattle Times*, wrote in a column in 1970,

> Seattle needs an effective arts lobby whose vote will be as resonant in the chambers of City Hall and board rooms as in the living rooms of arts buffs throughout the city. The one organization in town that attempts to encompass all the arts and to bring all arts organizations and arts buffs together in a cooperative enterprise is Allied Arts. This group has unimpeachable intentions, and many of its members are intelligent and talented in addition to being good, solid citizens. But Allied Arts—at least during the five years I've had knowledge of it—has been a sadly ineffective organization. It talks a big game, but its actual, concrete achievements have been minimal. There's certainly nothing wrong with lofty ideals and grandiose plans; these are, in fact, necessary sources of inspiration. But if they are not accompanied by accomplishments—however small—then the ideals and plans become so many words and the inspiration withers. Allied Arts is a super-comprehensive organization. Its areas of interest include nothing less than everything that affects the quality of life in Seattle. The intention is admirable, but it leads to a scattershot approach in which the problem of the design of park benches is of as much concern as, say, the problem of the mounting deficits of the symphony.

Five years later, Mary Coney, Allied Arts president, without intending to do so, issued a kind of rebuttal. She stated, in an interview in the *Seattle Times*, that Allied Arts was an amorphous group that escaped definition. "Allied Arts is not just concerned with the fine arts or with the rich, educated, and sophisticated. Cultural experience is central to the human experience, and towards that end we have always worked to make our ideas become a broad issue in public life. What we have become is a lobbying group on behalf of arts to the city."

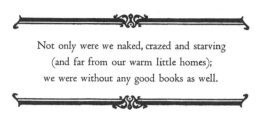

Not only were we naked, crazed and starving
(and far from our warm little homes);
we were without any good books as well.

11 / *Peggy Golberg*

PEGGY GOLBERG ARRIVED ON THE DOORSTEP OF ALLIED ARTS IN 1960, a representative of the Junior League, and never left. "I stayed on and on—serving in every office except president. I always turned that offer down. I was later chairman of the Washington State Arts Commission, but I am not a leader of that sort. I'm more a backer-upper." Golberg's power has been called "kitchen power," "the power behind the throne," according to fellow trustee Thomas T. Wilson. "And she was good at it. Her ideas and interests were first-class, and she was involved in all of them—billboards, the Market, underground wiring, public art. She would pick people out and wouldn't take no for an answer, shaming them into doing things. She entertained a lot, often with her children as waiters, even when they were underage." With her thick, now gray hair pulled back, Golberg is always dressed in a long skirt and some kind of sweater or blouse—maybe silk, maybe cashmere. "My mother and grandmother always wore a skirt and sweater," she says. Golberg represents a French kind of chic, which is good because she is a Francophile of the first order.

Llewelyn G. Pritchard, former Allied Arts president, said about her, "Peggy was a sort of glue because everyone admired her. Her mother (Margaret London Lindsay) said when Peggy was a little girl, everyone wanted to be her friend. She had this magic about her. So lovely and so interesting, she had the ability to attract people. When there was internecine warfare at Allied Arts meetings, she rose above it. She wasn't necessarily everyone's pal, but everyone liked her, and so she was at the heart of Allied Arts. Of the most

Peggy Golberg's print shop. Artist unknown.

significant people at Allied Arts, she would be among them, along with Victor Steinbrueck, Fred Bassetti, Ibsen Nelsen, Paul Schell, Jerry Thonn, and Robert Jackson [Block]."

Golberg was good at recruiting friends and neighbors for things that interested her, said Alice Rooney, former executive director. "Peggy was very strong, but kind of diffident too. She came from a family of influence in the city [her father was a successful stock broker, and her mother, president of the board of trustees of what was then called Children's Orthopedic Hospital]. Regardless of where you are, money and power talk."

Allied Arts was a lively institution in those days—the 1960s—an era of great ferment not only in Seattle but in the rest of the country and Europe as well. It was a time when the organization went from being a loose confederation of representatives from art organizations into a membership of individuals as well as groups. "There were so many architects and lawyers who were just waiting to fix the city and make things happen," said Golberg. "That was exciting. They were determined, would lean on people, and that

Peggy Golberg, 2013.
Photo by Roger Schreiber.

seemed to work. All these guys were willing to put in a lot of time to make things happen. I don't see that today."

In a 1976 essay in *Puget Soundings*, the excellent monthly magazine of the Junior League of which Golberg had been an editor, she explained Allied Arts in a straightforward manner, "It is a fragile liaison of diverse citizens who have managed to have a tremendous impact on the vital city that Seattle is becoming . . . as difficult to describe today as it was in 1954 when a steering committee of the Seattle Chapter of the American Institute of Architects formed a new group dedicated to aiding the arts and creating the kind of city that attracts people who support the arts: vague goals and absurdly idealistic too, in the years before the 1962 World Fair and its concurrent burst of artistic activity."

The group has loosely followed its original aims. Some years there are more artists on the board, some years more architects, some years more lay persons—and always many lawyers. The latter became more useful as Allied Arts moved into writing legislation and making in-depth studies of laws affecting the city, the arts, and artists. People joined Allied Arts who had particular interests, such as saving the Market, planting street trees, or abolishing billboards. Often they were able to garner enough adherents to form independent groups to focus on their special projects—witness Friends of the Market and the Washington Roadside Council. There were a lot of things Allied Arts "poked its fingers into," Golberg wrote. "We had influence with the city council and so on. It was a very interesting time to be down there."

Golberg, who turned ninety in 2012, is a native of the city. Her uncle was the first head of Seattle City Light, and her parents met at Broadway High

School, which Golberg attended except during the Depression when the family moved to its summerhouse in Bellevue. She later graduated from Roosevelt High School and the University of Washington, where she was awarded a Phi Beta Kappa key. She studied English as well as art with Walter Isaacs and Ambrose Patterson, two of the leading lights of the visual arts in Seattle in that era, both fine painters and still remembered today. "They were wonderful teachers, and I learned a lot, including that I was not a great artist. So I've always been on the fringes of doing things artistically. My first husband was a charming poet who was killed in the war" (less than a year after they were married). Golberg's father retired early as a stockbroker "so he could buy a sailboat and go sailing," she said. "I had sailed with him since I was maybe four. The boat was good size, about forty feet, big enough to go into Canada and the Pacific Ocean. It always worked. I never wrecked it. He thought my sailing it—skippering it—would help me get well from having polio."

In 1952, at the height of the polio epidemic, Golberg developed a full-blown case. "That was the plague year." She was, as she remembers, completely paralyzed and could only survive in an iron lung, which is where she and Robert Block, side by side in iron lungs, forged a lifelong bond. "I remember him so clearly from those days, when the only thing one could do was talk, or in Bob's case yell. Then we swam a little and eventually walked and breathed on our own. We had known each other through Allied Arts and various other things. He had two children and I had two children. He was a good friend and smart. He went through two wives while I knew him, or they went through him" (two after the death of his first wife, Dorothy, and prior to his widow, Mary Lou).

The effects of the disease were mitigated but never completely eliminated, leaving both Golberg and Block uncertain on their feet, in pain, and having difficulty breathing. Golberg, who now uses a walker, rarely leaves her house in Madison Park except for essentials like her Thursday hair appointment, going to her beach house on Whidbey Island on Saturdays, and getting together with her friend Edmund Raftis for lunch at Shirley and Alf Collins's house. "You learn to adapt."

Occidental Park in Pioneer Square was in part an Allied Arts effort. Golberg planted plane trees in honor of her seventeen-year-old son Ned, who was killed in an automobile accident while driving home from Wyoming in 1971. Golberg wrote Betty Bowen a thank you during that difficult time: "Robert [Golberg's husband] and I are so grateful for your love and comfort

Peggy Golberg and Mary Coney, early 1990s. Photo courtesy of Peggy Golberg.

and support these terrible days. The embarrassing fact that we continue to eat, and in great crowds of people, only shows your prescience in bringing ham and cake. Thank you for being our dear friend and aren't we lucky to know Ned. As ever our best to the Captain [Bowen's husband]."

Golberg was also deeply involved in PONCHO, a fund-raising group that established the local precedent of using auctions as fund-raisers and in the process dispersed millions of dollars to Seattle-area arts groups in its more than forty years of existence. For decades, Golberg and her group of women friends did the auction catalogue, typing on manual typewriters, with dozens and dozens of pages offering goodies of all sorts. Eventually, the organizing and writing of the catalogue was turned over to professionals. It was a sad day for Golberg. She loved the challenge of trying to make dozens of everything tantalizing, which in some cases was comparable to turning dross into gold.

Allied Arts was always on the grant list for a range of stuff, often quite prosaic, such as office equipment. Certainly the group had an inside track, with many interconnecting ties among trustees, but that did not always guarantee getting the money. For a while auctions were the group's primary fund-raising mechanism. They were great parties, typical of the organization, to create

camaraderie, and odd assortments of items to be auctioned, like a long and heavy Chinese fur coat from the 1920s. The man who bought the coat, when asked by a reporter from the *Seattle Times* why he, a happy journalist from the other side of the street, had purchased such an unlikely object, he couldn't remember having done so; he thought he had abandoned the bidding in time. He hadn't. In a gesture of sympathy and generosity, Golberg bought the coat from him and immediately assigned it to the back of a closet.

For those who know her even casually, the association between Golberg and fine printing is set in the name of Duck Press, which began in 1960 as a part-time operation between Golberg and Shirley (Turner) Collins, who rented the guest house on the Golberg beach front property in Bellevue, close to the East Channel Bridge. The press was situated in a little nine-by-twelve building near the water, home to a lot of ducks. "We

> *Golberg's power has been called "kitchen power," "the power behind the throne," according to fellow trustee Thomas T. Wilson.*

thought of pressed duck, and so the name Duck Press. Shirley had become interested in cooking, and became an excellent one. We were all reading Julia Child in those days." Collins founded Sur La Table in the Market in 1972, and it became a culinary center of striking originality and style.

The press is now located in Golberg's second garage in Madison Park, where she moved after Bellevue. The handsome, heavyweight flatbed press dates to 1923 and was purchased from the estate of Glenn Hughes, a professor at the University of Washington after whom the Playhouse in the University District was once named. For a while, Golberg ran the press pretty much by herself because Collins was preoccupied with Sur La Table. There are twelve faces of handset type, miscellaneous hardware, and a large stock of engravings, woodcuts, and linoleum blocks. Golberg turned out the most elegant and urbane invitations in Seattle, often to people in the social whirl of the city. Meeting announcements, programs, all sorts of invitations to parties and weddings, limited-edition collections of poetry, and dance scores were all part of the Duck Press résumé. They are a kind of Seattle history unto themselves.

Golberg was generous to Allied Arts. Invitations and announcements came out of the Duck Press door. "I did party announcements—'Come join

Allied Arts'—or 'Don't fall off the cruise boat.' The beauty of it was nobody cared. You could be, what I hope, was amusing. That was the lovely part of Allied Arts. No one was paying me, so they had to take what I gave them." She also did the newsletter, stylish and well written, full of information and verve. Golberg was instrumental in organizing champagne breakfasts at Lowe's in the Market "to drum up support for the Market." She often used her children to serve the champagne. They were obviously underage, but the police looked the other way.

Parties were held all over Seattle, but in the early days, many of them were held at the commodious Block house, perched on the northeast corner of Capitol Hill with commanding views, and at the Golberg house on the eastern shores of Lake Washington. Both were appealing establishments, long on charm. "It was lovely so many people came. It was very easy to have a big party. A lot of big parties." Golberg still hosts meetings of the Allied Arts Foundation at her house in Madison Park.

Golberg wrote in *Puget Soundings*, "The litany of accomplishments in no way illuminates the joyful experience of Allied Arts membership. Artful art-lessness is its style. Meetings are informal, comments are audacious, humor covers serious purpose. This coalition of determined individualists meets monthly, and certified non-joiners find themselves, in fact, joining to work toward elusive goals that are, as often as not, reached."

Golberg hopes "to go through life as a member in good standing. I have made marvelous friends—talented, dedicated, funny. These are the people who love Seattle and see Allied Arts as a real force for good, people who would welcome like-minded non-joiners with a penchant for positive action. . . . The next time you are imbibing a drop of wine in a sidewalk café, raise your glass to Allied Arts. They helped make that small pleasure possible."

12 / *Festivals, Publications, Exhibitions, Concerts, and a Miscellany of Projects*

ALLIED ARTS IS MOSTLY REMEMBERED FOR ITS INVOLVEMENT in large projects (such as Pike Place Market and Pioneer Square), historic preservation, public art, the urban environment, the regulation of billboards, and underground wiring. But it was also involved in a slew of smaller activities, from publications and poetry readings to concerts, film festivals, and exhibitions. Some were one-night stands, others lasted a season or two. Inevitability, some were successful and others not so much. Nevertheless, they reflect on the range of interests of Allied Arts members.

The organization's debut as a presenter was probably the Festival of the Arts in 1957. Plans for the festival were afoot the year after the Beer and Culture Society formally became Allied Arts of Seattle. John Ashby Conway, one of Allied Arts founders, wrote in a report in 1955, "Tentative steps have been taken toward founding a Festival of the Arts for Seattle. . . . If a festival such as had been envisioned could be established, Seattle's actors and musicians as well as its exhibiting artists would stand to benefit, and the city would be lifted from its berth in the nation's 'cultural dustbin.'" The term Conway used is a misquote of the epithet "aesthetic dustbin" that originated with Sir Thomas Beecham. It was one of his parting shots at post–World War II Seattle, as music director of the Seattle Symphony, before returning to his natural habitat in London. Beecham must have thought Seattle "stuck in the middle of nowhere," to borrow British prime minister David Cameron's

"Flags, Banners, and Kites" (calendar cover), 1978. Image courtesy of Koryn Rolstad Studios.

barb pointed at Salt Lake City. To Beecham's sophisticated eyes, Seattle was a hick town and would become an "aesthetic dustbin" if something was not done to change course.

The eleven-day festival to be held in May, Conway continued, would not have to be all new but could make use what was already happening in the city: for instance, the Pine Street Show; University of Washington's production of Mozart's *The Magic Flute*; productions at the Showboat and Penthouse Theaters; Bach concerts; Paul Horiuchi at the Zoë Dusanne Gallery and Mark Tobey at the Otto Seligman Gallery; the Seattle Art Museum's "Northwest Show"; a sculpture exhibit at the Henry Gallery; dance performances at various locales; exhibits of crafts around town, including the Bon Marché and Frederick & Nelson department stores, both gone now; foreign films at the Ridgemont Theatre; architectural tours in Washington Park and at Broadmoor; and poetry readings. "If drawn together, the festival could be a reality," Conway said with naïve confidence. Without question, he was ambitious: "Steps have been taken to integrate this committee with that formed by the Legislature to explore the possibility of a World's Fair for Seattle in 1959. . . . If a fair, or exposition, is a possibility, and there is reason

Festivals, Publications, Exhibitions

to think it is, an Allied Arts Festival Committee could be in a strategic position regarding entertainment and exhibitions as well as initial planning and design."

"With experience on its side," wrote Louis R. Guzzo in his column for the *Seattle Times*, "the festival will be ready to expand to a celebration of international importance to coincide with the opening of a civic center." Events were to be scattered across town. The very inconvenience of that, Guzzo wrote, will point to the "advantages to be gained when the festival is produced in the concert-convention hall and small auditorium to be built in the center. . . . Festivals in the future will be more lustrous affairs." At first the festival was to be focused in the Civic Center, with events held under tents, that proved to be too expensive—thus the scattering of offerings

There were those who thought the festival should be postponed until 1958 to allow more time for planning and fund-raising, but the fact that Vancouver, BC, and Portland were planning on festivals precluded taking the extra year; everyone, it would seem, was after the same tourists. Mayor Gordon S. Clinton proclaimed rhapsodically, "Seattle is being recognized throughout the world by a newly felt renaissance by many cultural groups. Representing all of the arts, Allied Arts of Seattle . . . is bringing into being Seattle's first Festival of the Arts."

The effort was short-lived. Guzzo, who had been so enthusiastic before opening day, did not have a good thing to say afterward: "too much money was spent on a brochure; a festival is not a festival if it has to be attended in a taxicab; too much reliance on the University of Washington; more money was needed for everything." In general, according to Guzzo, the festival "was a vivid example of what a festival is not." Conway issued a long and defensive rebuttal, admitting that the festival was not all that Allied Arts had hoped for, but the death knell had been sounded. Seattle was just beginning to learn how expensive festivals of any quality are.

Seattle and the Puget Sound area, especially Bellevue, have a long history of involvement in crafts—some ambitious works of art, some purely decorative, some functional. In the 1980s, Friends of the Rag took craft to clothing and called it wearable art. There was also jewelry. Where glass fits in is an open question. Certainly Dale Chihuly's pioneering work in studio glass and the Pilchuck School of Glass revived the genre and made Seattle an international center of glass art.

In the 1970s, Allied Arts sponsored craft exhibitions that gave the form wider exposure. Craftsweek was originally proposed by Allied Arts to show-

case the crafts of the Pacific Northwest and was inspired by the very lack of attention that the National Endowment for the Arts had given to the field. Janice Niemi, who has a long history of civic involvement, from the legislature to the courthouse, was chairman of the Visual Arts Committee of Allied Arts. In that capacity, she to wrote Elena Canavier, crafts coordinator for the Endowment, to invite her to a "celebration" of the crafts, saying, "We believe that during a three- to five-day visit, we would orient you to all the major aspects of craft activity in the area and pave the way for enlightened communication between Seattle and Washington, DC, in the future." The various exhibitors that had agreed to participate included Friends of the Crafts, Friends of the Rag, Northwest Designer Craftsmen, the Henry Gallery, the Cornish Gallery, the Bellevue Art Museum, Panaca Gallery, Pottery Northwest, the Factory of Visual Art, the Northwest Craft Center, the University of Washington, and the Seattle Parks and Recreation Department. LaMar Harrington, the former director of the Henry Gallery who organized the event, said in an Allied Arts planning meeting that "it was important to have things shown that will help to break down the line between arts and crafts."

Craftsweek '76 was deemed a huge success. It was the first in the nation. Canavier spent a week looking at an extraordinary collection of crafts. Joan Mondale, wife of vice president Walter Mondale (one of the few high officials—even if by marriage—to express any interest in the arts) also spent some time in Seattle. Her visit was greeted as if it were the second coming—except, of course, in this instance there had never been a first. Among the links between Craftsweek to Allied Arts' attempt at a festival in the 1950s, was that exhibits were scattered all over town. This time, no one seemed to mind.

Exhibitions of crafts continued into the 1980s under the auspices of Allied Arts. In 1982, the group mounted the well-received Northwest Crafts '82 Exhibition at the Museum of History and Industry. It was a juried show of all media, and artists from Washington, Alaska, Oregon, Idaho, and Montana were invited. The purpose, according to a grant application, was not only to give craftsmen greater exposure but also to begin development of a local market for crafts sales. In the end, there were 140 works by 115 artists, chosen from 1,200 works entered by some 500 artists. More than 5,000 people attended the show.

One of Allied Arts' most singular ventures in the visual arts was "Flags, Banners, and Kites" in 1976 to commemorate America's Bicentennial. A combination of an invitational and open juried competition was to be held in the

three title categories: flags, banners, and kites. Flags and banners were not to be more than ten feet in any dimension; flags were meant to be flown, banners not. Kites were to be judged "on the basis of aesthetic rather than aerodynamic" aspects, according to an Allied Arts announcement. The show was held in the Flag Plaza Pavilion at the Seattle Center, next to the Seattle Art Museum Modern Art Pavilion. More than 20,000 attended the exhibition. The downside was that the calendars created for the event lost money. A board member of Allied Arts at the time, who had pushed for the calendars, had moved to Washington, DC, to take a job and had left hundreds of calendars, which had been expensive to produce, still in their boxes. While Allied Arts was never good at making money, the organization tried not to lose money in any extravagant way. "It was a debacle," said Mary Coney, who was president at the time. "Jerry Thonn and I had to go hat in hand to all of our creditors and explain that we couldn't sell them. They generously forgave our debt."

The musical Survival Series, which lasted a few seasons, was Allied Arts' venture into presenting chamber works from various genres. It was an eclectic mix of art forms. Six groups, for example, were presented during the 1973–74 season: the Empty Space's *Alice in Wonderland*; Intiman Theatre's *The Underpants*; the Contemporary Arts Quintet (music and dance), the Northwest Chamber Orchestra, in its first season; the Skid Road Theatre; and Matrix, a jazz group. A season ticket went for an amazing fifteen dollars. The series was designed to give smaller, lesser-known groups a boost in exposure, and some money as well. However, by 1975 the series was in trouble—lack of ticket sales. "I find the whole thing unfathomable," Alice Rooney wrote to John Blaine, executive secretary of the Seattle Arts Commission, in a plea for money. All for naught.

Before the series went underwater, David Harrington wrote a letter to Allied Arts suggesting that his newly formed group, the Kronos String Quartet, now known as the Kronos Quartet, for the series. It was a "Dear Sirs" letter. Harrington obviously didn't bother to find out anyone's name, a bit of carelessness that is uncharacteristic of him. He wrote, "We are a young, vital addition to the West Coast music scene, and by the end of the 1973–74 concert season will have performed, in our first year, over sixty concerts." The group, which had been founded in Seattle, left the city early, moved to the East Coast, and eventually settled in San Francisco, where it has gone on to international fame. It was exactly the sort of ensemble that interested the Survival Series.

Coliseum (detail), 2013.
Photo by Roger Schreiber.

"Every once in a while a book is published that is absolutely useless to any except those who find it invaluable," wrote Pat Foote in a review in the *Seattle Post-Intelligencer* in 1971. "Such a book is *Arts and Organizations of Puget Sound.* . . . Published as a public service, the book belongs on the reference shelf of anyone interested in any facet of the Puget Sound area's artistic life. It not only has many facts, but can tell the reader where to find those it lacks. And that's a definition of a useful book." The title of the book eventually changed to *Access*, but in subsequent editions its intent remained the same. The project, cosponsored by Allied Arts and the Junior League of Seattle, was the first comprehensive single-issue directory of visual and performing artists and arts organizations in the Northwest. Later editions were undertaken solely by Allied Arts. By 1985 *Access* had expanded from seventy-three to three hundred pages. As popular as *Access* was, it had its critics in the community, mostly for its alleged administrative shortcomings, and its insufficient staffing and budget—all hard to correct when money is a constant issue. In 1991 there was a proposal to put *Access* online. A good idea, but nothing came of it.

Allied Arts commissioned and published two monographs relating to architectural styles and materials that had a particular relevance in Seattle. They were well written by experts in the field, beautifully photographed, and handsomely designed. The larger of the two was titled *Impressions of Imagination: Terra-Cotta Seattle*. Some of the most admired buildings in Seattle make extravagant use of terra-cotta to ornament their exteriors, buildings such as Frederick & Nelson (now Nordstrom's), the Bon Marché (now Macy's), Smith Tower, the Coliseum (now Banana Republic), the Eagles Auditorium (now ACT Theatre), and the Dexter Horton Building. The book is

composed of ten essays by various experts, such as Grant Hildebrandt (who was on the University of Washington faculty at the time), with an introduction by the architect Robert Venturi (before his connection with the Seattle Art Museum), and dramatic and telling photos by Victor Gardaya, who also contributed an essay.

As Lydia S. Aldredge, president of Allied Arts, noted in her preface, "On the West Coast, Seattle, Portland and San Francisco all possess rich and varied assemblages of terra-cotta architecture. San Francisco and Portland have recognized this architectural legacy with landmark designations. . . . Until now no comprehensive appraisal of Seattle's large inventory of terra-cotta has been completed." The book, which was published in 1985, stated, "Members of Allied Arts of Seattle . . . became aware of Seattle's terra-cotta legacy during their years of participation in the design of a new downtown plan. . . . The major purpose of this publication is to provide an overview of an identifiable inventory of historic structures so that development decisions are well integrated." There was an accompanying exhibit of the photos and architectural drawings in the book at the Equivalents Gallery in Pioneer Square.

The second monograph published by Allied Arts was essentially a catalogue of a 1979 exhibition, *Art Deco and Architecture of the 20s and 30s*. Lawrence Kreisman, architectural historian, curated the exhibit and wrote the catalogue text, and Gardaya took the photos. An exhibit was held at the Pioneer Square Gallery. In the catalogue, Kreisman gave a historical overview, both concise and literate, which set the stage for examples of Seattle's Art Deco, such as the Northern Life Tower, the Seattle Art Museum (now the Seattle Asian Art Museum) in Volunteer Park, the Washington Athletic Club, Bon Marché (now Macy's), St. Joseph's Church on Capitol Hill, and the Coleman Building.

The glories of Art Deco essentially ended with the Depression. Another architectural style, sleek and slim, succeeded it. "The buildings of the 1920s and 1930s [the pinnacle of Art Deco]," wrote Kreisman, "despite their seeming solidity and visual power, become very fragile pieces of real estate. . . . Seattle has often been credited with taking the lead in the preservation of its oldest extant districts. The continued rehabilitation and occupancy of its high-quality Art Deco buildings is another way in which Seattle respects its built heritage at the same time as it constructs a new skyline to meet its continuing growth." The effort to showcase Art Deco extended beyond the exhibit to tours of relevant buildings. There were also ancillary exhibits of

Seattle Asian Art Museum, 2013. Photo by Roger Schreiber.

crafts, decorative arts, and fashion. The Art Deco program and terra-cotta book reveal Allied Arts at its most intelligent and focused.

Ideas would fly at Allied Arts meetings. They ranged over many subjects. All must have sounded intriguing at the time. A lot were one-shot ventures. Here is a partial list:

- Pacific Northwest Writers Conference, 1950s
- Poetry reading by Theodore Roethke at the Playhouse, 1960s
- Arts and Crafts Bazaar, 1960
- Exhibit of industrial art and architecture in Seattle, 1980–1981, and self-guided tours
- A series of James Beard cooking demonstrations at the Olympic Hotel, 1966
- The "Which Street Are You Most Ashamed Of?" contest, 1962 (prizes of twenty-five to one hundred dollars were offered; the winners were West Spokane Street, Highway 99 from the Seattle-Tacoma Airport to East Marginal Way, and Beacon Avenue South)
- The world premiere of the play *The Short Happy Life* at the Moore Theatre, in 1961, in what may have been the first time Seattle was a tryout town for New York–bound theater (the play was a series of episodes

from various Ernest Hemingway novels and stories, written by A. E. Hotchner, and bombed on Broadway)

- Sponsorship of a Seattle Opera production of *The Lively Arts—A Trip in Multi-Media* at the Opera House, with the Retina Circus, Mary Staton's Dancers, films by Robert Brown and Frank Olvey, Peter Phillips's music, Doris Chase's kinetic sculpture. Henry Holt conducted, 1969
- "Artists and Audience," a television series of six programs, the purpose of which was to explore the condition of the arts in Seattle (painting, sculpture, crafts, theater, music, and dance), what artists were doing, and the relationship between artists and the audience, 1965
- A series of visits to artists' studios by junior high and senior high students, early 1970s
- A film festival, in which films that had not been seen in Seattle would be screened over eight days (there were two separate series, "The Film as Art and Document," composed entirely of short experimental and underground films, and "International Award Winners," from Denmark, Britain, Austria, Spain, and France), shown at the Pacific Science Center, 1968
- "Concurrence," a concert mixing Dixieland and electronic music, poetry reading, and a light show, in the Eames Theatre at the Pacific Science Center, 1967

13 / *Paul E. S. Schell*

I N A PIECE IN THE *ARGUS* IN 1973, NOT LONG AFTER THE ARRIVAL
in Seattle of Paul E. S. Schell and his wife, Pamela, Schell was described
as "one of that valuable breed, the foreigner-turned-native"; Paul was
from Iowa, and Pamela was from New York. Nobody would have argued.
At thirty-five, Schell had multiple careers ahead of him, in both the public
and private sectors. Alice Rooney, former executive director of Allied Arts,
did not equivocate. "Paul became a real leader," she said in an interview in
Western World, "presenting a very clear vision for us. I think he changed the
face of the city."

The Schells became one of the best-known couples in Seattle. In 1972, he
had just been elected president of Allied Arts and would stay for two years,
eventually becoming one of the most influential men in the region. After
Allied Arts came his election as mayor and as Seattle port commissioner and
his appointment as dean of the School of Architecture at the University of
Washington and director of the Seattle Department of Community Devel-
opment. He was also a trustee of any number of civic groups; a lawyer with
two leading Seattle law firms; and a key executive and sometimes CEO of
some local companies, the best-known probably being Cornerstone, a real
estate subsidiary of Weyerhaeuser. On occasion, he and his wife would eat
in good restaurants and travel to the south of France. Maybe even sleep. She
was busy too. In addition to being a trustee of Allied Arts, and particularly
involved with billboard regulation and the Washington Roadside Council,
she was president of the Intiman Theatre in its critical years when it was in

Paul and Pamela
Schell, 2012. Photo
by Roger Schreiber.

a major transition, moving away from the leadership of founding artistic director Margaret Booker.

Schell was born in Fort Dodge, Iowa, and was reared in Pomeroy, a town of 843 people, "probably a lot less now," he said. His father was a Lutheran minister, and his mother, a nurse. There were six children—five boys and one girl—scattered in their adult life across the country in various occupations and professions. "We still get together every summer in Northern Wisconsin, swat mosquitoes, and try to catch a few fish." Schell speaks to the advantages of living in a rural environment as a child: "I often think of growing up in small towns in the middle of the country. Nobody tells you what you can't do. The world seems full of possibilities, which is an advantage over growing up in cities, where you tend to box yourself in sooner than later, and those possibilities don't seem as broad as they are."

After University of Iowa came law school at Columbia University in New York, where Schell and his wife met, in the backseat of a car headed to a football game. They were married six months later. A native of New York, she was in gender studies, also at Columbia, and worked the graveyard shift as a nurse at Bellevue Hospital. Schell first encountered Seattle during the World's Fair and "fell in love with the city." He returned to New York, finished law school, and got a job with a major law firm, Dewey Ballantine Bushby Palmer & Wood. He stayed four years; then, in 1967, the Schells packed up their worldly possessions and moved to Seattle, where he joined

another prestigious law firm, now known as Perkins Coie. He thinks he may have been the first Democrat the firm ever hired.

The Schells were part of the great migration of highly educated professionals who moved to Seattle from the Midwest and East Coast and helped transform a beautifully situated, culturally isolated, somewhat smug conservative city with a lusty and sometimes radical past into the sophisticated urban center it is today, nationally known for its progressive politics. Many of these found their way to Allied Arts. At first, said Pam Schell, if you were in a group of four, three would be from Seattle. Over the next fifteen years, however, the proportions switched. Like quite a few other immigrants, the Schells began their Seattle life at the Edgewater, a sprawling apartment complex in Madison Park, then bought a house on Capitol Hill. "We knew we had made the right decision, moving to Seattle, so we got involved in the community," said Schell. "That's where it began for us."

Among the first civic groups Schell joined was Choose an Effective City Council. "A group of us got together . . . who felt we could do better at city government," he said. Among the people CHECC proposed for City Council in an early involvement were Phyllis Lamphere, Bruce Chapman, and John Miller, all of whom went on to lead major public lives. It was the beginning of progressive politics at City Hall. Also active in CHECC at the time were Allied Arts stalwarts such as Fred Bassetti, Ibsen Nelsen, and Victor Steinbrueck. "I give those guys credit for stimulating my interest in cities," said Schell. "They had done a program called 'Action: Better City,' from which I drew eight or nine ideas of how we could make Seattle a better city."

You can accomplish more when people are not elbowing their way to the front of the line for recognition.

During the late 1960s and early 1970s there was a broad group of people who gave their time and energy to making Seattle a better place, said Schell. "It was real grassroots, organizing effort to change the nature of the city. We were fighting freeways and building neighborhoods. Historic preservation—the whole idea of adaptive use or reuse of existing structure—was gaining momentum." The environmental movement was in its early stages. "This was an exciting time." The organizers saw Seattle for what it could be and realized it was still fresh and new and full of opportunity.

They came at the right time. "Wes Uhlman was the breakthrough mayor,

and he was really only a kid in his thirties." The citizenry had to date been pretty laissez-faire about local politics and issues. "They just let things go, taking for granted the natural beauty of the place. A succession of mayors saw their job as holding everything together rather than pushing things forward. Most of the power structure in town was a controlled, inside game and had been that way for a long time: city fathers making a lot of decisions while playing dominos at the Rainier Club. It was the ultimate 'good old boy network.' We stopped the construction of freeways, started on the very first neighborhood programs, and began historic preservation. The arts were viewed as a part of what makes a healthy community. And there was Forward Thrust, which cleaned up Lake Washington. Unfortunately, the first effort at rail transit . . . failed." All sorts of social connections were possible. The victories were "satisfying."

The newly arrived were joined at Allied Arts by natives such as architects Fred Bassetti, Victor Steinbrueck, Ibsen Nelsen, and Ralph Anderson, who influenced a lot of young lawyers like Schell. Altogether, they along with the media—not the owners but young reporters—were a "confederation of activists" who cared about the city, talked to one another in a way that resembled the Internet long before the Internet. "Who got credit was not of great concern to people," said Schell. "You can accomplish more when people are not elbowing their way to the front of the line for recognition. Civic tolerance was built. Their successes provided fuel to their energies. That bred more success. Seattle became a place where the creative and the smart wanted to live," he said. Schell is given credit in Allied Arts circles for teaching others how to lobby the various arms of government effectively. Schell didn't arrive at Allied Arts fully informed on these critical matters. "I had to learn as well, but we learned."

The preservation of Pioneer Square as a historic district was of paramount concern to Allied Arts: "[Allied Arts] wishes to record its position," wrote Schell to the chairman of the Seattle Board of Public Works in July 1972, "that all aspects affecting the Pioneer Square District should reflect its historic character." A few days later, Schell wrote to Mayor Uhlman and to the City Council about the "strong position" Allied Arts was taking in regards to Pioneer Square as well as the International District, especially to protect them from the impact of the Kingdome. A nine-point plan was laid out, including the planting of trees, "stringent controls" over land use, regulation of parking lots, rent control, and a commitment from the Seattle Housing Authority to provide low-rent housing.

During Schell's presidency, Allied Arts accomplished two major initiatives, among many others. The first was the One Percent for Art program, subsequently followed by communities elsewhere, and the second was convincing the Seattle Arts Commission to increase its annual allocation by a single leap of $350,000. The passage of the two measures gave Allied Arts a kind of respectability in the community that it had not had previously, Schell said in the *Seattle P-I*, and perhaps "helped us with some other projects that may not be so glamorous in the public eye. After all, it's more exciting to band together against something than it is to work on improving the public environment."

Allied Arts kept a keen eye on developments in the Pike Place Market after the public initiative that saved it in 1971. Two years later, the Pike Place Market Development Authority formulated a position paper regarding its future. A copy was sent to Allied Arts and to seven other groups, ranging from the Market Historical Commission to Richard Clotfelter at the real estate company Coldwell Banker, asking for their views. Allied Arts supported adoption of the plan, with two requests, wrote Schell to Seattle councilman Liem Tuai: that implementation of the plan be careful and gradual, and that public and private support for the Market be maximized.

The historic districts of Pioneer Square and the Pike Place Market may have been the most obvious neighborhoods of concern to Allied Arts, but, as Schell wrote to Mayor Uhlman in 1973, so was an area like Capitol Hill, which was filled with historic houses. The city was about to embark on a planning scheme for the area, and Schell expressed Allied Arts concerns: "We reiterate the importance of the Capitol Hill project to future confidence in local planning by Seattle government. It will become the test by which the city succeeds or fails in sustaining the confidence of its inhabitants. . . . The city must in all good faith commit resources adequate to the needs of the community to make the Capitol Hill planning project a landmark example of good planning for Seattle's urban dwellers."

One of the great debates in the city's attempt to preserve its history involved the University of Washington's ten-acre downtown site. By the late 1970s most of the old buildings had been torn down. All that was left was the Skinner Building (which housed the 5th Avenue Theatre), the Cobb Building, and the Olympic Hotel. They were all "of a certain age" and needed work. Plans were afoot to tear down every one of them. After the bitter struggle to save the White-Henry-Stuart Building a few years previously failed, the regents (the governing board of the university) proceeded

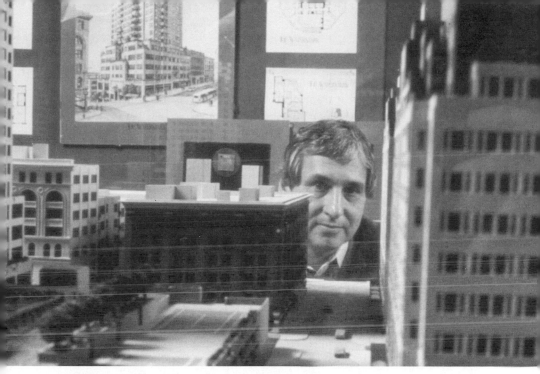

Schell peering down Western Avenue, 1980. Photo by Roger Schreiber.

cautiously and sought proposals as what to do with the Olympic: demolish it and build anew or renovate. The proposals were in hand by 1979. Most were sketchy, and only one complete—from the Olympic Center Associates, a group of Seattle developers of which Shell was a principal. The associates proposed a twenty-million-dollar renovation that did not succeed in winning the bid; the Four Seasons of Toronto won. In a news story in the *Seattle P-I*, Schell said that he was "deeply disappointed" at the decision because his group had spent nine months and $100,000 on a proposal that would have reduced 780 rooms to 530 larger rooms and would have been managed by Intercontinental, a subsidiary of Pan American Airways. Baumgardner Partnership of Seattle was to be the lead architect. But what the proposal had proved, Schell said, was the value of the property.

Post–Allied Arts, Schell was appointed by Mayor Uhlman to be director of the Department of Community Development, with Pioneer Square and Pike Street Market as his special charges. He liked the challenges, the possibilities, the way the office used his legal background to good advantage. He liked the public aspects of his job so much that he decided to run for mayor in 1977. He worked very hard at campaigning, with the full support of Allied

Arts. In the end he lost to Charles Royer, a former newsman at KING-TV. Schell spent the next decade running Cornerstone. Although the company had its financial issues, it transformed seven blocks, or 1.2 million square feet, of dilapidated downtown Seattle along the waterfront between Pioneer Square and the Market into upscale and stylish hotels (the Alexis, the Inn at the Market), offices (the National Building), apartments and condominiums (Watermark Tower), restaurants, and shops. Two years later Schell was elected to the Seattle Port Commission.

Schell never went far from Allied Arts. He told Maggie Hawthorn, theater and jazz critic for the *P-I*,

> Allied Arts has no model. And the reason it's been so effective is that it's a middle-class citizens' group, responsive to its members, a sort of Common Cause where we can use our umbrella organization to make the city a special place. Traditionally elected officials tend to respond more readily to organizations than to individuals, and Allied Arts is flexible enough to incorporate individual artists with the architects, attorneys, performing arts group, and concerned people who come together on the issue of arts and the environment. It works because it is so broad and fun, because it's not an institutional bureaucracy itself. For instance, I think one of our next great concerns in going to be the preservation of the neighborhoods. It's going to become a big thing, because it touches on the whole question of stability, and it's just the sort of thing Allied Arts can work on.

In the 1980s, Schell ran for mayor and won. "I really don't know all the details of Paul's mayoral term," said former Allied Arts president Mary Coney, "but he was very successful as an advocate: very dedicated, very hardworking, very thoughtful. Not a glad-hander at all, which may have cramped his style a bit as mayor, but he was very good otherwise." Schell is more pessimistic about Allied Arts now. "We have lost some of that energy. It needs to be rekindled. It is okay for organizations to die, to give them a decent burial, but you have to make sure the next generation knows how the whole process works."

· · ·

Paul Schell died suddenly after emergency bypass surgery on July 27, 2014, just before this book was going to press. His experience and expertise will be missed.

14 / Art Funded by the Public Purse

RTISTIC ENTERPRISE IN MOST PARTS OF THE WORLD IS FUNDED by the government—if not entirely, then a significant portion. Certainly the Christian church, the aristocracy, and later the very rich played major roles in the arts in the West, but always in concert with government—first kings and queens, emperors and czars, and then elected representatives. Governments' taste and idiosyncrasies might be called into question, and often were, but no one suggested that they had no role to play.

The United States government, both federal and local, came to its artistic patronage very late—mid-twentieth century—and then somewhat nervously, with the knowledge that many taxpayers, perhaps mostly philistines, did not like the notion of art, especially not high art—and even less the use of tax dollars for such expenditures. And these taxpayers had clout at all levels of government: city, county, state, and federal. But times were changing. The National Endowment for the Arts and the National Endowment for the Humanities were created in 1966, and after that huge step forward, all sorts of public agencies, ready and willing to spend tax dollars, sprang up across the country.

"The cultural bubble of the 1960s has never really burst," declared a *New York Times* editorial rather optimistically. "Contrary to rumor and recession, the arts are flourishing in America. It is a curious perverse flowering, in which creativity and nihilism are often equated, but what both fine and performing arts lack in easy comprehensibility is made up in intellectual ferment, productive energy and very real achievement." Everyone knows that

Black Sun by Isama Noguchi, 2012. Photo by Roger Schreiber.

groups form, prosper, then often disappear—for lack of money or lack of interest—to be succeeded by other groups. What no one predicted were the culture wars that followed in Washington, DC, and the long-running battles over money.

The blossoming of government-funded arts then hit the other Washington, pushed and prodded by Allied Arts. The Washington State Arts Commission, which has since suffered drastic budget cuts, was among the first to be formed in the country, in 1961. The King County Arts Commission (now 4Culture) followed in 1967, the first publicly funded county arts agency in the United States, and the Seattle Arts Commission, now called Office of Arts and Cultural Affairs, in 1971. Visual art programs in the city and county quickly followed in 1973, followed by the state in 1974. Allied Arts played a major hand in the formation of these agencies and programs. It was thought that these public monies would be a panacea for habitually underfunded arts organizations. They were not, of course. Nothing would be that easy.

In 1968 the National Endowment for the Arts appropriated forty-five thousand dollars for Isamu Noguchi's magnificent *Black Sun*—a nine-foot

donut of black marble—located in Volunteer Park between the Seattle Art Museum (now the Seattle Asian Art Museum) and the reservoir, overlooking the city. Richard Fuller, founding director of the Seattle Art Museum, contributed sixty thousand dollars through the Seattle Foundation, and the city of Seattle gave fifteen thousand dollars for creating a plaza and landscaping. *Black Sun* remains one of the most significant sculptures in Seattle and one of the most perfectly sited. The same year that *Black Sun* was inaugurated, 1969, Henry Moore's huge *Vertebrae*, in bronze, was sited downtown on a sweeping plaza on Fourth Avenue to mark the opening of Seattle First National Bank's new corporate headquarters. *Black Sun* was dedicated the following year, the same year the Port of Seattle allocated $300,000 worth of art at the Seattle-Tacoma International Airport, the first major airport to do so. This was all before anyone had ever heard of "publicly funded art."

The Municipal Arts Commission died in 1969. The commission, which had been created in 1956, had had plenty of sound ideas, some radical for their day (street beautification, for instance), but no money or clout. That same year Allied Arts drafted a resolution:

> We call on our city officials and members of the City Council to take a strong position in favor of a meaningful involvement of our municipal government in the arts. . . . The arts extend and enhance the culture of cities and without them civilizations become degraded and perish. There is no time now for hesitation and inaction. Our cities are deteriorating as a human environment. Despite great unmet social needs, despite massive shortage of funds, we do not think expenditures for the arts can be omitted. If our lives in the city are to be made humane again, some small portion of our time and treasury must be set aside for the arts.

Allied Arts had several ideas up its collective sleeve. The first was the elimination of the admission tax on cultural events at the Seattle Center; the second was a "modest hotel and entertainment tax . . . to be earmarked for programs for the arts"; and the third was "reactivation of the now inactive Municipal Arts Commission," this time with a budget and staff. "This should be done at once." The Municipal Arts Commission remained comatose, however. No similar agency would take its place for another two years. Then its successor was established, the Seattle Arts Commission, with real money and power and staff. "No longer can it be said by Seattle residents that 'scenery is our culture,'" said mayor Wes Uhlman, a progressive, for-

ward-thinking mayor at the time. "Art in Seattle is becoming part of the fabric of life." Subsequently, Uhlman said, the arts have to be recognized as an "essential service, equal in importance to other essential services." He was the first mayor to say such things. Later public officials, unfortunately, did not feel the same.

During that same landmark year, 1969, Allied Arts, along with the Washington State Arts Commission, the Contemporary Arts Council of the Seattle Art Museum, PONCHO, and the Seattle Chapter of the American Institute of Architects, sponsored a major conference, "Art in Public Places," which drew national attention. The conference was considered a catalyst toward the passage, in 1973, of One Percent for Art (one percent of capital construction) legislation in Seattle and King County and, the following year, One-Half-of-One-Percent in the state. All this in the years of the "Boeing Bust" and 13 percent unemployment—the worst the nation had seen.

With a Seattle Arts Commission budget of thirty-five thousand dollars, Allied Arts began to look toward getting more money for the arts, a process that occupied a good deal of its energy for the next two decades. In 1972, a subcommittee, with all sorts of influential members, chaired by Paul E. S. Schell, quietly began to formalize its study of municipal support for the performing arts, namely, how to broaden its scope and increase its scale. The following year, Roger Downey wrote in the *Argus*: "In its eighteen-year history, Allied Arts has a spectacular record in the public-lobbying line as creator of groups like the Washington Roadside Council and the Friends of the Market and has been a major participant in stopping the Bay Freeway and setting up the Pioneer Square Historic District and the Seattle Design Review Commission. . . . Its influence in creating . . . the Seattle Arts Commission has been considerable."

The arts became even more a priority, wrote Downey, with the formation of an ad hoc committee that studied city support for the performing arts. The group, organized under the umbrella of Allied Arts and comprised of some forty people, eventually became the Committee for Municipal Arts Support. "Actually, we began looking into the subject of municipal support for the arts a good four years ago," wrote Downey, quoting an anonymous member of the committee. "At the time all we got when we approached the majors—particularly the symphony—was a frosty stare and the suggestion that we tend to our business and let them tend to theirs." But inflation was catching up with everyone, so representatives of arts organizations wanted their say on the committee.

Adjacent, Against, Upon by Michael Heizer, 2013. Photo by Roger Schreiber.

Allied Arts' formal proposal was titled "A Proposal for the Performing Arts in Seattle." Wayne Johnson, arts and entertainment editor of the *Seattle Times*, called it a "substantial, important document. It is must reading for anyone concerned with the quality of life in Seattle; it also provides a basis for must action." Johnson quoted the proposal's preamble: "Seattle is developing a world wide reputation for unique atmosphere and identity, and our major arts organizations are playing an important role in that development. Seattle must continue to evolve as a center for the visual and performing arts if it is to realize its full potential as a major city." Schell, then Allied Arts president, said in a committee meeting that instead of the city subsidizing the arts, the arts were subsidizing the city. Among twenty major cities, Seattle ranked nearly last in per capita government support for opera and symphony.

The proposal had three goals: first, to repeal the admissions tax on tax-exempt performing arts; second, to reassess the relationship of the Seattle Center with its principal tenants by reducing the cost of services; and third, to directly support major arts organizations such as the Seattle Symphony, the Seattle Opera, and the Seattle Repertory Theatre. Those ideas, which formed the major thrust of the proposal, also provided, wrote Johnson, "a wealth of statistical detail and cogent arguments to support its recommen-

Olympic Iliad by Alexander Liberman, 2013. Photo by Roger Schreiber.

dations. The Allied Arts committee did an important job and did it well. Now if the right people pay attention. . . ."

Reviews started to come in. There was near-universal approval of the plan. The *Seattle Times*, in an editorial, proclaimed that the Allied Arts proposal was "gaining an impressive list of endorsements. It is high time that Seattle joined major cities in both the United States and Europe whose municipal governments make a major and continuing financial commitment to their artistic enrichment." Morrie Alhadeff, chairman of the arts commission, said in his usual forthright way in the *Seattle P-I*, "Seattle is one of the few cities in this country with a chance to make it into the twenty-first century with pride and a feeling for time and space, where people aren't too rushed or crowded together to appreciate life. . . . Members of the commission and those of Allied Arts are busy buttonholing the City Council and explaining various aspects of the proposal."

Alongside Allied Arts' proposal for the performing arts was a proposal that suggested adding $350,000 to its 1974 budget, bringing the total to nearly $450,000. This proposal was seconded by R. W. Wilkinson, of the

Art Funded by the Public Purse

city's Office of Management and Budget, in a memo to mayor Wes Uhlman. There were some objections, including a handful from the City Council and a few from the public at large. Schell had a fistful of arguments defending the expenditure of tax money. In purely dollars-and-cents terms, the proposal has economic viability, he said, because the majors are economically important. Moreover, "the city competes with the suburbs for the residents who provide its tax base. We can't compete in new schools, new streets, new houses, and safety, but we can make Seattle more exciting to live in. If we don't, we'll lose to the suburbs and lose the tax base we have. Property taxes will go up and services will go down." That said, in 1970–71 the Seattle Opera and the Seattle Repertory Theatre had their biggest-grossing year in history, and the Seattle Symphony had its second biggest.

Yet, uncertainty dominated the landscape. Peter Donnelly, producing director at the Rep, and later president of ArtsFund and an Allied Arts trustee, said that the theater was making conservative plans for the upcoming season. "We want our programs to be realistic both in concept and cost, yet do not endanger our existence because we feel that we have an obligation to the community to survive." The 1970s marked a dramatic increase of those attending performances, in some cases doubling the number of performances and the budget. Uhlman's encouragement through dollars and general support was given major credit. Seattle's experience ran parallel to that of the nation, which saw record budgets for the National Endowments for the Arts and Humanities.

Allied Arts was already providing arms to its forces and preparing its campaign. In a letter to Rolf Stromberg, music critic of the P-I, Alice Rooney, executive director, wrote, "We are planning to immediately visit each city councilman to discuss the report and its implications, answer any questions they may have, and, of course, consider the thorny path through the political byways." This kind of in-person campaign was typical of the sort of battle waged by Allied Arts in its early days. The measure passed. "Allied Arts was the motivating force and catalyst for all these achievements—a singular accomplishment for an organization with a membership of just under 1,000, a budget of less than $25,000, and a staff of two people at the most," wrote Rooney in The Arts, the joint newsletter of the Seattle and King County Arts Commissions.

Then began the yearly dance of proposed budget cuts, some major, some minor—all fought by Allied Arts, which argued that the art commission was so new it should be exempt from any cuts. In 1975, the city's budget office

proposed the elimination of funds for the highly respected Bathhouse The-
atre at Green Lake. As city councilman Bruce Chapman, a one-time Allied
Arts trustee, noted in an interview, "We will always be fighting the battles
of priorities for arts funding." The Bathhouse is among those that did not
survive into the twenty-first century.

In 1975, Mary Coney, president of Allied Arts, offered a primer to its
members who wanted to help. She wrote a nine-point plan: educate your
constituency; develop a broad base of support; study the political process
you're going to enter; start early; set your monetary goal; be prepared to be
reasonable; get the press on your side; enlist the various board members of
arts organizations; and marshal businesses that are directly affected by the
issue at hand. These tactics work, Coney wrote, pointing to efforts to sup-
port the Seattle Arts Commission's budget in 1975, which ended with a ten-
percent increase when all other city departments, except the police, were cut
10 percent; In 1976, the inclusion of a one-time Bicentennial appropriation
into the regular budget was secured; in 1976 to the King County Arts Com-
mission, which was heavily lobbied by Allied Arts, saw its budget increased
by nearly 75 percent.

Local issues of money aside, Seattle was getting favorable press out-
side city limits, particularly for its "sense and sensibility" in matters of the
arts. Mike Steele, a critic with the *Minneapolis Tribune*, wrote in 1974, "The
arts made their move by aligning themselves with quality-of-life concerns.
Arts advocacy groups such as Allied Arts battled the destruction of historic
buildings, battled freeways and billboards as valid artistic-aesthetic con-
cerns. The citizens of Seattle, who might otherwise have looked on the arts
as a frill, now saw them as part of a broader urban environmental quest."

Seattle also came in for praise from Nancy Hanks, the founding chair-
man of the National Endowment for the Arts and one of its most articulate
leaders: "Seattle has long been a national model in its innovative and mean-
ingful use of the arts as part of the lives of its people. The arts in Seattle are
not only diverse and vital, but are woven into the very fabric of the cultural,
economic and social life of the city." And more money was needed, she con-
tinued, so the arts commission could supply at least "adequate" support.

Curiously, in the mid-1970s, there were two surveys taken on public sup-
port of the arts. The first, which was widely distributed, came from national
pollster Louis Harris, and found that an overwhelming number of people
in the state not only said that they attended some arts events in a year but
also supported an increase in public dollars toward that end. The report ran

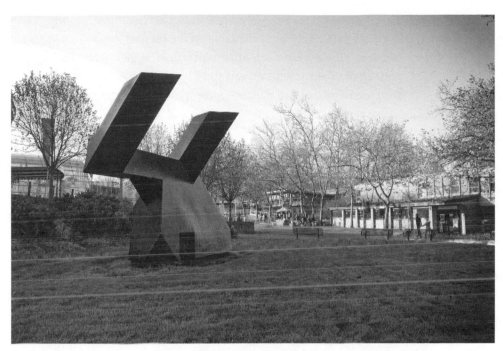

Moses by Tony Smith, 2013. Photo by Roger Schreiber.

360 pages. In a subsequent survey that covered the nation, 93 percent of the people polled said that "having the arts available to them is important to the quality of life in their community." In contrast was a local public-opinion poll that reported that only 33 percent of those asked would favor a five-dollar tax to support cultural activities—an amount Allied Arts had advocated earlier in Olympia. However, as income levels rose, so did support. "It strikes me that with all the educating we've done for an arts constituency," wrote Rooney in the 1970s to Jerry Thonn, Allied Arts trustee bound for the presidency, "that more people know now what needs to be done than has ever been the case before." In a report of the Committee for Metropolitan Arts Support in the 1970s, its chairman, Andrew M. Witt, who was also the general manager of A Contemporary Theatre, now known as ACT, wrote, "Lobbying for the arts is and will continue to be a necessary function if our arts organizations are to survive. . . . This is not a short-term project."

Indeed, Allied Arts was busy promoting new proposals, fighting to save newly established programs. A directive, "It's All Up to You Now" was issued to its members: "Have you written letters or sent telegrams or telephoned

your legislators?" Always, it seemed, Allied Arts and others had to constantly rebuild the case for public support of the arts and the reasons the arts could not "pay their way." These were often life-and-death struggles. Some were more dramatic than others, such as when the King County Arts Commission was faced with a proposal to slash 90 percent of its budget in 1981. The proposal did not succeed.

The Washington State Arts Commission has suffered the most financially over the past several decades, landing near the bottom of per capita spending for the arts in the country year after year. The state's saving grace is the Building for the Arts program proposed and lobbied for by the Corporate Council for the Arts (now ArtsFund) in 1991. It has provided millions of dollars in support for capital projects around the state. There is hardly a place in Washington not touched by this program. Studies were done by various people and groups (among the most notable were those by the Corporate Council/ArtsFund) that demonstrated how much money was generated by the arts, how many people attended live performances (more than 1.2 million in 1986, for instance), and how those numbers grew every year. The number of arts groups, small to large, increased dramatically, from a handful in the 1950s to dozens in the 1980s. They represented millions of dollars in business generated and people employed. An additional point was made by the ArtsFund study: budgetary cuts could be devastating, especially to smaller arts groups, and the corporate sector could not be expected to make up shortfalls in public monies, even though support from the business community, according to the *Wall Street Journal*, leapt from $22 million in 1967, to $464 million in 1980—a 2,000 percent increase in thirteen years. Corporate support had grown. R. M. Trafton, chief executive officer for the generous SAFECO in the early 1980s, reported that his company gave more money for the arts than all of King County.

A group of concerned citizens, some with close ties to Allied Arts, who called themselves the Washington State Arts Advocates, wisely hired Judith Whetzel, a long-standing member of Allied Arts, as an arts lobbyist in Olympia. Not only did she know the scene in the state capital, she knew it in Seattle, where she was a major force in the creation of the city's arts commission and visual arts program and a significant player in the creation of the state public art program. "So many individuals—people who were highly regarded and intelligent and possessed real integrity—committed extraordinary time and energy to these issues," Whetzel said. "I am astonished."

A crisis came in 1986 when, in response to the fiscal troubles of the

Seattle Symphony Orchestra, mayor Charles Royer assembled the Mayor's Task Force on the Arts to help not only the symphony but also fourteen other leading arts groups in the city. Nine of them were found to be in "fragile" financial condition. Harsh words were thrown at the Washington and King County art commissions, charging them with "negligence." The debate on how to raise the money (federal money was part of the mix) revived the Metropolitan Arts Committee of Allied Arts, which Mary Bruno, in the *Seattle Weekly*, as "historically potent"—but not as much as in the past.

By the end of the decade, according to James R. Uhlir, president of Allied Arts, and Paul M. Silver, vice president and chairman of the Committee for Metropolitan Arts Support, Allied Arts could point to increased funding for the arts over what the Seattle Arts Commission had requested,. But even that was not keeping pace with the annual costs of inflation. The arts employed more than two thousand people and generated a combined annual income of more then twelve million.

At the end of the decade, the city, with Charles Royer in the mayor's office, had a record budget for the arts, and the Committee for Metropolitan Arts Support, looking ahead, pronounced in a position paper, "The opportunity for Seattle to become a leader in the arts has never been greater. So too, the need for substantial support had never been more pronounced. . . . If the full potential of Seattle's cultural environment is to be realized, the allocation of public funds for the arts must keep pace with their growth."

Having grown from thirty-five thousand dollars in 1972, the budget for the Seattle Arts Commission in 2012 was nearly five million dollars. Nearly three million was allocated to One Percent for Art funds. Since 2001 the money is no longer derived from the government operating budget or dependent on the whims and winds of the political climate. It now comes from 75 percent of the for-profit admissions tax from activities such as movies, UW games, and even the giant waterfront Ferris wheel. About three thousand works of art are part of the city's art collection, including everything from a small watercolors to large-scale design projects. The King County Arts Commission began with a forty-thousand-dollar budget that has grown to eleven million dollars this year, which includes its One Percent program. It receives only a modest amount from the general fund.

The King County Arts Commission had another solution to escape the yearly juggling of the general budget, a tax that was called initially the hotel/ motel tax and was subsequently renamed the lodging tax. This legislation provided that once the two-percent county tax reached $5.3 million, the amount

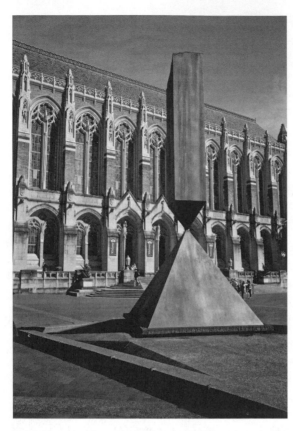

Broken Obelisk by Barnet Newman, 2013. Photo by Roger Schreiber.

deemed necessary to service the debt on the Kingdome, the excess would go to arts and culture. But the commission, aided by Allied Arts and other arts groups, had to fight to keep the money from other interested parties. "When it comes to the arts, everyone wants to rob the pot," said Cara Wells, acing director of Allied Arts in the late 1980s. Allied Arts fought the good battle with its usual battle kit of lobbying, memos, and panel discussions, although it was not anxious to fight arts education schemes: "[It was] better for the arts and arts education community to put forward a cooperative, collaborative plan for the use of the money, rather than to quarrel over it and leave the planning of its use up to the politicians and their staffs," summed up Faith Fogarty, chairman of the Allied Arts Education Committee. Ultimately the arts got the lion's share of the booty, said Jim Kelly, the capable executive director of the King County Arts Commission, which manages the funds. The formula has undergone a number of shifts in the past two or more decades, but Kelly has managed to weather them with political savvy.

Once the arts commissions were established, visual arts programs came swiftly. Allied Arts, among others, prodded and pushed in Seattle. Whetzel and Allied Arts were again in the forefront of that campaign. Public art as a concept was mostly foreign. Not since the WPA programs of the 1930s, created to give employment to artists, had there been any substantial public art, according to Virginia Wright, one of the region's most important art collectors, as well as philanthropist. In 1967 the National Endowment for the Arts initiated its public art program. Wright began her "public art program" two years later, funded with a one-million-dollar gift by her father Prentice Bloedel. One does not want to imagine Seattle without the Wright's contributions—works that she funded entirely out of the Virginia Wright Fund, often in partnership with one of the One Percent programs. The works include the Barnett Newman's *Broken Obelisk* on the University of Washington campus; Alexander Liberman's *Olympic Iliad* and Tony Smith's *Moses* at the Seattle Center; Michael Heizer's *Adjacent, Against, Upon* on the eastern shores of Elliott Bay; Robert Rauschenberg's mural in the lobby of Benaroya Hall; and Jonathan Borofsky's giant *Hammering Man* looming over the Seattle Art Museum downtown.

In the thirty or so years of public art programs, the climate changed from major works to design projects that involved not only artists in the traditional use of the word but also architects, engineers, and members of the community. Among the most successful of these team projects was the Metro bus tunnel nearly twenty-five years ago. The tunnel is 1.3 miles long with five stations under Third Avenue. Each station is unique. Twenty-four artists were involved, resulting in a variety of styles and media.

Most of the public art programs have proceeded without comment or controversy. But a dramatic exception was the debate in the 1980s about Michael Spafford's giant mural *The 12 Labors of Hercules* in the Washington State House of Representatives and the Alden Mason paintings in the Senate, both commissioned in 1979. Both works went through the usual process of selection, but then the state senators and representatives howled. They didn't like them—period—and fought to have them removed. The works first went into storage, then were reinstalled in the Capitol Building, then draped, then eventually moved to nearby colleges. The Spafford was never completed.

Allied Arts played a lead role in the fight to save these works, according to Douglas McLennan in the *Seattle P-I* in 1988. Members went to court and to Olympia to protest. Richard Andrews, the articulate former director

of the Henry Gallery, testified that tastes change; it takes time for people to become accustomed to some things. House speaker Joe King said that Spafford "has endured more embarrassment than we ought to put an artist through." The Mason work was called "inappropriate" for the state house, and the Spafford not just "inappropriate" but "pornographic." In the end, both works came down in spite of all of the protests. In 1988 Cara Wells, acting director of Allied Arts, thanked the 225 people who had donated money to the Mural Defense Fund. The legal bills ran to nearly thirteen thousand dollars. The bill would have been even greater, without the more than thirty thousand dollars in pro bono legal help.

Allied Arts fought a hard battle not only for the establishment of arts commissions but also for visual arts programs. Millions of dollars have been spent in the past forty years. Most would argue that the monies made a major contribution to the public good. However, there are those who would assert that the visual arts programs have become mired in small projects and design-team concepts that have virtually flooded the area with art of little major importance—especially compared with the public art of the early years in the 1970s. Today the program is neither ambitious nor exciting. It is geared toward helping local artists. Cultural groups are currently seeking legislative authority to put on the ballet in 2014 one tenth of one percent sales tax that could produce $42 million a year, said longtime arts advocate Kevin Hughes. Such groups would include the Woodland Park Zoo, Seattle Science Center, Aquarium, Museum of Flight.

15 / Jerry Thonn

I T ALLIED ARTS HAD A SLEW OF ARCHITECTS IN ITS ARSENAL OF professionals to carry its banner and do its collective deeds, it also had plenty of lawyers at the ready to write briefs, mount arguments, and corral lawmakers. In the early years there were more architects than lawyers, but that balance changed as Allied Arts changed.

In the thick of it all was Jerry Thonn, who came to Allied Arts in 1961, became president in 1968 69, and has since been a trustee with the Allied Arts Foundation, which he helped create. Thonn was a major voice in the campaign for the planting of street trees, a longtime key issue for the organization; for the regulation of billboards through the Washington Roadside Council, which was born at Allied Arts; and for the burying of utility wires underground. In the early seventies, he chaired a study on energy. During that same period, it became clear that the health of Lake Union was in jeopardy, and Thonn led several battles to save the integrity of this complex urban environment and to guide its future. In each of these various endeavors, he often served as president, chairman, or cochairman.

Of major concern for Thonn over the years were the preservation of the Pike Place Market and the charting of its future. He was active in the Friends of the Market, which sprang from the bosom of Allied Arts, and had a major voice in the drafting of the 1971 initiative that saved the Market. He became president of the Friends the next year and stayed with the various offshoots of the Market that followed, such as the Market Historical Commission, the Pike Place Market Public Development Authority, and the Mar-

Jerry Thonn, 2012. Photo by Roger Schreiber.

ket Foundation. Thonn's tenacity helped to save the Market a second time in the early 1990s when it was threatened with a takeover by a group of New York tax lawyers. No one at Allied Arts has stayed the course as has Thonn. When asked why, Thonn stated, "I did it because it needed to be done: good citizens working to the common good and betterment of the city in which they live. I never saw myself as a hero or a leader, but doing what I thought was the right thing to do. There were some sacrifices but rewards as well, including knowing some wonderful people. It is very satisfactory in seeing things that were accomplished in which I had some influence."

For forty years, Thonn was associated with two major Seattle law firms, Reed, McClure, Moceri, & Thonn, and then Helsell Fetterman. Over the course of time, the affable Thonn tried more than three hundred cases. Somewhere along the line, he went from the more formal "J. Edwin" to "Jerry."

Like many of his friends in Allied Arts, Thonn came from the Midwest—first Albert Lea, Minnesota; briefly Northwood, Iowa; then Fargo, North Dakota, where he grew up and graduated from high school. At the prompting of his mother, who wanted to start a business with her sister, the family moved to Washington, and ultimately to Yakima. Thonn spent a couple of years with the US Army in Austria and Italy in the 1950s, then attended Columbia Law School, thanks to the GI bill. "I loved New York. I sold librettos at the Metropolitan Opera (the old Met in midtown), for which I was paid with a seat in the fifth balcony." He got standing room for most plays

on Friday nights for a dollar. Although the new law school graduate left New York City and returned to the Northwest, his sojourn there left its mark on him. He met his wife, Ernalee, who became a noted designer of jewelry, and they settled down to their new life in Seattle.

He discovered Allied Arts over coffee with other young lawyers:

One thing led to another. I found it very interesting, a very lively group at the time, very much an advocate for the arts and the community. It started as a kind of umbrella organization for arts groups, trying to promote the idea of a regional theater, a viable symphony, a viable opera program, a viable city center, and all those things. We tried to do everything. Eventually the symphony grew up and had its own public relations staff and promotion activities. It didn't need to ride on the back of Allied Arts anymore. The same was true of theater, opera, and so forth. These organizations, which had just been fledgling and struggling, grew up and had their own agendas. So I think they kind of gradually drifted away from Allied Arts, not because of any antagonism, but simply because they did their own thing.

In Thonn's first few years with Allied Arts, he cut his teeth on the issue of underground wiring, with a committee was called Operation Deadwood, a name he did not like. "I replaced it as soon as I could." The new name was less catchy but more businesslike—the Underground Wiring Committee. The purpose was to advocate putting utility wiring underground and replacing utility poles with street trees. The city had a surfeit of utility poles clogging city streets. Part of the reason there were so many was that in parts of the city there had been a dual electrical system for some years. Both Seattle City Light and Puget Power had competed for territory. "For a while" Thonn recalls, "there might be poles of Puget Power on one side of the street and poles of City Light on the other side. There was a wonderful man from Northwest Bell who said Seattle had the most cluttered wire and pole superstructure of any place in the country." Eventually City Light prevailed over Puget Power.

Among the first objectives of Thonn and his committee was to find out why City Light wasn't doing much undergrounding. Not only that, said Thonn, but the agency was not cooperating with the neighborhoods that wanted undergrounding. "So we started meeting with City Light along with Jack Robertson (better known for his Herculean effort to rid roads of billboards) and a couple of other people."

They discovered that City Light was "an empire" unto itself at the time. It was supposed to be run by the city council, but the council didn't have the time or an interest in getting involved. "And City Light was doing great. The only time it came before the council was to lower the electrical rates. There had been no raises since about 1920. Every few years, they'd lower them because they had all this hydropower. We had very modest electric rates and a good performance, so nobody wanted to touch it." City Light had enormous cash reserves, Thonn said. The committee and Allied Arts began to apply pressure, drafting an ordinance mandating a certain amount of money for plant improvement and undergrounding arterials. The agency was adamantly opposed, but the ordinance passed anyway.

Thonn spent a lot of time on underground wiring. "At one point we were trying to combine our underground wiring program with street tree improvements. At the same time, there was a federal program called Urban Arterial Program as well as some poverty programs that had money for underground wiring or just neighborhood improvement. So we tried to get all those things going. There was a lot happening." Thonn clearly remembers getting a call from mayor Wes Uhlman. He told Thonn he wanted to see him and Jack Robertson in his office. "We went there and he took us into his conference room. He had a big map of the city spread out on it. Now you've passed this damn underground wiring for us, where am I going to put them? So we sat there and looked at the map and said, do this and this. He wanted to make sure it was equally divided in the various quadrants of the city."

Thonn's hard work and leadership did not go unnoticed. He was asked by Peggy Golberg and Shirley (Turner) Collins, among others, to take on the presidency of Allied Arts. He demurred, saying he was too young and inexperienced, "and maybe I was, but I went ahead anyway and agreed to it." He did his research. He had lunch with every former president and asked them what Allied Arts did or should be doing.

> They all had different stories. Everybody had a different perspective. I remember Ralph Potts saying that Allied Arts needed to encourage public fountains. I thought, Allied Arts is really a chameleon. It sort of changes as times change and presidents change and boards change. I think in my time Allied Arts was more focused on urban beautification and the role of the city in the arts community. The board meetings in those days were really wonderfully exciting experiences. I mean, they covered everything

that was going on of importance in the city. All the people there were those I read about in the newspapers. They were formidable people, all interested in the arts, the arts community, and what we were doing. And they were fun. They could fill council chambers with people or go to Olympia.

Among them were Ibsen Nelsen, one of the city's leading architects and urban thinkers, and Norman Johnston, a professor at the University of Washington in urban design.

Ibsen ran the best meetings—calm, forceful, polite. He kept things moving, but he saw that everybody was heard. We would arrive at a consensus and a sense of direction and then move on. Norm was very interesting and knowledgeable. His meetings were enjoyable because he had a dry wit. Where there were a hundred things in the course of a meeting he would just do this and do that and make you smile. He was also tactful. He was interested in expanding Allied Arts' reach to some of the communities that weren't being reached—minority communities, lower income communities. When you have a powerful board like this, they are often white people talking to themselves, prominent people talking to one another. There was a need to broaden the perspective of Allied Arts. Norm was very good at that.

Thonn is not sure to this day whether he came to Allied Arts with goals or whether the goals came to him. To him the organization seemed to represent different things to different people. "I assumed we would continue in doing what we'd always been doing. There were plenty of people who would bring problems to us. One such person was Betty Bowen, who routinely called people all over town first thing in the morning. Norm had a kind of agenda. Because he had a longer history with the organization, he knew what was possible and what not."

One of the things on the agenda was the Pike Place Market, which was in danger of being bulldozed into the faceless urban

> *The board meetings in those days were really wonderfully exciting experiences. I mean, they covered everything that was going on of importance in the city.*

renewal. The story, of course, is one of the celebrated stories in Seattle's history and a defining moment of people-powered liberalism that came to characterize the city. The *Seattle Post-Intelligencer* did an article about the Market in 1996 in which Thonn said,

> People need to remember why we saved the Market and what it was all about. It was a mixed community with an economic cross-section of people. It was never meant to be a fancy or a high-priced place. It was not a rich man's place or a poor man's place. It was everybody's place. There was a time when there were something like 5,000 single men living within a mile of the Market mostly in single-room occupancy hotels. They were the Merchant Mariners and loggers and retired alcoholics. They were all the people living there for the winter when their summer jobs were not functioning. Across the street, across Pike Place, there was what Victor [Steinbrueck] called the soft-food, the soft-fruit area, which meant day-old, the fruit that was about to go, the day-old bread, the week-old bread, the horse meat and all the things that made it possible for people of limited means to live.

That's what Steinbrueck loved about the Market, Thonn said. "I did too. Times change, but we wanted to preserve some of the character of the Market. It could be an uphill battle sometimes."

When Thonn arrived on the doorstep of Allied Arts, he didn't know much about the Market, he said. But he soon learned that there was a serious conflict within Allied Arts, "with good people on both sides. As an organization it was not taking a position. There was the group of people led by Victor Steinbrueck and Friends of the Market trying to save the Market as they saw it, pleading for retention of its character. On the other side were architects who had been retained to design a new market under urban renewal. They claimed the Market was essentially beyond redemption. Structurally it was unsafe and the plumbing wasn't operating satisfactorily. The cooling systems weren't working. It needed a big injection of remodeling, by which they meant to tear it down and build a five-thousand-car garage, fifty-story hotel and all that."

Thonn tried to remain neutral because he felt it that it was important that both sides within Allied Arts were treated fairly. "We wrestled with the question in Fred Bassetti's office. But then the situation became apparent. Victor was very persuasive, and the organization gradually shifted over toward the Friends of the Market point of view. Allied Arts took the posi-

tion in favor of public ownership of the Market, which nobody dreamt was possible at the time. Victor came out with his book on the Market, there were the champagne breakfasts at the Market, and the campaign gained momentum." Friends of the Market started as a committee within Allied Arts in about 1964, the year Thonn joined the organization.

The City Council voted to go with the urban renewal plan, meaning they would tear down the Market. "We had three choices: first, just say no; second, direct the city to buy the Market, which seemed impossible financially at

Jerry Thonn, 1980. Photo courtesy of Jerry Thonn.

the time; and third, declare the area an historic district, which would make implementation of the Urban Renewal plan impossible." Thonn helped write the now famous initiative. "There wasn't a lot of precedent in those days. There was no Tim Eyman to tell us how to do things, but we did and then went on the campaign trail. The entire business establishment, politicians, media were for tearing down the Market: the little guys—Allied Arts—against the big guys, the developers, who tried to trick the public. It didn't work. But when the initiative passed, Uhlman was among the first to say, 'We will work with you.'" Thonn was on the Historic Commission for a while, then he thought he was done. He was—until 1976, when Tim Mannering asked him to join the Pike Place Market Preservation and Development Authority. He did, and was immediately elected chairman. "We thought the Market battles were over," Thonn said. They were just beginning.

Steinbrueck wrote Thonn a letter that year that spurred him to continued involvement: "Dear Jerry, I want to thank you most sincerely for the great help that you have given to the Market cause over a long period of time. I feel that I can take the liberty in this situation of speaking for all of the Friends of the Market in expressing our appreciation. No one will ever know how much you have really contributed through your dedication, skill, and judgment. But I do have some measure of how significantly you have contributed." "I was very pleased to receive that," Thonn said.

If the market was a physical shambles, Pioneer Square was too for quite a long time, with its rundown character, shabby areas, empty stores, and slum hotels. Then people began to appreciate the Square's potential, such as a prominent interior designer Allen Vance Salsbury, who opened his office

there; the Blue Banjo Tavern; Ralph Anderson, an architect noted for his Northwest style of design and for being a fountainhead for development in the square; Richard White, who opened his gallery, now the Foster/White Gallery. White bought the Globe Building and offered Allied Arts a space at a generous discount. "We moved, the first office outside of Alice Rooney's dining room."

That was somewhat controversial within the organization, because some thought they wouldn't be safe. "We dissuaded them, cleaned up the space, and took a lease with some compatible organizations like Landscape Architects, American Institute of Planters, American Institute of Interior Designers, for which Allied Arts staff answered their phones and took messages," Thonn said. "There was also an active assortment of people with plenty of ideas who acted as a breeding ground for bodies when the City Council was being petitioned for one thing or another. There was strength in numbers."

With their big windows, they had a view, such as it was, of a parking lot that gave birth to Occidental Park. Some architects, including James Olson, proposed painting the park as a demonstration of what it might look like. How that was accomplished—getting all of the cars off the lot—is still something of a mystery to Thonn, but they did, painting a would-be green park on the asphalt surface. That helped the city envision a park in the space. A historic preservation ordinance was passed, Thonn said, and things began to turn around. "People began to move in. I don't think it hurt that Allied Arts had its main office down there."

Not one to rest on his accomplishments, Thonn got involved in the rescue of Lake Union, which was being threatened on numerous fronts.

> People were filling in the lake, using it as a dumping ground. They would come and fill and fill and fill. The state made a big mistake of leasing, or selling, some of the land around the lake to private developers, so there was a lot of encroachment. Others were going to build an atrocity on the west side called Roanoke Reef. Street ends ran into the lake and provided public access, but the neighbors would crowd into them, and pretty soon they began to disappear. We had some studies that showed the various sizes of Lake Union over the years. It had been a big lake once but was getting smaller and smaller and smaller as people filled in and filled in.

The matter was urgent to Thonn and his friends. They were determined to save the lake. "We got our groups together (including the Floating Homes

Jerry Thonn

Association), with Jack Robertson as the ringleader. We went to the city council with a petition and said, 'You've got to do something' and asked them to declare a moratorium on building over the lake. They weren't quite ready to do that, but they created a Lake Union commission of citizens to study the uses around the lake, encroachment on the lake, the restoration of street ends as public space, and the possible development of other public space for parks and access." During that time nobody wanted to build there because the future was uncertain. Subsequently the Shorelines Management Act passed, and that superseded everything, so all uses were controlled. "What we ended up doing, I think," Thonn remembers, "was basically creating a holding action that slowed development until there were some guidelines."

Perhaps even more impressive than his many accomplishments at Allied Arts, wrote Mary Coney, former Allied Arts president, "was his way of being. In all his good works for our city, he conducted himself in a manner that was quiet and reasoned, yet all the while maintaining a strength of purpose and clarity of vision. By his manner, he brings a sense of fairness to all that he does, and encourages all to speak and be heard; he listens well, and therefore hears the timid as well as the vocal. This judiciousness in itself is a rare quality and one undervalued in our noisy, competitive society."

16 / *Fighting to Regulate Billboards*

S URROUNDED BY WATER AND MOUNTAIN RANGES TO THE EAST and west, Seattle has one of the most spectacular natural settings of any city. But throughout the good share of the past century, this natural setting was marred by omnipresent billboards. Allied Arts and others worked mightily to change that in spite of resistance, often from official quarters. Other than the billboard constituency, only a few liked billboards. Unless one stood to gain financially, who would like the disagreeable clutter and ugliness and rampant commercialization they represent? However, fueled by untold money and well-greased professional lobbyists, billboarding was remarkably resilient. Billboard backers fought any attempt at regulation, winning (most often in legislative bodies on the national and local level) not necessarily because the pubic was in their favor but because the billboard business was well-organized and had deep pockets. The issues were diverse, but eventually the courts became favorable to sign control—in the city, in the county, in the state.

The growth of the state and national highway system, which accompanied the rapid development of automobile travel, created an opportunity for confronting a concentrated "captive audience," according to a statement by the Washington Roadside Council. An interest group born in the embrace of Allied Arts, the council did not hold back its criticism of the resulting ugliness of billboards: "Many of our highways are cluttered with disorderly and unsightly advertising signs," "garish and discordant," a "creeping blight." A number of states had enacted legislation to regulate or eliminate highway

billboards altogether, but Washington State was among the last to do anything concrete. Studies indicated that fewer signs meant more safety, the conservation of scenery, the promotion of tourism, and freedom from uninvited intrusion. Nearly sixty years ago the US Supreme Court ruled that the "concept of the public welfare is broad and inclusive. The values it represents are spiritual as well as physical, esthetic as well as monetary. It is within the power of the legislature to determine that the community should be beautiful as well as healthy, spacious as well as clean, well-balanced as well as carefully patrolled."

According to a report by the Washington Roadside Council, roadside clutter on principal thoroughfares probably reached its peak in the decade before World War II. A survey in the mid-1930s, for instance, shows that a forty-seven-mile stretch of road between Newark and Trenton, New Jersey, was lined with 472 billboards, 300 gas stations, and 440 other commercial establishments. Aurora Avenue, an extension or beginning of Highway 99 in western Washington, probably wasn't much better. A 1958 Federal Highway Act tried to encourage a system of giving bonuses to states to encourage the removal of billboards. The program was not successful. President Lyndon Johnson declared, "The conclusion is clear. The voluntary program has failed to control outdoor advertising." The key was in securing the will of elected representatives to take meaningful action.

Allied Arts leapt into the fray in 1955 with a proposal for roadside treatment and regulation. From that initial impetus was born the Washington Roadside Council. The strict control of billboards was a major facet of that draft. Three years later Allied Arts, now allied with the Municipal Arts Commission, was still working on the problem. Millard B. Rogers, writing for the executive committee of Allied Arts, did not mince words: "The outdoor advertising people protest any regulation." Billboard lobbyists were asking for the removal of all protection against billboards on 65 percent of the entire length of the interstate freeway. Cities and towns across the state would be affected. In the late 1950s, Allied Arts sent an urgent appeal to its members to take up the battle cry again. "We cannot emphasize enough," Allied Arts asserted, "that the situation is critical. . . . Write to the governor, write to your legislators, go to Olympia personally, attend hearings as they come up." Peter Blake, a distinguished architect and managing editor of *Architectural Forum*, put the matter bluntly, " In Seattle—a city that once boasted of some of the most beautiful environs in the world—the billboards have successfully blotted out nature."

Seattle and Washington State were slow to get billboards off the roads. By the time Washington was considering a modest billboard ban, Canada had outlawed them. So too, had Portland—although not without a fight. Mrs. Walter McMonies of the Portland Arts Commission told the Governor's Council on the Arts, the first such regional conference on the subject, of the struggle with the advertising industry, how they falsified the issues and how women had come to the aid of the antibillboard proponents by writing letters to advertisers threatening to boycott their products.

The year 1961 marked major legislation for the control of billboards in Washington State. The Highway Advertising Control Act, according to a Washington Roadside Council statement two years later, regulated advertising signs along the interstate freeways and select portions of a few scenic highways. This act brought to a climax the fight to obtain such legislation that had begun thirty years earlier. Numerous civic, political, conservation, and community organizations, including Allied Arts, had joined a statewide effort to secure passage of the bill. Unfortunately, only 15 percent of the state highways, and no county roads or city streets, were affected.

Legislators were besieged with letters and postcards and phone calls and personal visits, many organized by Allied Arts, which alone sent mailings to eleven thousand people. In March 1961, the Washington Roadside Council, of which philanthropists and Allied Arts trustees Bagley Wright and Anne Gould Hauberg were board members, wrote to thank Allied Arts for its efforts in getting the bill passed. "Every time additional messages to the legislators became necessary, Allied Arts responded. . . . The success of this movement must give special pleasure to your organization considering that the Roadside Council was originally sponsored by Allied Arts." The organization was among thirty groups that supported passage of the bill.

By reasonable standards, the new law was moderate. That said, the billboard industry kept the provisions of the law in the closet for years, through a variety of means. Under the new law's provisions, only 470 of the 760 signs owned by outdoor advertising companies had to be removed. As a footnote, proponents of controls pointed out that Hawaii and Switzerland had no billboards anywhere. Two years later a bill was introduced that would extend the restrictions to more scenic highways. At the same time, the industry, under the auspices of the Washington State Motor Hotel Association, sought to water down the 1961 bill or destroy it outright. All sorts of highways would be exempt, as well as highway right-of-ways acquired prior to 1956—half of the interstate system. Again, members of Allied Arts were

exhorted to contact legislators with their views. At the same time, another bill was introduced that would extend scenic highway protection. The two bills were then combined, forming a compromise bill, that would put the "good" bill to serious disadvantage. Members of Allied Arts were urged to contact legislators with their views: "write, wire, phone your legislator or the governor; go to Olympia. The billboard industry is counting on the natural inclination of volunteers to return to private interests and let up on pressure in a campaign such as this. We must show them and our legislators that we feel as intensely as ever and are determined to keep the Highway Advertising Control Act intact!" The compromise failed to get out of committee.

Subsequently a lawsuit was brought in Seattle, challenging the ordinance to remove nonconforming billboards. The antibillboard groups won in court, with some limitations in the judgment. Seattle passed its landmark billboard regulation statute the same year as the state, but there were delays in executing it, in part bowing to the statewide effort. There were those who felt that the two parallel campaigns could not be mounted successfully. The billboard industry was happy with the delays and pushed for more.

The *Seattle Times* exclaimed in an editorial, "Veterans of the antibillboard wars have learned that even the smallest measure of progress is made only at great expenditure of time and energy, and that is does not pay to scatter their fire." Philip Bailey, publisher of the *Argus*, proposed that billboards be eliminated entirely: "Viewed objectively the billboard firms are really parasites which live off the money taxpayers spend building roads which they then proceed to clutter with billboards. They contaminate our air worse than any smog. They are impossible to avoid, unlike advertisements in newspapers and magazines, or those on radio or television." And Norman J. Johnston, then president of the Allied Arts, wrote to the City Council, "Think Paris and Venice with billboards."

Another issue that involved Allied Arts, were some 332 nonconforming billboards, defined as signs that had nothing to do with the business or residence on whose property they were located. Allied Arts wanted them taken down. In 1957, the Seattle City Council had approved a new zoning code that excluded most billboards from residential and neighborhood business areas. Proposed legislation in 1962 would allow for the indefinite extension of these billboards' life and the termination of only a few.

One of the most clever tactics the industry used to gather support and weaken opposition was to give billboard space to nonprofit organizations, some of which were connected to Allied Arts. The latter's position was very

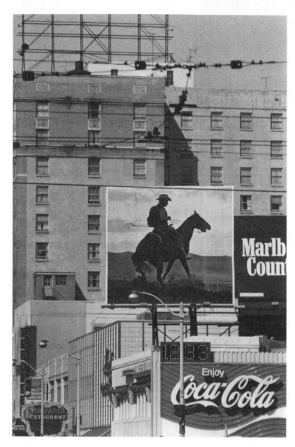

Anti Art Squad photo of Marlborough and Coca Cola billboards at Fourth Avenue and Pine Street, 1972. Photo by Edward D'Arms. University of Washington Libraries, Special Collections.

clear: "We request that all organizations refuse such advertising." The Seattle Symphony was among those groups to whom pleas were made to stop accepting free offers from billboard companies. They complied. Allied Arts also adamantly opposed the proposal of the General Insurance Company for a variance to erect a sign atop their building in the University District that would measure eighty feet by ninety-six feet, along with 360 reflector lamps and nearly a half mile of neon tubing. After a considerable protest lodged by Allied Arts, the variance was not approved.

In 1964, Allied Arts was already filling its coffers for expected battles in the 1965 legislature with stickers such as "Fight Billboard Blight," while the billboard lobby and its friends were warming their guns to try to destroy all or part of the 1961 bill. Jack Robertson reminded Allied Arts members that the battle was ongoing and that they could not let up on the pressure. The consequences would be devastating. The subject came up at every monthly

Fighting to Regulate Billboards

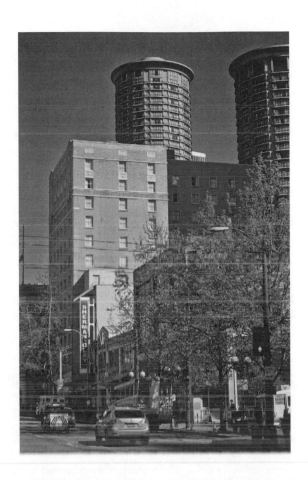

Fourth Avenue and
Pine Street, 2013. Photo
by Roger Schreiber.

meeting of the Allied Arts board of trustees. The *Seattle Times*, in an editorial, called the battle "unending": "Slowly Washington's citizenry are being awakened to the relentless spoilage of their state's scenic and outdoor-recreational assets." The legislature sustained the law.

Among the many letters that were written to legislators was one, in 1965, by Ibsen Nelsen, then president of Allied Arts, to Slade Gorton, then in the House of Representatives. Nelsen implored Gorton to keep the provisions of the 1961 act intact: "Our 1961 act represents a good investment for Washington citizens. I hope you will oppose any relaxation of provisions of the act that will compromise a heritage we hold in trust for our children." Jack Robertson, then president of the Washington Roadside Council, asked allies to keep up the fight on several fronts against "indiscriminate placement of billboards."

Despite support from the White House and good intentions, the 1965

federal act was regarded as flawed and weak, a "bust," according to the *Seattle Post-Intelligencer*. "It is one of the most disappointing statutes Congress ever enacted," echoed the *Washington Post*—the result of too many compromises brought about through intense lobbying. Senator Warren G. Magnuson, in a letter to the secretary of commerce, wrote that the bill constituted no standard. The provisions of the 1961 bill were saved in the 1965 legislature. By one vote. Two women, Marjorie Phillips and Phyllis Kirk, representing Allied Arts and Washington Roadside Council, among other organizations, spent the entire legislative session in Olympia. They were given full credit by Allied Arts and their allies for saving the 1961 statute.

The lesson for the Washington and all other states with superior legislation, argued the Roadside Council, was to keep their own laws. The newly enacted federal legislation was in conflict with the much stronger and better-written 1961 Washington law. The worry was that if the state law was not "crippled," to use the *P-I's* term, its higher standard of regulation could face a reduction in its federal highway allocation. The differences between federal and state legislation were major, including the requirement of compensation for signs taken down. The cost would be prohibitive, and with no justification, or, as the *Seattle Times* wrote in an editorial in 1967, "We cling to the old-fashioned notion that those who create nuisances definable by law ought to be obliged to remove that at their own expense."

The struggle continued. The billboard industry was indefatigable. But so were its opponents, who were less flush with money but armed with volunteers and the public. The industry brought suit in Thurston County, backed by a slew of lawyers. For two weeks, arguments ranged back and forth, with some two thousand pages of testimony recorded and two hundred exhibits introduced. It was one of the largest trials of the year. Billboards lost. The judge ruled than the federal legislation did not preempt that state's 1961 measure. Appeals were predictably filed, eventually leading to the US Supreme Court. Another suit was filed in US District Court.

Six years after the initial sign-control ordinance was passed, it was not being enforced. The Seattle City Council, wrote the *Seattle Post-Intelligencer* in an editorial, had failed to deal forcefully with the problem. A new ordinance did not win a majority vote. "The proper solution to the problem lies not in the passage of a new ordinance," the editorial asserted, "but rather in the enforcement of an ordinance already on the books, which has lain dormant while compromise negotiations have been underway." The same year, the billboard lobby returned to the legislature with another proposed

bill that would roll back the 1961 landmark bill. "Time is short," implored Robertson. He urged Allied Arts members to write, to call, and to visit their legislators. "I need not tell you that Allied Arts is moving into its sixth year of supporting billboard control. And I need not tell you of the weary succession of years in which we have roused ourselves to beat off the special interest pressures of the billboard people and their allies to exploit our tax-financed highway system with the blight of billboards." Norman J. Johnston, an Allied Arts trustee and president, implored Representative Jonathan Whetzel to "stand firm" in his support of the 1961 bill, which he did.

In 1973 there was an initiative to virtually eliminate all billboards. Not surprisingly, it was opposed by the Downtown Seattle Development Association and the Seattle Chamber of Commerce. "We shouldn't be too surprised at these actions," said Paul E. S. Schell, president of Allied Arts, in a statement, "since they are the same people who supported the Bay Freeway, bulldozing Pike Place Market, opposed the Westlake Plan, Pioneer Square Historic District and even school levies." After a massive campaign against it, the initiative was defeated. Afterwards, Schell surmised that most people wanted regulation, not elimination. And the following year, 69 percent of the electorate said it wanted strict regulation. Essentially the industry vacillated between seeking unbridled freedom to put signs where it wanted them and seeking weak regulation as long as profits continued. The public good—and public opinion—were rarely considered.

Legislation was passed in 1977 that would require financial compensation for billboards that were removed, in spite of a court decision that ruled that the amortization of projected losses of billboards was sufficient. Councilwoman Phyllis Lamphere, an outspoken opponent of billboards, said that the issue should go to court. Allied Arts sought a moratorium on new billboard construction until the legal issues were resolved. The saga continued locally and nationally, with Allied Arts in front, writing letters, meeting both state and local legislators, and contacting federal officials. New bills were seemingly introduced every legislative season, and new lawsuits filed. In 1978, a major billboard company was suspected of topping off in the middle of the night one hundred city-owned trees on Aurora Avenue near billboards owned by Ackerley Communications. The public was predictably outraged.

Rebuffed at every other turn, the billboard lobby managed to get its allies in the legislature to insert a measure in the Omnibus Highway Bill that would in effect kill the 1961 bill. It was turned back in committee, only to reappear in a different guise that slipped through the legislature in the clos-

ing days of the session. The Lone Ranger, in the disguise of Governor Dan Evans, rode to the rescue. He vetoed the measure and went one step further by eliminating any billboards that could be readily seen by a motorist.

Another instance of tree pruning to clear a visual path to various billboards backfired. Councilman Paul Kraable was outraged by the act and sought an outright ban on billboards. Mayor Charles Royer proposed only a reduction in the size of billboards, but the council, by a vote of 7 to 1, simply ignored him and voted for an outright ban. The industry, Kraable said, had made no effort to minimize the effect of billboards or to eliminate them. Ackerely Communications, the biggest of the billboard companies, said it would sue. Subsequently the State Supreme Court, in a 5 to 4 decision, ruled that taxpayers would not have to compensate billboard companies when their signs were removed.

In a joint letter in 1980, Paul Silver, then president of Allied Arts, and Pamela Schell, chairman of the Sign Control Committee, pointed out that in spite of existing laws, there were still numerous billboards that should be removed. "The purpose of this letter is to let you know of our support for the immediate removal of illegal billboards. We are very concerned, however, that the city continue with its efforts to enforce the existing ordinances in a courageous and aggressive manner."

As time went by, there were fewer and fewer billboards. "It was a long, long battle, at least ten years" said Jerry Thonn, an Allied Arts president. He and Jack Robertson led the fight with an unyielding persistence that matched their opponents move by move. "The billboard industry was very powerful," said Thonn. "Eventually they were banished in many places. They had gone out of fashion." Victory did not come easily or quickly, but it did come.

17 / Mary B. Coney

ALLIED ARTS HAS ALWAYS THOUGHT OF ITSELF AS FORWARD-thinking, but there was one notable exception to this characterization, probably more a result of happenstance than design: presidential leadership by a woman. For two decades the organization of freewheeling thinkers only had men presidents. Then in 1976, Mary Coney, who had a doctorate in nineteenth-century British literature and had spent most of her academic career on the faculty of the University of Washington, became president. Coney doesn't think that seems such an accomplishment now. "There are a number of times I've been the first woman for different things, as were a number of women in that era. The atmosphere for such issues was changing." Did anyone object? "I don't think so. For one thing, in fairness, Alice [Rooney, executive secretary, then director, for two decades] helped to break the mold because she was the woman who was really the bigger power. Alice always handled that very well." "Mary probably was the best person we could have had as president," said Rooney. "She worked very hard at it. This period is when Allied Arts lobbied for the Seattle and King County arts commissions budgets. That was a very big thing."

Being elected president of Allied Arts didn't seem so groundbreaking then, although at the University of Washington faculty women were in the distinct minority. "Now there are all sorts of women in positions of power," Coney said. "Although at the University of Wisconsin, where I was an undergraduate and active in student government, women were not so marginalized. It was a very progressive place, accustomed to women in leadership roles." Besides,

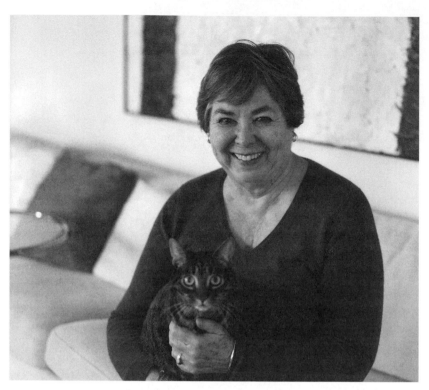

Mary Coney, 2012. Photo by Roger Schreiber.

both her sisters, also having moved to Seattle in the 1960s, were high achievers; her older sister, Pat O'Very, was a teacher in early childhood education and the founding director of the Valley School in Madison Valley, and her younger sister, Jane Uhlir, has had a long, prominent career as a physician and administrator at Swedish Hospital. "We always encouraged each other to take risks."

Coney also gives her former husband, Byron Coney, a lot of credit. "He was supportive, wasn't threatened by my doing things. He would be bemused at times, but he had his own activism. He is a kind of an eccentric fellow, but he gave me a lot of backing, which was very important at the time. I didn't feel like I was out there by myself. I must say, I think, if I had been a single woman at the time, I might not have felt quite as willing or able to take on some of these fights. Byron would say, 'Let's do this,' and he would be willing to do it."

Much later, near the end of Coney's career at the University of Washington, she was elected chair of the Faculty Senate, the body that represented

Mary B. Coney

faculty interests to the administration and the larger community, including the state legislature. In that capacity, Coney chaired meetings filled with articulate, often adversarial voices. In looking back, she credits her experience as president of Allied Arts with preparing her for this later leadership role. In fact, she recalls, "no one at the University had sharper knives or arguments than Allied Arts board members. Even a normal meeting was filled with the cut and thrust of experts. I was schooled by the best of colleagues."

Those years, the 1970s, when Allied Arts leadership included architects such as Fred Bassetti, Ibsen Nelsen, and Victor Steinbrueck; lawyers such as Llewelyn G. Pritchard, Jerry Thonn, and Paul E. S. Schell, were clearly "a high-watermark," Coney recalled. Then, perhaps inevitably, came "a period of decline" and "turmoil." "Early presidents had two-year terms. Later some people slipped into one-year terms, which I think was a shame. You needed a couple of years to really get up to speed and work on some real projects. Then, after two years, you got a little burned out and needed to give more attention to your job and family."

Schell was a kind of a "talent scout" for new leadership, Coney said. "He wanted me to be vice-president, then president following him. I really wanted to do it at the time because I liked working with Paul, and the work we were doing, but I felt the need to finish my dissertation at the UW ["Reflections of Reform: Novels of the 1870s"]. As you know, thesis times run a certain amount of years, and after that, you may have to re-do some of your doctorate work, which of course I did not want to do. So I did not run that year."

There were any number of local board members from Seattle who were smart and ambitious, but there was also an influx of members from points farther east. "An awful lot of people came from the Midwest—Paul Schell from Iowa, Jerry Thonn from North Dakota, and Art Skolnik from Illinois. We saw this wonderful city that had not yet been ruined. At that time a lot of cities were discouraging downtown development and building malls outside the urban core. We wanted to ensure that Seattle didn't follow the same ugly path. I think a big impetus came from people from other places, although I don't want to take credit away from those born in Seattle. There was a nice joining together of people from many places who saw this period as an opportunity to save lots of things."

Reared in the Chicago suburb of Downers Grove, Coney moved to Seattle in 1965 and joined Allied Arts five years later. Through a college friend she

Mary Coney, 1979. Photo by Roger Schreiber. University of Washington Libraries, Special Collections.

had met the painter Thomas T. Wilson, also from Illinois—a big farm in the southern part of the state, near Champaign. After graduate school at the University of Illinois, Coney was footloose and came west, visiting Wilson in Port Townsend, where he was living and working, and enrolling at the UW to finish her PhD. Through Tom she met Peggy Golberg, owner of the Duck Press; Shirley (Turner) Collins, who later founded precedent-setting Sur La Table; Lorenzo Milam, founder of KRAB, a noncommercial radio station, and all sorts of other people involved in the civic life of the city, including Allied Arts. That whole period, from the 1960s to the 1980s, Coney feels was the heyday of Allied Arts:

> There was so much evident work to be done. There were lots of lawyers—Paul Schell, Jerry Thonn, Paul Silver, Llew Pritchard, Jim Uhlir, Lish Whitson, Henry Aronson—so we had smart legal minds to guide us. We also had a lot of architects with strong aesthetic vision, and a community of ordinary people like me, who saw that Allied Arts was a good cause. It was frequently described as a bunch of talkers. Well, we were. We did others things, of course: write, organize, lobby, put on festivals, give parties, support crafts weeks, sponsor debates, sell. Allied Arts did not appeal to everyone. For those who liked order, organization, and status of a certain kind—well, this wasn't that kind of board.

Coney quickly lists all of Allied Arts' past accomplishments, among them public funding of the arts, the planting of street trees, underground wiring, the regulation of billboards, securing a human cityscape, and historic preservation of places such as the Pike Place Market and Pioneer Square, the Olympic Hotel and the Skinner Building—"one thing and another, not in any predictable fashion. Rae Tufts, longtime trustee and influential member, mentioned to me the other day, and I think her point was well taken, that there was so much that needed to be done, we didn't just do one thing, and then another thing."

"They really came one on top of another, almost at the same time. It was very good we didn't stop that. I mean, there was lots of energy. The atmo-

Mary B. Coney

sphere was kind of helter-skelter, but that could be very exciting. There was always something going on, and we were always down at city hall. At the time we also knew the mayors, and they always knew us. We were kind of movers and shakers. An important point," she added, "is that an Allied Arts person was not just a solitary figure with an idea but one who could summon support from a whole group of people. Allied Arts provided an automatic constituency."

"We had a few establishment people, by that I mean money people," Coney said. "We were never good about raising money, and our few attempts to raise money were usually a disaster. I was involved in one as president. The arts were a very large part of our lives, but not money. We were there to do the right thing, at least that is what we thought. If people were offended because they were in some way financially hurt by some of the actions we took, that wasn't our problem. We didn't want money to be a criterion for membership. I don't think Victor [Steinbrueck] had much money, but look how much influence he had. The rich could put a damper on our efforts and conversations. They often had too much of an investment in the status quo. There could be all sorts of conflicts. As for those at the other end of the economic spectrum, they were trying to put food on the table."

Rae Tufts with David Skellenger at an Allied Arts fund-raiser, 1984. Photo courtesy of Rae Tufts.

Everyone at Allied Arts, it would seem, remembers the parties at stylish houses and "funny places," to use Coney's phrase. She remembers one, for instance, at a restaurant in Pioneer Square that hadn't formally opened. "In fact they didn't have any wine or silverware for us. So we were all running around the neighborhood trying to get wine, but all we could find was fortified wine. Then we had to borrow the silverware from where we could. But there was a spontaneous quality to the party, and it was in keeping with the character of the organization."

Among the critical issues of Coney's tenure was the struggle to get billboards off major highways. Billboard companies lobbied against regulatory legislation and, when it passed, they tried to nullify it in a subsequent legislative session, stall its enactment, and sue or make compensation for taking down the signs so expensive that it rendered all attempts at control negligible. "They were powerful advocates for themselves." Coney wrote to Washington State legislators in 1977,

> You have before you a bill that would undermine many years of effort to control visual pollution of billboards. Of greatest concern to us are two things: the precedent-setting nature of compensation as outlined in the bill and the overwhelming cost to local communities which would have to pay this compensation. The billboard industry has too long enjoyed subsidy by taking advantage of taxpayer-funded thoroughfares. There should be not a double penalty to rid the roadways of unsolicited blight. In Seattle we have tried to accommodate the billboard industry through an amortization program. The city entered this in good faith, and some progress has been made despite nonconformance by elements of the industry. The bill would nullify this effort and would set an untenable precedent. Since 1960, Allied Arts has fought for the right of individuals to drive along a publicly funded roadway without being captive to distracting, intrusive things. It has been extremely difficult to get enforcement of existing ordinances limiting billboards. And now SB 2956 proposes that we forget the enforcement of limitations and instead spend more money to compensate property owners and sign companies as a regulatory means.

The Seattle City Council proposed an ordinance in 1976 that would require parking lot owners to landscape their properties. Inevitably the owners put up "a wall of opposition," according to a *Seattle P-I* editorial. "Joe Diamond," it said, "who manages a large number of lots, has flatly refused

to discuss the city's draft plan to make downtown lots into more present-able neighbors." Allied Arts was inevitably in favor of the legislation. Coney wrote to the *Seattle Times* the following year,

> Allied Arts of Seattle has long been convinced that downtown surface parking lots, however necessary, have created blight in urban Seattle. The proposed city ordinance to require landscaped screening of parking lots offers a constructive way of erasing this blight without eliminating essential parking facilities. The citizens have been assaulted through the mail, through the press and over television by propaganda threatening increased parking rates because of this ordinance. . . . Obviously, the landscaping law will increase the costs to the operators of running parking lots, and the operators will try to pass on as much of the increased costs as they can. The point is, however, that with or without the new law, they will still continue to set their rates as high as the market will bear. . . . The ordinance is an example of the highest kind of government commitment to serve all its residents, not just those with a narrow economic interest.

The effort failed.

Two other items on the Allied Arts agenda kept popping up year after year: trying to convince City Light to bury unsightly utility poles and planting trees on roads, both of which City Light opposed. The Coneys got involved with City Light in pruning trees on city streets in an unexpected way. They lived in the handsome and spacious O. D. Fisher house, built in 1909, in the Harvard-Belmont historic district on Capitol Hill, the only residential historic neighborhood in the city. Next door was a house once owned by a member of the Bullitt family, former owners of King Broadcasting, which was later owned by Ibsen and Ruth Nelsen. The two houses were frequent sites for the Allied Arts parties billed as "moveable feasts." One day Coney was at her kitchen window, looking straight up East Prospect. "I was pregnant at the time. I remember it was early spring, in 1970. All of a sudden there was this awful racket, and up the street was City Light cutting off the tops of some wonderful old trees. I went running up the street and yelled, 'Stop!' then called my husband and said, 'We have to do something about this!' They will ruin our street trees, I thought. So my husband (a lawyer) got a stop-work order, and by noon the cutters were called off."

Then a judge came out to take a look at the trees, with all sorts of people and the press accompanying him. "A lot of the old trees were given a

five-year clearance, which means the tops were sufficiently cleared for overhead wires so that they didn't require cutting for another five years. Well, when you do that to a tree you wreck it, because it loses its balance, and you get these silly little shoots coming out. The outcome of that lawsuit was that City Light, which had the responsibility to keep trees clear of the wires, hired an arborist to oversee pruning efforts to ensure that the trees were not ruined. I haven't kept up with it, but when you see trees tunneled now, that's a part of that effort—trees can no longer be topped." Allied Arts played a key role in changing the city's approach to pruning. This was a case that hadn't begun with Allied Arts, but ended there. "When you get someone to go down and file a stop-work order, you can really put a halt on things," Coney said. "Allied Arts was always willing to pull people in on special things because they had a relevant talent or influence. We were pretty shameless about it because we thought the issue was so important."

Many members were fearless when it came to people in power. I am sure some mayors occasionally thought of us as a pain in the neck.

The case of the Capitol Hill trees was a good example of how quickly and decisively Allied Arts could act when needed. "In earlier days, leadership was sharp and focused. It was very smart, very good, very dedicated. You know, it wasn't a particularly democratic organization, more libertarian maybe. People came because of their talent, because of their drive, and because they believed that a particular issue was really important. That's kind of how we went. It was about advocacy. It wasn't a planned agenda necessarily, but there were always things going on that you wanted to pick up and carry on with."

Among Coney's accomplishments was streamlining the committee structure, from large standing committees to more ad hoc ones. "Allied Arts depends on the knowledge, energy, expertise, and willingness of its members to create and accomplish its goals," Coney wrote to the general membership in 1976. "This year, therefore, we are dispensing with large umbrella committees and concentrating on ad hoc committees that hopefully may have a beginning and end, a short-term purpose." Among the committees were those dedicated to issues of underground wiring, urban

planning, sign ordinance, visual arts, performing arts, historic preservation, and public art.

Not every organization could operate in the manner of Allied Arts. "We were all there was. It wasn't like we had a museum or an opera company to support. We were the whole thing, and that is very different. I don't know if there is anything like that now. We went beyond advocating. We went to the streets, did the work, sat in the committees, raised money to fund projects," said Coney. "Allied Arts was not for everyone. I think it took a certain amount of joie de vivre, a lot of laughter, people who were very self-confident. If you were shy and uncertain, Allied Arts might not be the right place. However, many stood at the back and made their contribution. It was not a good place to climb the social ladder. Allied Arts could be antiestablishment at times. If you wanted to become socially prominent, this wasn't a particularly safe way: you could step on toes you didn't want to step on. However, it could be useful as a stepping stone in politics and government." For instance, trustees Peter Steinbrueck, Margaret Pageler, and Sally Bagshaw became Seattle City Council members; Dow Constantine, King County executive; Norm Rice and Paul Schell, Seattle mayors; and Dixie Lee Ray, governor. "Many members were fearless when it came to people in power. I am sure some mayors occasionally thought of us as a pain in the neck," said Coney in an interview in the *Seattle Times*. The organization "escaped definition. We believed the cultural experience is central to the human experience, and toward that end we always worked to make our ideas become broad issues in public life."

18 / The Campaign to
Bury Utility Wires

"**E**VERY SEATTLE HILL IS TOPPED BY POLES AND CROSSARMS, every view from a street is framed by sagging loops of wire," wrote E. B. Dunn in a letter to the *Seattle Post-Intelligencer* in 1966. "Perhaps we don't care how we look after years of conditioning, but what about the impression on visitors? We are the most blighted city in the world in this respect. We worry about littering and billboards, and we should, but nothing can make Seattle look anything like a modern, mature city while our streets are lined with poles. . . . I, for one, am sick of Seattle's black 'hangover' and tired of apologizing to visitors. We worry about pollution of the air and water. What about pollution of the landscape?"

Or, as "Underground Wiring in Seattle: A Report to City Council," written by an Allied Arts committee and chaired by Jerry Thonn, asserted, "We are not content to live forever in a leafless forest that contaminates our horizons and clutters our space." Seattle had as many light and telephone poles as it had people, and more poles than street trees. Its system was antiquated, long in need of modernization, prompting Ibsen Nelsen, prominent Seattle architect and a president of Allied Arts to observe, "Our jungle of poles and web of overhead wiring is an inharmonious and jarring menace to the future of Seattle as a beautiful city."

Dunn and Nelsen were not exaggerating. Because Seattle had parallel power companies (Puget Sound Power and Seattle City Light), there were

Queen Anne Boulevard (now Eighth Avenue West), Seattle, ca. 1928. Photo by *Seattle Post-Intelligencer*. Seattle Post-Intelligencer Collection, Museum of History & Industry.

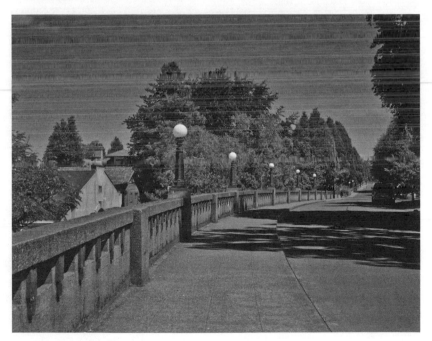

Eighth Avenue West, 2013. Photo by Roger Schreiber.

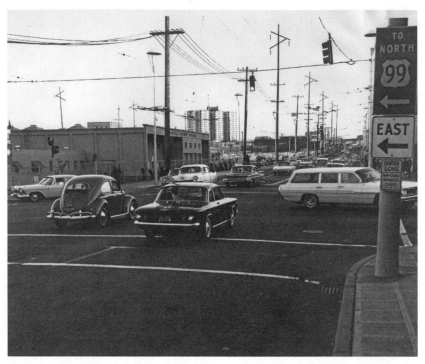

Intersection of Mercer Avenue and Fifth Avenue North, 1962. Photo by Phil H. Webber.

Intersection of Mercer Avenue and Fifth Avenue North, 2013. Photo by Roger Schreiber.

The Campaign to Bury Utility Wires

parallel lines of power, with duplicate lines on city streets, until 1951, when Puget Power was acquired by Seattle City Light. City Light began to remove the extra poles, but it was too slow and cumbersome a process for many. So, exasperated by this lack of speed—not only in the elimination of the duplication but of all of the poles—the Municipal Arts Commission (forerunner to the Seattle Arts Commission) and Allied Arts, under the clever name Operation Deadwood, began a long effort to nudge and sometimes push City Light into action.

Allied Arts played a key role in the passage of an ordinance that outlined "an orderly program of underground wiring," wrote Alice Rooney in a press release in which she quoted Thonn saying that Allied Arts had "nothing but commendation for City Light's concern for providing electricity to residents at the lowest possible rates and for the well-known efficiency of their system. However, we believe that City Light has overlooked the impact of overhead wires on Seattle. In fact, we would expect City Light to demonstrate the same kind of leadership in underground wiring as they have in other areas under their jurisdiction." That was not to be the case.

By 1962, just before the opening of the Seattle World's Fair, there were those who said that City Light's efforts so far were mostly window dressing and public relations. Jack B. Robertson, a civic activist well-known as president of the Washington Roadside Council and for his role in the effort to remove unsightly billboards from streets and highways, wrote in a memorandum, "The attitude of the officials of City Light was interesting and gave no sense indication of the future of undergrounding in Seattle. Some officials indicated some interest in undergrounding; however, they felt their job was only to deliver power at the lowest possible rate. Others officials gave the impression they were personally not in sympathy with the undergrounding effort." During this period Thonn and Robertson met frequently with City Light superintendent John Nelson and City Light senior staff to discuss underground options and the financial feasibility of the undergrounding projects.

As a result of these negotiations, there was a handful of bright signs and positive innovations. City Light appointed an undergrounding coordinator, and developers were beginning to appreciate the appeal of not having overhead power lines. These were only a start, however, the proverbial drop in the bucket, given the scope of the problem. To push matters along with City Light and to develop momentum in the public sphere, underground advocates drafted position papers focusing particularly on financing issues

(since most arguments against the concept revolved around money). And the press engaged as well. City council candidates began to realize that the public was in favor of "an accelerated program for reduction of the blight of overhead wiring," according to an Allied Arts questionnaire. Town hall meetings were held, letters written, a slide show of particularly egregious examples of the problem assembled,; and informative talks initiated for diverse groups of people.

Although it would seem otherwise, the issue of overhead wiring was not a new one in the city. In 1927, Seattle's mayor had recommended a program of pole elimination. In its annual reports of 1935 and 1936, City Light asserted that, while underground wiring was appealing, it was not possible. Alfred V. Perthou, in an article in *Puget Soundings*, wrote that there were men at City Light who were not opposed to a program of underground wiring, but there were also those who simply resisted the notion.

City Light was not the only utility company in the country to resist underground wiring. A natural conservatism in favor of the status quo, despite its obvious shortcomings, often prevailed; building codes from the 1930s were often retained, the cheapest route forward being based solely on financial considerations. Despite arguments that invisible power lines not only contributed to the aesthetics of a neighborhood but also improved safety and required less maintenance than overhead wires, City Light remained recalcitrant: with the lowest rates in the country and huge cash reserves, its mantra was "business before beauty."

The 1960s and 1970s were a time of ferment in the effort to get wiring established underground. Polls indicated overwhelming support for the program, although support predictably diminished when it was determined that costs were to be carried substantially by individual property owners. In a 1965 report to the Allied Arts board of trustees, Thonn said that because of the vagueness of the 1959 ordinance, City Light spent money only in areas where load requirements necessitated doing it anyway. It seemed that little had been accomplished. "They have yet to underground simply for appearance purposes," said Thonn. A new and more precise set of recommendations was drafted by Allied Arts, which included a mandate that all new construction be underground, the removal of duplicated poles be expedited, monies for the program from City's Light general fund be increased, and highway entrances to the city as well as scenic drives be given top priority.

In an editorial, the *Seattle Times* had high praise for the report, especially its recommendations and conclusions. "City Light's execution was ugly

. . . unduly adding to the multiplicity of wires and poles: City Light and City Hall should give full attention to implementing Allied Arts' recommendations. . . . [The organization] represents forces and sentiments far beyond its membership which will not be denied a voice in improving Seattle's townscape." An ordinance following the guidelines of the 1965 report was subsequently drafted by the city. The hope that real action would be taken came at the end of the year with the prospect of federal financing (50 percent) in addition to a competition for an urban beautification project, the winners of which would receive 90 percent funding. However, inexplicably, the city declined to participate in the urban project. Meanwhile, Nelson told City Council members that the utility was spending a higher percentage of its gross income on underground power lines than was any other utility in the country. Not many believed him.

In 1966 City Light proposed a $1.5-million rate reduction. Allied Arts and others opposed it on the grounds that the city had among the lowest rates in the country and the reduction would amount to only pennies per household while it would further erode any chance for a significant underground wiring program.

Thonn wrote a detailed and particularly lucid rebuttal of the proposal:

Once again, City Light has turned its back on a clear and forthright policy of eliminating overhead wiring. Although it had repeatedly earned substantial profits, which exceeded eight million dollars for each of the past three years, no portion was spent on undergrounding. In spite of a beautiful urban setting, Seattle has cluttered its skyline and its scenic views with an overhead distribution system of unmatched complexity and unsightliness. In the nearly ten years since the first ordinance was passed, City Light has not only failed to develop an undergrounding program which extends beyond those areas where high power use makes undergrounding absolutely necessary, but, in its proposed five-year capital improvement budget extending through 1971, it plans to spend more than twice as much for 'normal extensions' of overhead wires than its plans to spend converting overhead to underground. As such the utility is going against the national trend.

Thonn's rebuttal was followed by a proposed ordinance in 1968, signed by five groups, including Allied Arts, the American Institute of Architects, and the Roadside Council:

> The undersigned have been working for several years toward the adoption by the City of Seattle of an orderly and effective program of undergrounding. . . . We are disturbed by the lack of real progress and . . . that real progress is not in sight. At the present rate of undergrounding, it will take more than two hundred years to convert the present system. . . . We are not content to be told that the burial of utility wires must be restricted to suburbia—where the obstacles are fewer and the costs are less. . . . We believe that it is more important to more people that the problem be faced squarely here and now by and for the people who live here and now. . . . The time will come when no other standard will be acceptable.

The city approved the rate reduction anyway, citing the need to attract more business.

Two years later, the city gave City Light more specific direction: that it should proceed to underground all principal arterials, if practical, and spend $3 million annually on the program. In the following year, City Light had spent only $317,000. When criticized, officials pointed to "bookkeeping" issues and said that they would make up the difference the following year. Yet the next year it spent only $1.14 million instead of $5 million. Of that, most of the money went to engineering.

City Light responded by asserting that it was spending millions on the underground program, removing dozens of miles of duplicate poles. In an editorial in the *Seattle P-I*, City Light and its superintendent John Nelson were criticized for their "great reluctance" to moving ahead on its undergrounding program. The editorial was also highly critical of the Utilities Committee of the City Council for its lack of leadership in the underground wiring upgrade. "City Light should be more responsive to the public needs, and one of the most urgent needs is the cleaning up and modernizing of the city." The editorial was also critical of councilman George Cooley, who was pushing for a two-year moratorium on the program. In a hearing to consider Cooley's proposal, Donald Voorhees, a member of the Seattle Park Board, said that all overhead wires in Manhattan had been buried in 1888. The proposal did not succeed.

Allied Arts published a report that laid out the advantages of underground wiring, including the standard aesthetic arguments as well as reduced maintenance costs, dependability of service, and increase in property values. That said, there was hope that with the change of leadership at City Light (Gordon Vickery) and City Hall (mayor Wes Uhlman) the politi-

cal atmosphere might improve, especially with continued pressure from groups like Allied Arts. Seattle attorney Llewelyn G. Pritchard, president of the group in mid-1970s, urged the City Council to "remain firm in its support for Seattle City Light's program for the undergrounding overhead utility wires. . . . We urge the City Council to recognize the substantial importance of this program to maintaining Seattle as a place in which people do not merely 'live' but rather live a quality life." However, there were murmurs in City Council chambers, such as from councilmen Wayne Larkin in 1974, to put a two-year moratorium on undergrounding for financial reasons. Pressure from Allied Arts and others was sufficient, and that moratorium failed.

The battle was not over. In 1976, the program was in jeopardy because the engineering department was either unable or refused to budget its share of the $3-million budget. James Uhlir, then president of Allied Arts, asked Mayor Uhlman to investigate the matter. At the same time, the Office of Policy Planning proposed a budget cut of $1.2 million from the $3 million allocation—more than a third. Uhlir wrote a letter to city officials, objecting to any reductions in the program. The following year, he wrote a very nice letter to Vickery, commending City Light for supporting the program. Predictably, Uhlman wrote a long, thoughtful response to Uhlir, saying that the city remained committed to the undergrounding program and that funding problems would be resolved, to keep the program alive and well.

In one more turn of fortune, Mayor Charles Royer in 1980 put a halt to the program, citing budgetary constraints. The momentum of the program never recovered. The city had completed only twenty-eight miles of undergrounding since 1968, in spite of a clear majority of Seattle residents showing in a city survey that they endorsed this kind of "aesthetic improvement." Ironically, the report concluded that undergrounding was the most cost-effective type of aesthetic improvement.

Also, said Thonn, the energy crunch came along; money disappeared, and City Light said undergrounding was no longer feasible. However, a lot had been accomplished, according to Thonn, not only in terms of wiring that had been buried but also in the public's perception. Developers of quality projects would no longer settle for overhead wiring. The public at large agreed. There was no longer as much money, but there was less outright opposition and foot dragging. As a matter of business, underground wiring was now considered a necessary public amenity.

19 / Llewelyn G. Pritchard

L EWELYN G. PRITCHARD HAS BEEN AROUND THE BLOCK, IN THE good sense. He has appeared just about everywhere in the civic, social, and cultural fabric of the city, making connections, doing good, and having a fine time while at it. And, when he has a free moment, he practices law. Pritchard's professional affiliations are long, particularly with the American Bar Association, locally and nationally, which began in the early 1970s, a decade after he arrived in Seattle from New York with his wife, Jonie. His community involvement is deep and broad: from the corridors of high art like the Seattle Symphony Orchestra, universities like the University of Puget Sound, foundations like the Seattle Foundation, and a whole miscellany of others, like the 5th Avenue Theatre, the Museum of Glass, Planned Parenthood, and the United Methodist Church. Pritchard served as a trustee and often as president of these organizations.

Allied Arts came into Pritchard's life not long after his arrival in Seattle with his election as president in 1974. Pritchard recalls, "I believe my introduction was Peggy Golberg. I had gotten to know her through PONCHO. My life has never been the same. I spent a great deal of time thinking about the value of the arts in the city, and the need for those arts organizations to be supported financially, not only by private philanthropy but also by public involvement. It was easy to become the president of Allied Arts after my tenure as president of PONCHO." It was interesting, Pritchard said, because he thinks that he is only president of PONCHO who also served as president of Allied Arts. Coming from a massive arts-funding organi-

Llew Pritchard, 2012.
Photo by Roger Schreiber.

zation, one of the first in the nation to raise money for charitable causes through auctions, to being involved in an arts-advocacy organization was quite revealing. "It was exciting to see the public sector become more involved in the arts," he said. "One of the things I did during my tenure at Allied Arts was to host a symposium on the arts and newspapers, with Grace Glueck from the *New York Times*, to try to get newspapers to cover more proactively the arts in depth, the way sports were covered. . . . It was all a different time and place."

Pritchard is a talker, rich in opinions but open to the ideas of others:

In those days Allied Arts meetings were exciting treasures. One was
exposed to a diverse group of people. They were a plunge into the cultural
life of the city, with people like Mrs. Frederic Hall White, a grand society
lady, and Joanna Eckstein and Georgia Gellert, bickering and arguing all
the way, yet the dearest of friends. All these people, like Victor Steinbrueck,
Fred Bassetti, Shirley [Turner] Collins, Peggy Golberg, Paul and Pam Schell,
Jerry Thonn, Robert Jackson Block, Ibsen Nelsen. It was a primordial group
for things great and good. People looked forward to these meetings. They
could be tumultuous, like a French picnic at times. You went to meetings
and you never were quite sure what would happen. Everybody wasn't all of
one socioeconomic class or one mind about any issue, except they wanted
the arts to survive and thrive in our region. Victor would habitually come
in late, and you would never know what was on his agenda.

Llewelyn G. Pritchard

Parties were usually planned to help fill the treasury, but also to help members bond with one another. They were amusing, dynamic, unpredictable. Pritchard says that members sought not expensive glamour but a good time, and hoped to break even. They did, usually by a few dollars, but not always.

A major factor in the success of Allied Arts in its early days was a score of volunteers who did everything, especially intelligent, educated women willing to work for no money. Jack Jarvis, a columnist for the *Seattle Post-Intelligencer*, said it vividly in a column in 1967, "Of all the do-gooder organizations with which I've worked, Allied Arts and Friends of the Market [given birth by Allied Arts] have the highest percentage of doers, the lowest percentage of watchers. They also have the highest percentage of good-looking broads, er, that is women. Unfortunately, most of the women are Dedicated. They pin you to the nearest wall with a poking forefinger and a direct no-nonsense look and spew out statistics, quotes and opinions. The men are Dedicated, too, but their approach is less dramatic—and frankly, not nearly as much fun for the person pinned to the wall." In a more genteel voice, Pritchard makes the same point:

> The whole volunteer community is different than what it was in those days. Much has to do with the changing work pattern, women's rights. A lot of women were not employed for dollars outside the home in those years. And they became in Allied Arts the bulwark of the organization. I mean just incredible amounts of time. The mix that ran volunteer organizations at that point of time was totally different. One of the fascinating things was the opportunity to network among similar organizations that had a desire to contribute in some way to the urban environment, the arts or things of that nature. Allied Arts became the meeting place for a whole lot of people with different interests. Allied Arts was a kind of oscillating wave of focus—arts and urban environment. You can see it in the personality and backgrounds of the presidents.

Historic preservation—a movement that was just coming into fruition—was a major concern during Pritchard's tenure as president. "It was an exciting time," said Pritchard, "with the past being a prologue to our city to come." Not all of the battles launched were won; some were protracted and bitter, like the fight for Broadway High School on Capitol Hill, now home to Seattle Central Community College. That battlefield was not as fixed as one might imagine, said Pritchard, with natural allies finding themselves on

Llew Pritchard and Peggy Golberg, 1992. Photo courtesy of Llewelyn Prichard.

different sides of the issue. Allied Arts was among those leading the crusade
to save the handsome old building from destruction. The African American
community, along with local and state school officials, wanted to tear down
the school. Pritchard said that many African Americans felt that keeping
the present building was the equivalent of being treated like a second-class
citizen and being shuffled off to the usual back corners. Even many of the
alumni were in favor of demolition. The battle was fierce, and in the end
only the auditorium was saved. It was the kind of compromise in which
no one ends up happy. The stand-alone auditorium serves as a reminder of
what was lost.

Saving the Olympic Hotel was a major fight that ended happily. So, too,
the Skinner Building, which houses the 5th Avenue Theatre. The theater was
beautifully restored, Pritchard said, as was the Skinner Building, and the
Olympic (Fairmont Olympic now). "They are among the architectural jewels
of downtown Seattle. We rose in indignation and used every weapon we had
at our disposal. It was a great effort but bore fruit." Other buildings went
like the wind, including the White-Henry-Stuart block. Under Pritchard's
guiding hand was a position paper on the White-Henry-Stuart block that
was issued with other civic-minded groups. "Allied Arts . . . challenges the
adequacy of the University of Washington's Environmental Impact State-

ment . . . the organizations call on the University's Board of Regents to give more in-depth consideration to a variety of alternatives . . . announce its intention to do so, and then adhere to a well-publicized and open process during the review period." Pamela G. Bradburn, a spokesman for the preservationists, said in a statement, "It is unfortunate that the University of Washington has been unable to adhere to the spirit of environmental laws. One would have expected more from the state's highest institution of learning." All to no avail. The White-Henry-Stuart block was torn down to make room for a sterile pedestal in white.

Yet another effort failed. Allied Arts made valiant appeals regarding the preservation of the Bay Building, a handsome connection on First Avenue between Pioneer Square and the Pike Place Market. Pritchard was quite frank. He wrote Harbor Properties, which owned the building, to object to plans to demolish it. "Your present plan to destroy this beautiful Elmer Fisher design would be a calamity." Pritchard also wrote John Miller, chairman of the Seattle City Council Planning Committee, "We have attempted to be a strong community voice for historic preservation—involved in the campaigns to Save the Market, to renovate and restore Pioneer Square, and, most recently, in a futile attempt to save old Broadway High School. Because of our continuing interest in Pioneer Square and the Market, we feel that the destruction of the beautiful Bay Building would destroy the opportunity for it to be a vital link in joining these two important areas of our downtown city." The building, along with its neighbors, fell to the bulldozer. Not even the facades were spared. Jeanette Williams, a member of the city council, wrote Pritchard, thanking him for Allied Arts' opposition to the demolition of the Bay Building. "It is unfortunate that more members of the city council did not share our views on this subject."

Allied Arts' advocacy on behalf of historic preservation did not go unnoticed. The president of the Downtown Seattle Development Association, Victor O. Gray, accused Allied Arts, among others, of "killing" or crippling" the growth and jeopardizing the "continued health" of the central business district. Always sensitive to the needs of artists, Pritchard wrote senator Wilbur A. Mills, chairman of the Committee on Ways and Means, and sent copies to the state's influential senators, Warren G. Magnuson and Henry R. Jackson, and representatives Joel Pritchard (no relation), Lloyd Meeds, Julia B. Hansen, and Brock Adams, asking for legislation that would allow artists to deduct 100 percent of the value of their work, a deduction that recent federal legislation had severely limited. The campaign was successful. With

some hope that design could be improved in Seattle, Pritchard wrote mayor Wes Uhlman, a politician with progressive ideas, asking the Design Committee to review all property owners' requests for variances, conditional use permits, and rezoning. Uhlman's response was polite but stated that the proposal was essentially unworkable.

In addition to leading the forces for good, Allied Arts had to take care of more mundane matters like raising money, a perennial concern with the seemingly always-poverty-stricken organization. Thus there were periodic letters to members for contributions. "Allied Arts needs you!" Pritchard pleaded in a letter in 1975 so that the staff could be paid. And in 1979, Pritchard wrote a somewhat testy letter to Paul Silver, then president, regarding the annual auction, the main fund-raising event of the year. "Peggy Golberg and I are willing to be of subterranean assistance to Allied Arts on this event. We will not, however, do the scut work, carrying, lifting, organizing, procuring, etc., which we have done in the past. . . . It is now approximately ninety days until the auction and nothing has been done. We stand ready to help but not in the last thirty days."

> It was a primordial group for things great and good. People looked forward to these meetings. They could be tumultuous, like a French picnic at times.

Edging toward the twenty-first century, the organization lost steam. "I don't think there is any doubt that the organization is not as strong as it was. . . . Some of that is a result of the success it has had. There is nothing like a good controversy, a good concern, to get people involved in organizations, in an effort to protect the environment or save something or other." So much of the work done by Allied Arts in the past was taken up by various forms of government and other nonprofits, said Pritchard, and so the need was less urgent. Many of the arts organizations that had been struggling had become "very vital, very active, very involved." Lobbying for the arts became something that the organizations directly involved could do on their own, having full-time people in Olympia, all of that kind of thing, Pritchard said. Some of the controversies, some of the challenges were no longer present, the way they had been before: "Part of the problem is that the kind of convergence of a lot of different kinds of people that existed in

Allied Arts in those days has disappeared. Many are working in mainline arts organizations. One of the things that Allied Arts was always trying to do was to save an individual group of artists or arrange for better housing for them, or medical care. It was also fertile ground for exciting, new ideas. Various small programs to give people an opportunity to experience avant-garde theater, music, and dance came out of Allied Arts." Pritchard calls organizations like Allied Arts, the League of Women Voters, and the Municipal League "general community-good organizations because you can never recreate them. They are artifacts, to a degree, of another time, because everyone is so narrowly focused now. Everyone has their own groups, like the environmentalists and the arts. But I think it's very important to keep these organizations around them."

20 / Allied Arts' Embrace
of the Urban Environment

ALLIED ARTS ASSERTED IN 1955, "THE SEVERAL PHYSICAL ELE-
ments that comprise the city—its buildings, homes, streets, bridges,
open spaces—are in combination the setting for its citizens and the
lives they create within that environment. Allied Arts of Seattle believes that
cities are better and the lives within them richer when principles of beauty
are applied to their continuing growth. Seattle has unique opportunities for
building on the magnificent advantages that nature has already granted
her. . . . Seattle . . . (must) acknowledge its opportunities for growth in which
the city and its environment shall mutually enhance each other."

The urban environment comprises many elements: from the design of
manhole covers to the planting of trees, from the height and bulk of down-
town buildings to the regulation of billboards, from the preservation of the
old to the creation of the new, from the support of cultural institutions to
underground wiring, and from the design of Seattle bridges to the shape
of its parks. Some issues are major and require sophistication and imagi-
nation to solve. Others are simpler, like sidewalk cafés, something we take
for granted today. That was not always so. In the righteous era of blue laws,
not only was eating at a sidewalk café not permitted, but drinking was not
allowed either. Allied Arts, fond of both, took up the cause in the early 1970s.

Wes Uhlman, a progressive mayor, wrote Fred Bassetti, president of
Allied Arts, in January 1971, "I only recently became aware of your letter to

JoBar, Harvard Avenue East. Photo by Roger Schreiber.

City Council Chairman Carroll concerning sidewalk cafes. As you may know, I have sent a proposal to the City Council suggesting that sidewalk cafes are crucial to a vibrant and colorful downtown. I am extremely hopeful that the Council will see fit to act favorably on this matter in the near future." Two months later the council gave its collective nod of approval. In its story on the action, the *Seattle Times* noted, "Allied Arts of Seattle had requested the legislation, which was approved also by the Board of Public Works."

There were other projects as well that caught Allied Arts' attention. In August of that year, the Allied Arts Street Tree Committee, chaired by Mary Coney, began to formulate its plans for the future—who should be in charge, where trees should be planted, what kind of trees should be planted, who would pay for the plantings, and who would direct their maintenance. Some of its work had already been done by the Seattle Natural Beauty Associates, whose resolution in 1966 was filled with good ideas. So was Coney's

committee, which shared the experience and expertise of Mea Mann of the Natural Beauty Associates. Among Mann's very practical words of caution was the warning that not all pruners were of equal ability—so be careful. Coney's committee presented Uhlman with a report in 1973 that advised bringing up-to-date the city's "scattered ordinances and extending the city's protective powers over all trees planted on city streets, whether privately or publically owned or planted." The report also suggested an administrative structure that would include the office of a director and "sufficient power within city government to oversee the program." As Concy wryly noted, "The problem now is to make certain this proposal surfaces from the dark depths of city bureaucracy. . . . Thus Allied Arts' work in 1974 would seem to be one of prodding and pressuring the city to bring to fruition this very necessary program."

That program, according to the *Seattle Times*, was a success—in spite of random vandalism. However, only two years later, the City Council proposed a moratorium on the street planting of trees until the city had determined the economics of the program, so that "such costs can be equitably shared between the neighborhood and the city." Eventually more than one thousand trees were planted. The one place where the concept of street trees was not a success was in connection with parking lots. Allied Arts proposed that paid parking lot owners be required to plant trees to soften the appearance of all that concrete. The owners at first gave a tentative "yes" but then, led by Joe Diamond, who owned most of the lots, they issued a firm "no," saying that parking rates would go up and that the planting of street trees would destroy the downtown business community. And that was the end of that. Allied Arts pointed out that the fact that parking lot rates always went up, whatever the market would bear, seemed to get lost in the war of words.

Late in 1970, the Department of Defense transferred a huge swath of land on Magnolia Bluff—what was called Fort Lawton and renamed Discovery Park—to the General Services Administration. The buildings, constructed by the US Army, included twenty-five wooden barracks, officers housing, and support structures dating from 1898 to 1908. The fort had been used in World Wars I and II and had served as a training post for reserve officers and the National Guard. When the federal government decided to turn the property over to the city to manage, arguments sprang up—inevitably—about what to be done and who had the right to use the park.

Even before the mad scramble and arguments about what to do with the property, there were struggles that predated the official turnover, namely

the intent of the Department of Defense to install a Sentinel antiballistic missile complex on the property and legislation to make the transfer of land to cities like Seattle cost-free. The buildings had been mostly unoccupied since 1975. Native Americans asserted claim to much of the land; they sought a cultural center that could accommodate five thousand people, with parking lots, a medical facility, a university, and a restaurant. To call attention to what they considered to be their right to the land, 120 Native Americans "invaded" the fort, along with actress Jane Fonda. The Coast Guard and the Navy also sought "a piece of the action." Real estate developers called for a shopping center, while others claimed the property for a domed stadium, a golf course, a conference center and resort (an idea that disappeared quickly), and a park—just a park, with everything else torn down. Preservationists wanted to save some of the buildings. The Seattle City Council at first wanted to tear down all but two of the buildings. Allied Arts urged calm and a middle course—a "natural" development.

The issue went in and out of the courts for nearly forty years, some cases revolving around how much the city could do in terms of demolition. Eventually the necessary compromises were reached in 1983. Native Americans ended up with the Daybreak Star Center—an attractive facility, but far less than they had hoped for. Leonard Garfield, an architectural historian and executive director of the Museum of History and Industry, said that the officers' quarters (colonial-style buildings), although not architecturally unique, told a dramatic story about Fort Lawton's history. The "handsome examples of turn-of-the-century architecture" in what is now called the Fort Lawton Historic District, according to an editorial in the *P-I*, were saved. Allied Arts had joined a coalition of interested preservationists such as the Seattle Chapter of the American Institute of Architects and the Washington Trust for Preservation, among others. In February 2012, the fort was formally decommissioned, with the federal government continuing to own the property but giving the city the right to control its use. The park has seemingly miles of walking paths.

In the *Seattle Post-Intelligencer* in the summer of 1988, columnist John Marshall wrote,

> After three decades of bitter controversy, after the countless plans, after the court cases and the petition drives and the last-ditch appeals, this is what has finally been wrought at Westlake: a granite-paved plaza with traffic running through it, a shopping mall much like Bellevue Square, and a collection

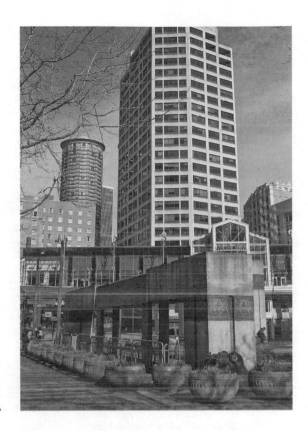

Westlake Center, 2013.
Photo by Roger Schreiber.

of snack eateries like the Food Circus at Seattle Center. Oh Seattle! City of
Moderate Vision! City of Big Dreams Argued to Death! City of Compromise
Solutions That Are Finally Chosen to Offend the Fewest Folks! Oh Seattle—
Westlake Center will forever be a civic monument to your committee mental-
ity! What Westlake once was, of course, was a dead-end embarrassment, a
grimy little pigeon zone in the shadow of the Monorail stanchions, right in
the heart of the city. What Westlake is now, of course, is a vast improvement.
How could it not be—when well over $100 million has been spent at West-
lake, with $18.8 million thrown into pocket parks and $110 million poured
into a four-level shopping mall and twenty-four-story tower.

Jean Godden, one of the most enlightened members of the Seattle City
Council, now in her third term, was once a journalist, first with the *P-I*, then
with the *Seattle Times*. She was no more enthusiastic about Westlake than
her former colleague. In one column in the *P-I*, she compared Westlake to
Bellevue Square, a charge immediately denied by the developers.

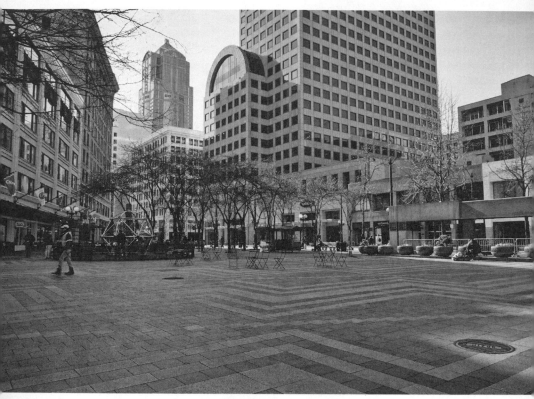

Westlake Mall, 2013. Photo by Roger Schreiber.

Those who frequent Bellevue Square . . . may well see Westlake as Bellevue
Square West. The two shopping malls share many of the same features—
multiple levels of shops, a bright, bustling atrium, natural light from
skylights, different styles of storefronts, hard surfaces everywhere to give
that much-desired din that says, 'Urgent shopping activity in progress.' . . .
What once gave city shopping its character—actually walking outside on
sidewalks and going into individual stores—is fast disappearing. Down-
town Seattle is well on its way to becoming a series of enclosed mini-malls,
most often laid out around a central atrium. First there was Rainier
Square, then Century Square, now Westlake Center, soon Pacific First
Center. . . . But all those years of arguing over Westlake have indeed come
to an end, all that talk about having Seattle's own Central Park at Westlake,
a vast living room for the city.

Allied Arts' Embrace of the Urban Environment

Given his liberal, if skeptical views, of politics and culture, it is not surprising to find that David Brewster, founding publisher of the *Weekly* and *Crosscut*, was also critical of Westlake Mall. He said in 1988, "Please excuse the search for symbolism, but isn't there something ominous about this city's failure to find a civic center? . . . Westlake Mall changes from being a town square to being a war zone where angry street gangs fight over turf." And the *Times*, in an editorial in 1987, expressed its disappointment:

> The hole in the ground at Westlake is about as deep as it will get. Soon the underground parking garage will go in, . . . As work proceeds, many citizens will feel sad and wistful for what might have been. It's not a bad project—but it's not a great one, either. It should have been. It could have been. Unfortunately, it was not until very late in the game, after demolition on the site was well under way, that most people saw the marvelous beneficial effect of openness in that critical downtown block. The light, the room, the views—all captured many imaginations. A last-ditch, grassroots campaign sprang up to reconsider the project's design, to provide somehow for more open space, create a large park, perhaps eliminate the office tower. It was admittedly a long shot—but it was worth taking. Some called it irresponsible. It was not. It was the height of civic responsibility. . . . Several City Council members, rightly responding to an unprecedented groundswell of citizen concern, tried to find a way to redesign the project at reasonable cost. They came close to a compromise, but Mayor Royer willingly opposed their effort and prematurely—almost spitefully—released a draft letter that council members were circulating for discussion. Now, unfortunately, the effort is essentially is over. . . . Leadership is lacking at City Hall. But it has been a valuable exercise, thanks to many citizens who care deeply about this city. . . . The battle for Westlake was a good fight.

An opening gambit in the Westlake brouhaha was made by Allied Arts president Paul E. S. Schell, who wrote an impassioned letter to Mayor Wes Uhlman, in 1972, urging him to take action that would "revitalize the downtown retail commercial core through the implementation of the long-planned, much-discussed Westlake Square." Then Schell added a few suggestions, such as strengthening street-level pedestrian activities and discouraging elevated sidewalks. He concluded by saying there were differences of opinion. Those differences "should be openly recognized, but at the same time, we urge the City, the major property owners, and representatives of the

retail businesses to join us to make this effort to find a common ground to obtain action and development in the heart of Seattle."

For decades Westlake had been a downtown crossroads and focal point of civic interest. The Westlake project called for redevelopment of most of the two-block area between Fourth and Fifth Avenues and Olive Way and Pike Street. The main features would include a public square surrounded by a multilevel shopping mall. Ideas were never in short supply. When Royer was elected in 1977, among his ideas for Westlake was a new home for the Seattle Art Museum. Four years later, the State Supreme Court ruled that the Westlake project was not constitutional because it blended public and private projects, for example, the museum. Exit SAM from Westlake.

In a letter to the *Seattle Times* in 1987, Margaret Pageler, president of Allied Arts, wrote that Mayor Royer's

> effort to derail a Westlake compromise brings new hope to Allied Arts and other supporters of a park at the Westlake site. . . . The report makes clear that a majority of City Council members favor a change of direction. While we appreciate the council's need to negotiate with the developer behind closed doors, we are delighted to discover that most of the council members have been listening to the public outcry and are seeking rational alternatives. What the public really wants at Westlake is a park. We encourage City Council members to stay on track, hold together, and find a Westlake solution. Eliminating the office tower from the project . . . would provide significant public benefits. . . . If the tower is built, it will be a monument to failed leadership.

Allied Arts had visited this territory previously when, in 1981, it formally opposed the city's proposal for a dense development of Westlake. At the time it reiterated its support for Victor Steinbrueck, the hero of the Pike Place Market, and his opposition to high-density development on what Pageler termed "Seattle's town square." It was all for naught. The city, led by Royer, was committed to the office tower and all that it implied. The new Westlake activists included Allied Arts and the League of Women Voters. The league's president, Lucy Steers, contended that there was never any public support for the office tower. The city said that it was too late to back out of signed agreements, and besides, it would be too expensive. Opponents argued that it would not be too expensive. The *Times*, once opposed to such a notion, changed its mind. Letters came rushing over the threshold in support of the idea.

Of course Steinbrueck as well as Folke Nyberg, both professors of architecture at the University of Washington and long active in Allied Arts, argued that Westlake needed a large public space, and so did plenty of others, including some thirteen thousand who signed a petition to that effect. The two architects headed the Committee for Alternatives at Westlake, which for years had urged creating a large park at Westlake to provide "breathing room" in downtown Seattle. They provided alternatives to the city's plan, lobbied the City Council and mayor, filed administrative appeals, and wrote op-ed pieces about their vision for Westlake, according to their lawyer, Peter J. Eglick, in an op-ed piece in the *Times*. When Royer was running for office, Eglick asserted, he invoked Steinbrueck and Nyberg's ideas. Then Royer changed his mind, arguing for "development rather than a public square." Just as the mayor lost his enthusiasm for a large public park, the City Council did not exhibit enough interest to generate sufficient support to change direction. At one point, the *Times* called Steinbrueck and Nyberg "the same small band of naysayers, whose skills at manipulating the legal system for years have give them clout far beyond the constituency they represent." A compromise, which no one liked, was offered by city attorney Doug Jewett. Steinbrueck and Nyberg acquiesced, presumably on the grounds that something small is better than nothing at all. What is there today recalls Marshall's prescient words about Seattle's "committee mentality."

In 1967, the city of Seattle issued a look at downtown planning:

> Like it or not, Seattle will build, demolish, rebuild, and change with or
> without direction, purpose, or order. City planning is the effort to guide
> that energy of change away from chaos and sprawl into an exciting urban
> environment. Few times in the city's history have seen as much expan-
> sion as is currently underway. . . . But it has not always been so. For the
> first half-century of its existence, Seattle just grew. Then, during the first
> decade of the twentieth century, the city commissioned the Olmstead
> Brothers of New York to develop a park plan, and funds were voted to carry
> out key parts of that plan. At the same time, the city's first urban planning
> efforts began with the creation of a Municipal Plans Commission, which
> hired Virgil C. Bogue to prepare a master plan. His plan for the future was
> grandiose, calling for a massive civic center, rapid transit, boulevards,
> port development, and parks. Many of the proposals were later enacted,
> although the voters rejected the plan . . . in 1912.

Eventually planning commissions were established, zoning ordinances enacted. At the end of World War II, the city did create a comprehensive planning program, but it was not formally adopted for another decade. Inevitably there were revisions and subsequent plans. In the 1970s and 1980s, planning was at an all-time high. More comprehensive plans were afoot for what was new, as well as a plan to preserve the old. In 1979, Allied Arts conducted a series of what it called "planning roundtables," on topics such as downtown development, zoning, land use, and urban design, the purpose of which was to find out how public policies were made and implemented.

In 1981 Allied Arts offered its own downtown plan. It was intended to be more than a "wish list," wrote Rachel Ben-Shmuel, chair of the Downtown Committee. The *Seattle Business Journal* published highlights of the report. There were eight major points, including controls to ensure that new development did not "degrade the existing quality of life and historic character of downtown"; it was decided that downtown districts, from the International District and the Kingdome to the Denny Regrade and the Cascade neighborhood, should remain intact and connected with a system of pedestrian "linkages." A series of parks and plazas were to be created, height limits on buildings (particularly in areas of heavy foot traffic) were to be enforced, and a transportation plan was to offer alternative to the private automobile. Allied Arts and a dozen other groups called upon on the Seattle City Council for interim controls until a new plan could be enacted by the city. Exactly what those controls should be were not laid out. Instead the council would hold hearings on the subject.

By 1985 the city had a plan. In a letter to the *P-I*, Henry M. Aronson, president of Allied Arts, and Margaret Pageler, chair of the Downtown Committee, wrote, "While Allied Arts has some concerns about the plan (for example, height limits, particularly in the retail core, are still too high, and they don't exist for a large portion of the financial core), we wish to emphasize that the plan is a compromise. If the City Council waits to adopt it, the greatest risk is that economic forces will eliminate much of the opportunity, which is already slipping away, to channel growth." Allied Arts was among several groups that contributed to the study, at the request of city officials. Among the issues raised was downtown housing, which reiterated a concern over the loss of low-income housing. "A public policy to provide additional housing for all income levels will require major public commitments and resources," Allied Arts said. While downtown office buildings

had nearly doubled downtown, there had been virtually no compensating increase in downtown residential stock. The Denny Regrade was given serious attention, as well as the retail core.

Concerned that there were too many tall buildings, there was an initiative, called the Citizens Alternative Plan, known by its acronym CAP, which Allied Arts formally endorsed in April 1989, among the last of more than a dozen civic organizations to do so. The vote was close—18 to 15. The previous year the organization's ad hoc Committee for CAP, chaired by Peter Steinbrueck, recommended that the whole organization not take a stand, and issued a study sheet that was a forthright weighing of pros and cons. In December of 1989, Allied Arts was still not prepared to take a stand, instead offering an interim position. In March 1989, Tom Graff, cochairman of the Allied Arts Downtown Committee and an articulate and hard-working advocate for intelligent growth, wrote the City Council on behalf of Allied Arts, "We feel that the support behind CAP (which would limit height and density of building) comes from three key areas: the office tower boom in the retail core and terra-cotta district; the congestion on our city streets and highways; the sense of out-of-control development throughout the Puget Sound area." There were thirteen items in the Allied Arts proposal, including a limitation on the amount of construction in the downtown core at any one time; a transportation plan for downtown; endorsement of a down-zone in the retail core to the maximum height of what is now Macy's; and a restructuring of the bonus arrangement, deleting, among other aspects, on-site amenities. Lydia S. Aldredge, president of Allied Arts, was more forthright in her letter to Seattle's Department of Construction and Land Use: "Historically Allied Arts of Seattle has lobbied to reduce heights in the retail core. We support the CAP Initiative and the interim controls which limit the maximum height to 150 feet in this fragile area with its irreplaceable terra-cotta buildings."

The perception of many citizens, wrote Timothy Egan in the *New York Times* in 1988, was that the city's quality of life had declined. "While Seattle has experienced record growth in jobs, construction, and the migration of newcomers, many residents say the price has been too high: traffic gridlock, soaring real estate prices, and a drain on government services." Egan pointed out that Seattle had the tallest building on the West Coast—the seventy-six-story Columbia Center—and several sixty-story high-rises in the offing. The new construction came at a time when the city was torn up by a 1.3-mile "ditch" for an underground bus tunnel. "Financed in large part by

Japanese banking money," Egan continued, "Seattle's downtown has been radically transformed since 1980. At that time the metropolitan area . . . contained about thirty million square feet of office space. By the early 1990s the area is expected to have sixty million square feet of office space, with about twenty-six million of that downtown."

All of downtown seemed torn up. In a separate article, also in the *New York Times* that same year, Egan wrote, "Chipped by jackhammers, torn by tunnel-boring machines, and carved to its glacial depths by bulldozers, beautiful downtown Seattle looks like a war zone. . . . Streets are full of mud and debris, walls reverberate with the clank of construction and the hard-rock song of the jackhammer. The sidewalks make no sense, ending suddenly, diverted around a forest of cranes. There is so much construction that a developer recently announced that he may run for mayor on the platform of stopping all major developments downtown for five years."

After years of bickering, a zoning plan went into effect in 1985 that included a raft of bonuses if developers provided certain amenities of which the striking 1201 Third Avenue building is a prime example, increasing its square footage by 50 percent over an unbonused building size, wrote Peter Steinbrueck in a position paper he did for a Vision Seattle newsletter a few months before the election. But developers slipped in before the law went into effect, and thus the rush of tall buildings, thus the crush of new construction, in the mid-1980s.

Mayor Charles Royer said that CAP was too strict, and offered his own, less harsh, plan. Some considered it a political ploy, lacking "sincerity" to use Joni Balter's telling phrase in the *Times*. When Royer ran against Paul E. S. Schell in 1977, backed by Allied Arts, Royer was considered pro-neighborhood, and Schell, pro-downtown development, but perceptions changed, and Royer admitted that the prospect of CAP on the ballot forced him to come up with an alternative. Schell predicted that CAP would win. "The idea is to stop the mega-buildings that have real serious negative impacts on traffic and the office market," said Schell in Balter's story. "A lot of people want a breather."

Just like the fight to save the Pike Place Market from developers and the city, CAP was the cause of immense bickering and in-fighting. The opposition claimed that CAP would stunt growth, distract the city from more pressing issues, and force growth to be horizontal rather than on First Avenue. The big anti-CAP campaign was to begin in 1989, wrote Terry Tang in the *Weekly*. "The Downtown Seattle Association and local developers and

architects are starting to amass ammunition," Tang said, but added, "the CAP initiative raises a lot of issues," and that "should be a good debate."

CAP won. It was one of the few defeats of the Downtown Business Association, "the most powerful lobby in Seattle" in the 1980s, according to Walter Hatch and Joni Balter in the *Times*. In the previous decade the organization was clumsy, what one writer called "the city's only all-purpose demon, a kind of synonym for stupidity." It got smarter and grew up. "In many ways," according to Hatch and Balter, "it has forced Seattle to do the same. It has helped transform the sleepy town of the 1960s into the boom town of the 1980s—a city with a bubbling economy and a rich culture. . . . It successfully lobbied for a convention center, the Washington State Convention and Trade Center, on top of Interstate 5, instead of the less expensive Seattle Center, which Allied Arts favored; a Metro bus tunnel below Third Avenue; city permits to build thirty-three new steel-and-glass towers with more than thirteen million square feet of office space in the central business district and Denny Regrade; a retail complex at Westlake Mall instead of a large park."

Parallel to but also somewhat separate was the issue of the central waterfront. Allied Arts tracked its development through its Downtown Committee throughout the 1980s. As Joan Paulson wrote in the Allied Arts newsletter in 1989, the Downtown Committee believed so strongly in the importance of a good plan for the waterfront, it took time to prepare an alternative to what the city already had on the stove. Initial bond issues came, were defeated, and went. A central issue was the conflict between maritime uses for the harbor—about 60 percent owned by either the city or the Port of Seattle—and tourism.

In a position paper dating from 1984, Allied Arts began its list of recommendations, with some history: "The central waterfront is Seattle's birthplace. It was once the heart of trade, transportation, and manufacturing for the young and impetuous city. With the advent of highways, containerized cargo, and industrial evolution the need for passenger vessels declined. The location of cargo handling moved to expansive terminals, and the early businesses evolved and moved or died. . . . What distinguishes Seattle is the opportunity to combine new and exciting maritime uses with redevelopments which provide the public with access to a waterfront filled with attractions and amenities for all to enjoy." As Dick Clever wrote in the Sunday edition of the *Seattle Times/Seattle P-I* the following year, "The city is pressing ahead with plans to revitalize the waterfront as a people place,

while trying to hang on to as much of its salty flavor as possible." The plan, developed by a group called the Alaskan Way Harborfront Committee and the city, had strong supporters, including Allied Arts and the Downtown Business Association—one of the few times the two were on the same side of an issue.

The plan was only in the talking stages, supposedly with adequate votes in the City Council and the support of Mayor Royer. But by 1986, Royer had developed his own plan, as had the Port of Seattle. Royer's plan was pedestrian- and bicycle-friendly, and automobile-unfriendly. There would be new parks. The public would have to vote—altogether $34.7 million. There would be a luxury hotel and upscale condominiums. Royer's plan did not find favor with the voters and was defeated, the *P-I* proclaimed in an editorial, by Vision Seattle's insistence that there were other more pressing urban needs. But, the editorial suggested, there were possible avenues of compromise, which Allied Arts took up in a 1989 position paper. That settled little. The waterfront would have to wait another thirty years or so for another plan to be developed, this time without Allied Arts and the viaduct, and at a far greater scale as well as cost but with extraordinary ambition and vision.

21 / *Margaret Pageler*

ARGARET PAGELER CAME TO SEATTLE IN 1981, A YEAR AFTER
graduating from the University of Chicago Law School, and
began to practice law at Jones, Gray & Bayley. She quickly became
involved in the life of the city. "We wanted to get out of the Midwest," she
told the *Seattle Post-Intelligencer* six years later. "We scouted the country
and discovered Seattle. It was an exciting blend of new construction and
preservation—a good, dynamic balance. Allied Arts had the kind of com-
mitment to that balance that I wanted." She joined the group the year she
arrived, jumping into its myriad of activities, became president in 1987, and
was reelected the following year.

At the time Allied Arts had three principal focuses, according to Pageler.
The first was the arts: the individual artist and emerging and small organi-
zations; second, urban planning and design with public projects; and third,
historic preservation. "At any one time, Allied Arts is more visible in one area
or another, and what happens once we get a successful project going, is that
it spins off with its own organization." The biggest successes in the 1980s,
she added, were its downtown plan and its influence on downtown zoning;
its book on terra-cotta architecture, *Impressions of Imagination: Terra-Cotta
Seattle*; its consciousness-raising about the value of historic buildings; and
"Art à la Carte"—annual public visits to artists' studios. Among its biggest
failures was not saving the Music Hall Theatre.

Pageler ponders the why the Music Hall was not saved. Certainly enough
people tried, including Allied Arts, who poured time and money and energy

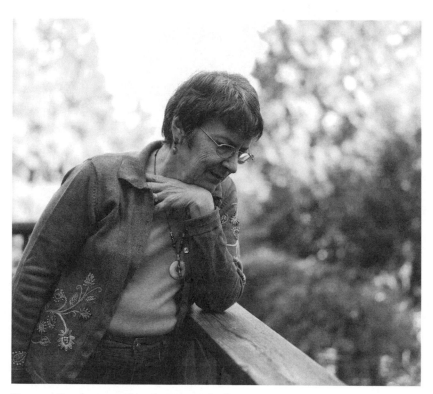

Margaret Paegler, 2012. Photo by Roger Schreiber.

into the fight. Was the failure a product of lack of imagination, of will? Pageler refuses to call the Music Hall scenario a failure. "Not to have tried would have been the true failure," she wrote in an Allied Arts newsletter. "Out of our experience has come a renewed effort to secure the long-term future of downtown Seattle's remaining historic theaters. We have overcome significant bureaucratic inertia and political skepticism. . . . The important fact in this struggle is easy to overlook because it is so obvious: there would have been no fight to save the Music Hall and no effort to protect the other theaters if Allied Arts did not exist. We were the only warrior on the field, we were the sole bugler sounding the alarm for the public, and we remain the lone sentry at the gates to resist the forces of expediency and the greed that threaten our architectural and cultural heritage."

Rescuing historic buildings is sometimes a question of timing, Pageler wrote. "At the time the Music Hall was destroyed, there was not much going on in the retail core. Everything was on hard times, and people were scram-

I am excited about grass-roots involvement in the local school or park district or whatever. It is important the city be committed to openness and community interaction.

bling. Development seemed to be concentrated on huge office towers. Ten years later, twenty years later, people were building hotels and entertainment venues in that area. These things come in cycles. The question is whether a property owner is willing to wait. Can the owner afford to lose money or keep a building vacant and wait for an economic turnaround?" Now the property on which the Music Hall used to sit is surrounded by other hotels, retail businesses, and restaurants, all of which would have encouraged some kind of development of the Music Hall, with its extraordinary exterior but difficult interior.

Pageler wrote in a 1987 Allied Arts Newsletter,

I get lots of calls about preservation: a Normandy Park business man wanting to see an old school renovated for use as a civic center; a developer hoping to adapt industrial buildings with great wooden beams; a promoter looking for space in a historic theater; a woman trying to arrange for salvage of carved stone panels from a building being demolished. Even over the phone one can sense the passionate energy of these callers . . . News reporters like to refer to "preservationists," but these calls seldom come from preservationists. They come from ordinary folk who have an extraordinary personal identification with special places and a common appreciation for quality in architecture and workmanship. The real groundswell of support for saving Franklin High School came from south end residents: poor, elderly, ethnically diverse, not necessarily alumni and certainly not "preservationists." Whenever historic structures are threatened, a new grassroots constituency in favor of preservation arises. Allied Arts is strongest when we draw our strength from these constituencies. Like a lightning rod, we can focus the spontaneous energies released when newly active interests seek to make an impact on existing systems.

Pageler also worked on the Allied Arts Downtown Plan, which won a Washington State American Planning Association award for excellence. That plan stressed pedestrian-friendly streets, human scale in the retail

core and other areas, green linkages, an active waterfront, and preservation of historic districts and buildings. Design rules were proposed that would require public open space and street-front retail on skyscrapers.

Members of Allied Arts come from a wide variety of backgrounds, but there were probably not many like Pageler, whose parents were missionaries in China. Her parents' experience with repressive Communist and Nationalist regimes heavily influenced their daughter and helps explain her long interest in local government and land use issues. "I am excited about grassroots involvement in the local school or park district or whatever. It is important the city be committed to openness and community interaction."

One of Pageler's major battles was the Stimson Center, a two-hundred-million-dollar, forty-five-story retail complex next to the Sheraton Hotel and the Washington State Convention Center that was intended to be "the crowning glory for the Graham dynasty [of Space Needle fame]," wrote Evelyn Iritani in the *P-I* in 1987, "but became a financial disaster that sucked the life out of the corporate empire." At the peak of John Graham, Jr.'s influence, in the 1960s and 1970s, his architecture/development company dominated local development and created skylines throughout the world. In spite of his influence, Graham had a genuine disdain for notions of architectural style. He understood the refinements of real estate, but not architecture. "He wasn't very well respected by his peers," said Howard Wright Jr., a major competitor, whose family had been partners with Graham on several projects, including the Space Needle and the Sheraton. "In those days architecture was too much reflected as art," Wright said. "A designer/builder was a no-no because it put the architect in bed with his contractor."

Battles on nearly every front went on for years between Graham and city officials and civic groups. The city maintained that the Stimson Center project was ill-timed and poorly planned. Allied Arts, with Pageler as president, and the League of Women Voters led the fight from the vantage point of civic groups. Graham blamed the two groups for killing the project. In his view, they were the "real villains," wrote Iritani. He went further, calling them "little, uneducated girls." In this particular battle, Fred Bassetti, a former Allied Arts president, was not on Allied Arts' side. Working as a consultant on the project, Bassetti argued that the project got more criticism than it deserved, mostly because of Graham's high profile in the city. "It could've been one of the best-designed buildings in town. It had honesty. It had spirit. I was quite chagrined when Allied Arts and the League put on the big pressure and had it stopped." Pageler has no apologies for Allied Arts'

position. It was concern about the building's environmental effects, not its design, that had prompted the organization's opposition. There was no vendetta, although members were concerned about the prospects of another Graham building in the neighborhood. "The Sheraton is conspicuous for its inhospitality on all four sides to pedestrians."

During Pageler's decade with Allied Arts in the 1980s, she was concerned about "projecting an image of Allied Arts (and myself) as rational, not anti-development, willing to compromise." That said, she added,

> We never took a hard look at the city's downtown growth policies or analyzed capacity issues. We compromised too readily on height and density limits. Take Westlake Mall, for example. Should Allied Arts have dug in its heels years ago and insisted on a real public square in Seattle? What if we had thrown the whole weight of the organization behind Victor Steinbrueck in his battle with the city and the developers? Given the muscle and staying power of the folks with a financial stake in urban zoning and development decisions, perhaps those of us whose only stake is the quality of the urban experience should be more idealistic, more visionary, and above all more stubborn if we are to have any influence on the shape of Seattle.

In 1983, at the invitation of the developer of Century Square, Pageler, as chairman of Allied Arts Downtown Committee, drafted a series of comments, both positive and negative, about the project. She reiterated the committee's conviction that the "retail core is the vital heart of Seattle's downtown and that it should be preserved and enhanced as a special district of downtown with its own style, scale and predominant use. . . . The proposed Century Square project demonstrates problems and potential problems that arise because there is not yet a clear, rational, and certain zoning scheme in place to define and preserve the retail core." To the hearing examiner, Pageler wrote that Allied Arts supported keeping street and alley right-of-ways in the public domain "to ensure pubic access and pedestrian open space linkages." Exceptions could be made, as in the case of the Harbor Steps, which Allied Arts supported, because the public sector probably could not achieve "such a grand improvement scheme on its own. We encourage public/private cooperation of this type."

Pageler wore "several hats," to use her term, during her most active time at Allied Arts. She could even laugh at herself. In a letter to Fritz Hedges of the Seattle Department of Parks and Recreation, she listed them: "Allied

Margaret Paegler, late 1980s. Photo courtesy of Margaret Paegler.

Arts president, Seattle Planning Commission member, Vision Seattle candidate, historic preservation and neighborhood busybody." Little wonder people paid attention. She was educated, smart, experienced, articulate, and passionate about the city in which she lived. But she was careful not let her different interests conflict with one another. In 1988, in the heat of the battle over the CAP (Citizens' Alternative Plan) initiative that would limit the height and density of buildings in the downtown core, she stepped down as chair at an Allied Arts meeting regarding CAP because she was a member of the CAP steering committee. Not only did she disqualify herself from active participation in the discussion, she abstained from voting. Others in Allied Arts at the time who also had apparent conflicts did not take Pageler's lead, and created a substantial controversy that served no one.

Among Pageler's non–Allied Arts hats was Vision Seattle, formed in 1987 to encourage "more perfect municipal politics." The group presented a slate of three candidates to challenge incumbents on the City Council. Pageler was one of them. They—along with CAP, their "kissing cousin"—sought "to capitalize on citizen discontent over new zoning regulations and suspicions that incumbent officeholders are tired and don't respond to ordinary people anymore," wrote Rebecca Boren in the *Seattle Weekly*. All three lost. In lieu of a council seat, Pageler was reelected president of Allied Arts in 1988, saying in a news story that she hoped "to stir things up out there."

One ongoing issue that concerned Allied Arts was the central waterfront. Vision Seattle is credited with defeating the $34.7 million levy to improve the area; it asserted that the city had more urgent needs, such as neighborhoods, transportation, park improvements, and human services. In 1989, Allied Arts presented a position paper with its own ideas. Pageler didn't write it—Tom Graff, another articulate voice in the organization, then chair of the Downtown Committee at Allied Arts, wrote it—but Pageler had a hand in its creation. She was also concerned with historic preservation, offering new ideas and plans and efforts to preserve the Alden Mason and Michael Spafford murals in the State Capitol.

In 1991, Pageler ran for Seattle City Council again and was elected, bring-

Margaret Pageler

ing to a larger public platform her views on city planning and development. She served three terms. She lost touch with Allied Arts as it began to dissolve and eventually collapsed. "I don't know what happened. There was a split focus between small arts organizations and urban planning. I think the center of gravity moved back and forth, which makes it difficult to raise money and get new members. It developed a split personality, perhaps a victim of its own success. The Commons might have been a part of Allied Arts' unraveling." No doubt Pageler brought lucidity, intelligence, and commitment to

Allied Arts. You didn't have to agree with her to admire her and her viewpoint.

Epilogue

A S THE LAST CENTURY DREW TO A CLOSE, MORE AND MORE things happened in Seattle without Allied Arts' advice, participation, or consent. It was no longer a major player. As Rae Tufts, long-time trustee put it, the organization had lost "a lot of credibility. Its time had come and gone, its trustees no longer central in the civic arena. I think organizations are created because there is a need for them. But as needs change, so does the response. In its heyday of influence, the question was often 'What does Allied Arts think?'"

The reasons for this withering away are multiple and hard to see clearly. No one seems to have a definitive answer about what happened. By the 1980s, board meetings often fizzled for lack of a quorum. The number of trustees was expanded, then reduced, in an attempt to make arriving at a quorum easier. Attracting volunteers—critical to the success of the early days—became more difficult. Many of the important campaigns of the past, which had attracted scores of people, had been won and were now part of the fabric of the city. Less influential people served on the board. Dissatisfaction appeared on several fronts. The minutes of the executive committee in 1991 recorded the wish, for instance, of "many trustees . . . to put the fun back into Allied Arts."

Money, of course, was hard to come by, but that had always been the case. Dollars were always minimal. The success of a fundraiser was usually measured by whether it had simply ended in the black. Staffing began with the inimitable Alice Rooney, who carried on for twenty years (from 1960 to

1980), often by herself, sometimes with minimal help. Government money for extra staffers diminished until only the executive position was left. Then it went away. Eventually Allied Arts did not file tax returns, and the Internal Revenue Service revoked its nonprofit status. As early as 1984, Dick Lilly left the executive job after only thirty months for lack of money. He said in an interview in the Seattle Weekly that fund-raising was his biggest disappointment. He said he thought the organization "needed a new director for the long haul to come."

Interest in the organization has not evaporated entirely. There has been some rustling about it on the Internet (but not by any of the old hands) and in some recent town-hall-like gatherings in the name of Allied Arts, but no sponsors have been identified. Where this will lead is unpredictable. Something similar—a kind of disintegration—happened to PONCHO for different reasons over the same period. The annual auction, begun in 1963, raised millions of dollars for the arts. At its peak, there was the main auction, a wine auction, and an art auction. It was the party everybody in the social whirl of the city attended. Then PONCHO began to have more trouble procuring items for sale and more trouble selling them. Certainly it no longer had the field to itself; it was the first to hold auctions to raise money, followed by many, large and small. The competition for people with money and items to be auctioned was fierce. The ancillary auctions disappeared one by one until finally, in 2012, the organization announced that it was closing is doors.

The development of South Lake Union, with which Allied Arts was at one time closely involved, has taken off on it own, with office buildings, apartments, a biomedical and technology hub, and even a university—an extension of Northeastern University. Inevitably there were disagreements about height and density, yet building continued. Amazon is on a significant building spree, with all sorts of new construction. The Museum of History and Industry relocated from Montlake to a thoroughly renovated building on the lake. It is now splendid. The Fred Hutchison Cancer Research Center has become a significant presence in the area, as has Paul Allen's Vulcan Real Estate.

Allen played an important, and generous, role in trying to turn the area into a dreamboat plan of housing and parks, called the Commons, in the 1990s. This whole effort was the subject of contentious civic debate. Instead of leading the way, Allied Arts waffled so badly that the best it could do was to split its vote. For many that was the beginning of the end for Allied Arts. The voters rejected the issue twice in the voting booth.

Boren Avenue North and Republican Street, South Lake Union, 2013. Photo by Roger Schreiber.

Arts groups—theater companies, chamber orchestras, dance troupes, and art galleries—have come and gone since the peak of the 1980s. The total number is more than two dozen. It can be argued that there was little Allied Arts could have done to save them. In any event, the organization had already moved away from the arts, its first thrust of interest in the 1950s. However, the majors have prospered—with some exceptions. The Intiman Theatre almost went under; it has now been revitalized under a reduced banner. So did ACT, which has been completely resurrected. One of the most significant things Allied Arts had a hand in was the formation of a historic theater district. Although the Seattle City Council did not formally adopt an ordinance until 2011, the genesis for the idea came from the 1980s. There are five downtown venues, all pre-1930: the 5th Avenue, the Paramount, the Moore, A Contemporary Theater (ACT) and Town Hall. The notion is not only to protect the buildings but also to allow the organizations that use them to work together for a common end.

Among Allied Arts' earliest, and most successful, efforts was Pioneer

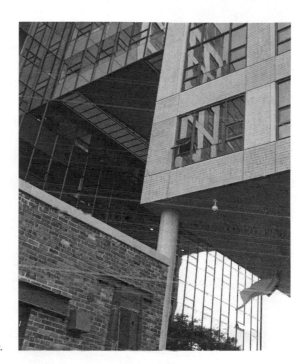

Amazon campus (detail),
South Lake Union, 2013.
Photo by Roger Schreiber.

Square—saving old buildings and creating a historic district, the state's first. Then the neighborhood changed, became more violent, and people were scared away, particularly at night, until finally only a few people actually lived in the district. Stores left for sunnier horizons. Major emporiums, such as the Elliott Bay Book Company, moved away. High-tech businesses filled many of their places, but there was still a lack of full-time residents. The Nisqually earthquake and Mardi Gras riots made people even more wary of living in the Square. Now that problem is on the way to being solved, with developers such as R. D. Merrill Company, north of CenturyLink Field, bringing people to the area to live. New retail spaces and hotels, some quite remarkable in design, and apartment buildings are in the near future. Streets have been cleaned up, and trees planted.

Perhaps the most intriguing and far-reaching development in Seattle is the central waterfront, which is being called Waterfront Seattle, a joint venture of private and public capital. Doing something with the central waterfront has long been a vision for Seattle, but with few concrete results. Nothing could happen until the viaduct came down—something that was advocated in every Allied Arts manifesto I ever read. A massive tunnel will replace the viaduct (completion date set for 2016), including all sorts of pub-

lic amenities planned to make Seattle's front lawn inviting, if not exciting. The first step, replacing the Elliott Bay seawall, was approval by city voters in 2012. Promenades, beaches, parks, recreating old piers, viewing areas, a walk designed to link historic piers, and a connection between Belltown and the waterfront are planned. The cost is estimated to run beyond $1 billion, with construction to be completed in 2019. All of this development—the arts, commerce, city planning, historic preservation, beautification, and design—is the end result of what Allied Arts began to advocate sixty years ago. It is an extraordinary legacy.

Patrons

Nancy Alvord
Anonymous
Fred and Gwen Bassetti
Cynthia and Christopher Bayley
Penny Berk
Daniel Block
Mary Lou Block
David and Joyce Brewster
Marlys Erickson
Jean Falls
Carey Family Foundation
Robert Carlson
Adele and Dan Clancy
Elizabeth Close
The Coney Family
Jane and David Davis
Terri DiJoseph
Hugh and Jane Ferguson
 Foundation
William and Ruth Gerberding
Kathryn Alvord Gerlich
Kathryn Glowen
Jean Godden

Peggy Golberg
Gene Graham
John Graham
Mary Griffin
Gerald and Carolyn Grinstein
Robert and Sally Hayman
G. David Hughbanks
Rena Ilumin
Norm Johnston and Jane Hastings
Karen Kane
Melvin and Edna Kelso
Janet Lynch
Walter and Betty Kerr
Janet W. Ketcham Foundation
Barbara Kline
Jennifer Pohlman and
 Sabrina Knowles
Wayne Dodge and
 Lawrence Kreisman
LeAnn Loughran
Virginia McDermott
Ann Magnano
Richard Mann

Michael and Michelle Miller
Olympic Associates
James and Katherine Olson
Matthew Patton
Miriam Pierce
Llewelyn and Jonie Pritchard
Alice Rooney
Scott Rooney
Robin Rooney Cassidy
Gladys Rubinstein
Ginny Ruffner
Betsy Schmidt
Cynthia Sharp
Mimi Sheridan
Paul Silver

Estate of David Skellenger
Linda Strout
George and Kim Suyama
The Talley Family
Boyka Thayer
Jerry and Ernalee Thonn
Rae Tufts
Lish and Barbara Whitson
Mary McLellan and
 J. Vernon Williams
Thomas T. Wilson
Philip and Christina Wohlstetter
Virginia Bloedel Wright
Ann Pigott Wyckoff
Wyman Youth Trust

Selected Bibliography

THE VAST ARCHIVES OF ALLIED ARTS OF SEATTLE HOUSED AT Special Collections, University of Washington, collected by members of the Allied Arts staff, were a principal source for this book. The archives contain personal papers, correspondence, minutes, newsletters, grant files, financial records, committee records, event files, publications, reports, drafts of speeches, programs, position papers, resolutions, newspaper and magazine clippings, ephemera, memoranda, by-laws, and photographs from 1954 to 2000. Periodicals in the archives include those from the *Seattle Post-Intelligencer, Seattle Times, Argus, The Weekly, Puget Sound Business Journal, Puget Soundings, Pacific Northwest Quarterly, Seattle Magazine, New York Times, Los Angeles Times, Washington Post, House and Garden,* and *Capitol Hill Times.* In general they are in excellent condition—but not entirely. There are gaps and omissions in news and magazine articles, and parts of pages have been inadequately photocopied. In some cases, there is no date, or only a partial date. A miscellany of records, including newsletters and minutes from the 1980s and 1990s, were mistakenly discarded; no one seems to know by whom, or how much is gone, but this represents a major gap in the files. Another important source were interviews by Walt Crowley and Jeff Katz done over a decade, which I intermingled along with my interviews in the book. Crowley also contributed the timeline.

The Allied Arts Foundation also has related records, including minutes, financial records, project files, programs, photographs, and clippings. Organizations represented in the collection include the American Institute

of Architects, the American Symphony Orchestra League, the Arts Councils of America, Friends of the Market, Pike Place Market, the Seattle Municipal Arts Commission, the Seattle Symphony Orchestra, the Seattle Youth Symphony Orchestra, and the Washington Roadside Council.

Armbruster, Kurt E. *Before Seattle Rocked*. Seattle: University of Washington Press, 2011.

Becker, Paula, Alan Stein, and HistoryLink Staff. *The Future Remembered: The 1962 Seattle World's Fair and Its Legacy*. Seattle: Seattle Center Foundation, in association with HistoryLink, 2011.

Berger, Knute. *Space Needle: The Spirit of Seattle*. Seattle: Documentary Media, 2012.

Cotter, Bill. *Seattle's 1962 World's Fair*. Charleston, SC: Arcadia Publishing, 2010.

Crowley, Walt, and HistoryLink Staff. *Seattle and King County Timeline*. Seattle: University of Washington Press, 2001.

Dorpat, Paul, ed. *Legacy: The Kreielsheimer Foundation*. Seattle: University of Washington Press, 2006.

Elenga, Maureen R. *Seattle Architecture: A Walking Guide to Downtown*. Seattle: Seattle Architecture Foundation, 2007.

Humphrey, Clark. *Vanishing Seattle*. Charleston, SC: Arcadia Publishing, 2006.

Johns, Barbara. *Anne Gould Hauberg: Fired by Beauty*. Seattle: University of Washington Press, 2005.

Keniston-Longrie, Joy. *Seattle's Pioneer Square*. Charleston, SC: Arcadia Publishing, 2009.

Link, Karin Murr, Marc Blackburn, and Dana Cox. *Seattle's Oldest Neighborhood*. Edited by Mildred Tanner Andrews. Seattle: University of Washington Press, 2005.

Lowe, George. *The Trouble with Seattle*. Self-published, 2011.

Morgan, Murray. *Skid Road*. New York: Viking Press, 1951. Reprint, Seattle: University of Washington Press, 1982.

Ochsner, Jeffrey Karl, and Dennis Alan Andersen. *Distant Corner: Seattle Architects and the Legacy of H. H. Richardson*. Seattle: University of Washington Press, 2003.

Pomper, Steve. *It Happened in Seattle*. GPP, n.d.

Ridley, Jo Ann. *Zoe Dusanne: An Art Dealer Who Made a Difference*. McKinleyville, CA: Fithian Press, 2011.

Sale, Roger. *Seattle Past to Present*. Seattle: University of Washington Press, 1978.

Shannon, Robin. *Seattle's Historic Hotels*. Charleston, SC: Arcadia Publishing, 2010.

Speidel, William C. *Sons of the Profits*. Seattle: Nettle Creek Publishing Company, 1967.

Steinbrueck, Victor. *Market Sketchbook*. Seattle: University of Washington Press, 1962.

———. *Seattle Cityscape*. Seattle: University of Washington Press, 1968.

Tanner, Mildred Andrews, ed. *Pioneer Square*. Seattle: University of Washington Press, 2005.

Index

O

P

Post-Fair Unlimited, 98–99

Potts, Ralph B., xxi, xxii, xxiii, 113, 162

Pratt Fine Arts Center, 108

Pritchard, Joel, 18–19, 49, 198

Pritchard, Jonie, 194

Pritchard, Llewelyn G. (Llew), 195, 197;
on Allied Arts, 195–96, 199–200;
on Block, 104; fundraising and,
199; on Golberg, 122–23; life and
career of, 194–95; mentions, 179, 180;
presidency, 195–99; timeline events,
xxviii; underground wiring and, 193;
on volunteer community, 196

Priteca, B. Marcus, 95

Program for the Arts (Municipal Arts
Commission), xxi

Proposal 21 (Pike Place Market), 26–27

"Proposal for the Performing Arts in
Seattle," xxvii, 149–50

Public Library, Seattle, 93

publicly funded art: background,
145–46; Borofsky's *Hammering
Man*, xxxii–xxxiii, 114, 157; budget-
ing and financial issues, 148, 150–52,
154–56; Committee for Municipal
Arts Support, 148–49, 155; estab-
lishment of commissions, 146–48;
Heizer's *Adjacent, Against, Upon*, 149,
157; Liberman's *Olympic Iliad*, 101,
150, 157; Moore's *Vertebrae*, xxx, 147;
Newman's *Broken Obelisk*, 156, 157;
Noguchi's *Black Sun*, 146, 146–47;
praise for, 152; "Proposal for the
Performing Arts in Seattle," 149–50;
Rauschenberg's Benaroya mural, 157;
Smith's *Moses*, 153, 157; Spafford's *The
12 Labors of Hercules* and Mason, con-
troversy over, xxxi, 157–58; surveys
on, 152–53

Puget Power, 161, 186

Queen Anne, 93

Raff, Douglas, 49, 50

Raftis, Edmund, 125

Rainier Square, xxviii, 46, 48–49, 52, 57

Randlett, Mary, x, 108

Ray, Dixie Lee, 185

Reed, Janet, 117–18

Reed, Victoria, 49

Rekevics, Karlis, 32

Retina Circus, 137

Revelle, Thomas Plummer, 21

Rice, Norm, xxxi, xxxii, 59, 185

Ridley, John, 96

Riely, Keith, 51

Robbins, Tom, 67–68

Robertson, Jack: billboard campaign
and, 172, 173, 175, 176; Lake Union
and, 167; underground wiring cam-
paign and, 161, 162, 169

Robinson, Herb, 74

Rockey, Jay, 98

Roethke, Theodore, xxiii, 17, 66, 136

Rogers, Millard B., xxii, 169

Rogers, Will, Jr., xxiv

Rooney, Alice, 11, 12, 16; on billboard
and Pike Place campaigns, 14–15; on
Bowen, 67; career of, 11–12, 18–20;
on character of the group, x–xi;
Coney on, 177; departure of, 18–20;
on Detlie, 13–14; Generous Service
to the Arts award, 104; on Golberg,
123; hired as executive secretary, 10,
103–4; mentions, 166, 222–23; opera
festival and, 115; on Pioneer Square,
80; publicly funded art and, 151, 153;

Rooney, Alice (*continued*)
 role of, 10–11, 12–18; on Schell, 138;
 Skolnick and, 81; Survival Series
 and, 133; timeline events, xxii, xxix;
 on "truth and commitment," 18; on
 underground wiring, 189
Rooney, Bob, 12
Roosevelt, Eleanor, 112
Rosellini, Albert D., xxiii, 12
Ross, Glynn, 115, 117, 120
Ross, W. Duncan, 120
Royer, Charles: billboard campaign and,
 176; Bumbershoot and, 119; CAP and,
 212; Pioneer Square and, 82; publicly
 funded art and, 155; Schell vs., 144;
 timeline events, xxix, xxx; under-
 ground wiring and, 193; Volunteer
 Park Conservatory and, 64; water-
 front and, 214; Westlake and, 207,
 208, 209
Russell, Francia, 118

S

Sale, Roger, 3–4
Salsbury, Allen Vance, 78, 165–66
Sand Point Arts and Culture Exchange
 (SPACE), xxxiv
Sand Point Naval Air Station, xxxiv
Sarkowsky, Herman, 52
Sato, Norie, xxxiv
Schefelman, Harold, xxi
Schell, Pamela, 138–40, *139*, 176, 195
Schell, Paul E. S., 16, *139*, *143*; on Allied
 Arts, 140–41, 144; billboard campaign
 and, 175; CHECC and, 140; Coney
 on, 179; life and career of, 138–40;
 mayoral candidacy and term, 143–44,
 185, 212; mentions, 180, 195; Olympic
 Hotel and, 50; open letter on arts

and, 120; Pike Place Market and,
 32; Pioneer Square and, 80; presi-
 dency, 138, 141–43; Pritchard on, 123;
 publicly funded art and, 148, 149, 151;
 quoted by Steele, 8; Royer vs., 119;
 as "talent scout" for leadership, 179;
 timeline events, xxvii, xxix, xxxiv;
 Westlake and, 207
Scheme 23 (Pike Place Market), 27–30
Schram, Donna, 83
Schultz, Cecilia, xxiii, 97, 112–13
Schwarz, Gerard, 55
Schweppe, Alfred, 95
Seattle: Beecham on, 129–30; descrip-
 tions of, 3–4; discovery and pioneer
 settlement of, 3; Great Fire (1889), 78;
 Pioneer Square and history of, 77–78
Seattle, Past to Present (Sale), 3
Seattle Art Museum (SAM), *114*; about,
 118–19; Betty Bowen Award, 76;
 Borofsky's *Hammering Man*, xxxii–
 xxxiii, *114*, 157; Bowen at, 74–75;
 mentions, 111; "Northwest Show,"
 130; timeline, xxii, xxx; Westlake
 and, 208
Seattle Arts Commission: annual alloca-
 tion, 142; budget issues, 150–52, 155;
 creation of, 146, 147–48; Survival
 Series and, 133; timeline, xxvi, xxviii.
 See also Municipal Arts Commission
Seattle Asian Art Museum, 119, *136*
Seattle Center and World's Fair (Cen-
 tury 21 Exposition): beginnings
 and planning, 91–95; Bumbershoot,
 119–20; Chihuly garden and glass,
 100; as cultural watershed moment,
 110; design and construction, 95–97;
 50th anniversary of, 91; Flag Plaza
 Pavilion, 133; funding for, 93, 94–95,
 98; grounds of, 92, 95; Liberman's

Yeaworth, David, xxxv
Yesler, Henry, 77

Z

Zimmerman, Herbert, 71–72
Zoë Dusanne Gallery, 111, 130